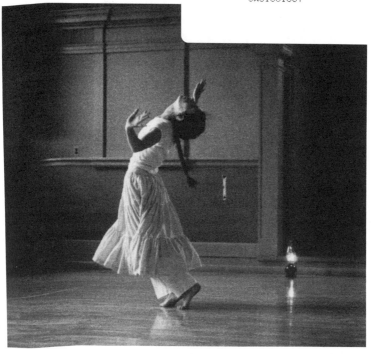

PAJ Books
Bonnie Marranca and Gautam Dasgupta
Series Editors

Art + Performance
1. Deborah Jowitt, ed., *Meredith Monk*
2. Moira Roth, ed., *Rachel Rosenthal*

Meredith Monk

Edited by Deborah Jowitt

The Johns Hopkins University Press Baltimore + London

© 1997 The Johns Hopkins University Press
All rights reserved. Published 1997
Printed in the United States of America on acid-free paper

06 05 04 03 02 01 00 99 98 97 5 4 3 2 1

The Johns Hopkins University Press
2715 North Charles Street
Baltimore, Maryland 21218-4319
The Johns Hopkins Press Ltd., London

Library of Congress Cataloging-in-Publication Data will be
found at the end of this book.
A catalog record for this book is available from the British
Library.

ISBN 0-8018-5539-x
ISBN 0-8018-5540-3 (pbk.)

Permission credits may be found on page 209.

Contents

Photograph gallery follows page 84.

Acknowledgments

When I first began to assemble material for this anthology, I had no idea how consuming and enthralling a process it would be—or how difficult. Because no complete book in English has yet been devoted to Monk, a wealth of material, published and unpublished, had to be sifted through, appraised, resifted. The last select bibliography had been compiled in the early 1980s. Some choices of articles to include were obvious; other decisions required agonizing deliberations, in consideration not just of excellence, but of length, information revealed, and balance within the book.

I would like to express my gratitude to the writers who graciously consented to have their articles reprinted, many of them adding, "I'm so glad you're doing this!" or "This is a wonderful project!" Photographers, too, have been immensely accommodating and unstinting in their admiration for Monk's work. Monica Moseley of the New York Public Library's Dance Collection and a founding member of The House helped me find elusive dates and facts.

The staff at The House Foundation for the Arts made my editorial job immeasurably easier by opening The House's files to me, tracking information and articles, and providing me with their in-process chronologies. Toward the end, I began to worry that my phone requests would elicit unvoiced, "It's Jowitt *again*" sighs. If they felt this, they never showed it. I thank them all, especially Barbara Dufty, managing director; Kerry McCarthy, director of development; and Amy Santos, company manager.

The one person without whom this book would not have been possible is Meredith Monk herself. Gracious even when her schedule was at its most pressured, she gave me access to material I could not otherwise have seen and lent me treasures from her collection. I sat on

the floor of her loft while she brought out stacks of photographs, clippings, charts, and notebooks for me to peruse. Furthermore, she gave the impression that sorting through the valuable debris of her past was as much fun for her as it was for me. A remarkable artist; a remarkable woman.

Meredith Monk

Deborah Jowitt

Introduction

It was Halloween week, 1971, and raining in Manhattan. The spectators for Part Three of Meredith Monk's *Vessel* huddled together on bleachers in an empty downtown parking lot. Damp we may have been, but it hardly mattered. We were nearing the end of what felt like a treasure hunt, accumulating magical fragments of this "opera epic" about Joan of Arc, as we traipsed from Monk's loft on Great Jones Street (Part One) to the Performing Garage on Wooster (Part Two) to the lot for Part Three. Suddenly, to our left, almost a block away and across West Broadway, the portico of a church lit up. There stood the performers identified with Joan's three saints. People gasped, nudged neighbors to look. I still get goosebumps remembering the apparition of those distant figures outside the frame that had been established.

Vessel contained other startling images. Why isolate this one? I think because it vividly illumines how Monk the artist works as both archae-ologist and seer. Wanting us to experience past and present simultane-ously, she creates the poetic equivalent of a cross-section of soil strata. And in *Vessel,* by layering an imagined French past onto a very real church in her own neighborhood—a crumbling, nineteenth-century industrial district of Lower Manhattan—she not only brought legend closer to us; she expanded our definition of art to take in the entire visible landscape of sound and motion. I remember someone seriously wondering if the plane that flew over was on her payroll.

Vessel was, arguably, the culminating piece of Monk's early period and her first use of fictional elements; it also gathered in themes, im-ages, and structuring principles that would continue, in various guises, to figure in her work for years to come. Although Monk has matured and developed as an artist since her beginnings in the early 1960s, she

has remained more consistent than have any of her contemporaries in the American avant-garde. Whether she presents epics like *Vessel* and her more recent *American Archeology* (1994), small music theater pieces like *The Plateau Series* (1978) and *Facing North* (1990), or solo vocal recitals, whether critics consider her as composer, playwright, choreographer, filmmaker, singer, or dancer, she seems descended from bardic tradition. Her forms may be wholly contemporary, but her images, her voices, her themes resonate with myth and legend. A thread runs from the visionary Joan to the child who sees the future in the film *Book of Days* (1985) and the truth-seeking traveler in the opera *Atlas* (1990). In Monk's 1969 "theater cantata," *Juice,* one of the apparitions that paraded up the ramp of the Guggenheim Museum was a woman sitting on a man's shoulders, the same black skirt covering them both; a mask where his face ought to have been burgeoned between her legs. Over twenty years later, in *Atlas,* the figure emerged from pageantry into drama. A hungry ghost, aching to get its fingers on an unwary traveler, appeared as an immensely tall woman in a long white gown— her supernaturally high, rasping whimper accented by an occasional creaking from the bass voice hidden under her skirt.

Although by 1984, Monk had collected many honors, awards, and prizes, critic Alan Kriegsman commented ruefully that she was at that point more famous abroad than at home, and noted as a possible cause the difficulty critics have in classifying her presentations. "I work in between the cracks," she once said, "where the voice starts dancing, where the body starts singing, where theater becomes cinema."[1] The urge to pigeonhole can work against one so multifaceted; however, as critic Marcia B. Siegel has pointed out, Monk achieves true *Gesamtkunstwerken:* "[Her] overall process transforms the elements, overspreads, and finally displaces them altogether. You can't really say which is the crucial medium when you look at the end product. Considering how many dance and theatre artists in the 20th century have tried for such a synthesis, and how few have truly accomplished it, Monk's achievement is doubly impressive."[2] The accolade in 1995 of a MacArthur Fellowship (famously nicknamed the "genius award") confirms to the larger public what many have believed for years and what Kriegsman trumpeted: "When the time comes, perhaps a hundred years from now, to tally up achievements in the performing arts during the last third of the present century, one name that seems sure to loom large is that of Meredith Monk. In originality, in scope, in depth, there are few to rival her."[3]

Monk often speaks in interviews of her musical family: the great-grandfather who was a cantor in Russia, the musician grandparents who founded a music school in Harlem, the mother who worked as a pop singer. You can hear the vocal family tree in Monk's singing and compositional styles: powerful a cappella work, ululations, modal melodies, and repetitive, easily graspable motifs that can sound, in the words of music critic Gregory Sandow, like "folk tunes of a culture she invented herself."[4]

Unlike many other little girls raised in New York and Connecticut,* Monk wasn't first piloted to after-school ballet classes (they came later). Instead, Mrs. Monk noted Meredith's less than model coordination (owing to a vision problem) and took her to classes in Dalcroze Eurhythmics, where her superb rhythmic sense could enhance her motor development. Even though she sang and played piano from an early age and has said that she could read music before she could read books, she didn't opt for a conservatory education, but attended Sarah Lawrence College in Bronxville, a small liberal arts college that featured an innovatively structured curriculum. It was as a choreographer that she first attracted attention.

Monk remembers herself in college as "this completely obsessed little thing";[5] schoolmates recall her in dance composition class hunched on the floor behind a curtain of hair. Bessie Schönberg, co-director of the opera workshop (in which Monk participated), head of the dance department, and a legendary dance composition teacher, spoke only of how interesting Monk was, how Schönberg knew she was remarkable from the moment she walked in the door. *Timestop,* premiered at Sarah Lawrence in 1964 and later shown in New York, was an accomplished and unusual dance for a twenty-one-year-old.

We remember the 1960s as a time of enormous ferment in the art world. Certain rebels, many of them influenced by John Cage's radical ideas and his New School composition classes, were intent on breaking down the traditional dividing lines between the arts and between art and life. In Events and Happenings, visual artists such as Red Grooms, Claes Oldenberg, and Allan Kaprow turned themselves—and sometimes their audiences—into performers in highly imaginative fabricated environments and real public sites that they commandeered or

*Imagination and mischievousness goading each other on, Monk once wrote in a program biography that she was born in Peru, a fact that has become embedded in her history. She was born in New York City.

simply invaded. In a period of antiestablishment and antielitist radical-
ism on the part of American youth, the members of Judson Dance
Theater queried another elite establishment, that of polished tech-
nique and the dramatic, high-gloss performing style of the reigning
modern dance companies. They chose instead to present everyday hu-
man movement structured into imaginative tasks or games, with the
performer as matter-of-fact worker. The downtown New York art
scene of the 1960s had much in common with the Dada movement
that had burst into riotous bloom in Zurich just before World War I,
but lacked the bellicose iconoclasm; the rebel choreographers' urge to
prune art back to its essence and purge it of some of its accumulated
veneer had an almost idealistic fervor.

Taking Robert Dunn's composition class in 1964 brought Monk in
touch both literally and philosophically with Judson Dance Theater;
Dunn's first composition class at Merce Cunningham's studio in 1961
had spawned the obstreperous Judson group of performers, prominent
among them choreographers Yvonne Rainer, Steve Paxton, David
Gordon, Trisha Brown, Lucinda Childs, and Deborah Hay, film-
maker-choreographer Elaine Summers, and artists Robert Rauschen-
berg, Alex Hay, and Robert Morris. Monk also appeared in the Fluxus
events *Celestials* and *The Tart* by Dick Higgins and, with Higgins, his
wife Alison Knowles, and Ay-O, realized the scenario of Erik Satie's
Dada theater piece *Relâche* for the New York Avant-garde Festival of
1965. Two Monk works, *Radar* and *Blackboard,* were created for the
same festival.

From the beginning, Monk, unlike the Judsonites, took an interest
in theatricality, persona, transformation, and narrative. She, Kenneth
King, and Phoebe Neville, who often shared concerts and appeared in
one another's dances, formed a renegade second generation not wholly
approved of by the senior artists associated with Judson. Yet certain
preoccupations of the day seemed to strike sparks from Monk: the
notion of an objective performing style; the interest in collage as a
structure; the use of film; and the exploration of non-proscenium
spaces. Altered and personalized, they have remained integral to her
work.

"Cool" presentation, especially when juxtaposed to "hot" or loaded
subjects, sets up a powerful tension, as noted by Marshall McLuhan
in his popular *Understanding Media,* which came out in 1964. Monk's
early experiments with this notion could be observed in the 1965
Blackboard: dressed in tailored street clothes, she turned a blackboard

to expose now one side, now the other, writing directives to the audience ("Please look under your seat") and charged phrases—some drawn from poet Jackson MacLow's *Pronouns for Dancers*—with matter-of-fact efficiency. To deal with extremes of emotion in *Duet with Cat's Scream and Locomotive* (1966), performed with Kenneth King, she studded the area with wooden mouths (all smiling but one) that could be rocked by means of strings leading offstage. To show feeling, Monk might hold a mouth in front of her face; its size magnified the emotion, but by creating a barrier between performer and audience, the prop removed feeling from the realm of the personal.

In *Vessel,* Monk read the last, highly dramatic speech from the trial scene in George Bernard Shaw's *Saint Joan* in a simple, almost neutral voice, as if to imply that she was standing in for Joan rather than attempting to portray her. Monk's recent music theater works and solo performing are less reticent, but a degree of objectification has been carried over. In *Atlas,* the character played by Robert Een, crazed with power, sat manipulating a flashing console, yet his truly terrifying singing and bizarre motions seemed to be a force speaking through him, not a performance that he was working up. In Monk's solo song recitals, her amazingly flexible voice suggests personae, sometimes in deeply passionate states. Her body mirrors these not through involuntary gestures, but through subtle, meticulously coded behavior, as if the performer were, like St. Joan, a vessel for expression rather than its perpetrator or its commentator.

For radical artists of the 1960s, media, technological developments, and new materials became vehicles for ironic or exuberantly playful commentary. In *Homemade* (1965), Trisha Brown danced with a projector strapped to her back, throwing careening vistas of her tiny black-and-white self around the performing space. *16 Millimeter Earrings* (1966), one of Monk's first uses of film within a live performance, offered a more theatrically charged presentation of self. Monk counts it as a breakthrough work for her. Close-up images of her face were projected onto a paper globe placed over her head (one of her eeriest objectifications of the performing persona) and onto a flat screen (the camera eye investigating her eye); later her body became a screen for receiving images. The red wig she put on at one point, the red paper streamers fanning upward from an open trunk, the film of a long-haired, naked doll in the midst of flames—these resonated pungently with the final image of filmed flames consuming her naked body. The correspondences in *16 Millimeter Earrings* constitute an early example

of the musical flow of imagery and the "visual rhyming,"[6] as she puts it, of her later theater pieces.

Both performing artists and visual artists of the 1960s queried the traditional presentation sites—museum walls, proscenium stages—as well as the modes of viewing that they engendered. *Break*, the first solo Monk made after her graduation from Sarah Lawrence in 1964, shattered the performer's body by occasionally concealing all but isolated parts of her behind screens, creating haunting analogies to sounds in her collage score that hinted at a traffic accident (crashes, breaking glass). She startled spectators by stepping off the stage at one point to join the audience in gazing at the performance site. Both *Coop* (1968) and the 1969 "lobby exhibits" (the latter part of downtown dance's foray uptown as part of a series at the Billy Rose Theater) ironically juxtaposed static, or nearly static performers to perambulating spectators.

Monk's 1966 notes on *Portable* (reprinted below) provide striking insights into her mental processes. How many twenty-three-year-olds would become intrigued with making a piece that would express through its formal process the idea of "mapping" both as a separate strand of performance and a record of it?

Many of the artists who created work for large public spaces during the late 1960s and early 1970s did so in part to undermine the concept of the performer as "star" and the site as background or frame. Merging the figure with the ground and imprinting the planned onto a space rich with everyday associations were practices in keeping with the antielitism zeitgeist. Monk's *Juice, Needlebrain Lloyd and the Systems Kid* (1970), and *Vessel* carried architectural and perceptual concerns into the area of myth and pageantry.

In *Needlebrain Lloyd*—created at the American Dance Festival, billed as a "live movie," and anticipating MTV in fantastic imagery (if not in hectic speed)—Monk treated the summer landscape of the Connecticut College campus as a prism to capture and refract archetypal visions: a ghost-pale couple in a boat gliding over a lake toward the spectators, horses galloping, "pioneers" gathering around campfires to cook a meal.

As Mark Berger pointed out in his *Artforum* article "A Metamorphic Theater," (reprinted below), *Juice* and *Vessel*, city pieces, raised issues of scale and distance in relation to perception. Like *Needlebrain Lloyd*, both involved journeys for performers and audience. In *Juice*, which began as a pageant in Frank Lloyd Wright's Guggenheim Museum,

spectators first watched a parade of fabulous beings winding its way up the spiraling ramp; later, wandering up the ramp themselves, they observed performers as moving gallery exhibits. The audience did not actually travel between *Juice*'s three sites; the Second Installment occurred in the small Minor Latham Playhouse at Barnard College a week later, and the Third Installment—essentially an exhibit of the detritus of the two previous ones—took place at a downtown loft later still. But the experience of seeing all three sections was like a journey in which the landscape seemed to shrink and come closer. Ironically, although in the loft the audience could smell sweat and touch props, no living person appeared. The four performers (Monk was one) who, painted red and wearing red clothes, had hiked in a chain up the Guggenheim ramp now appeared in extreme close-up on television monitors; their nearness, together with their natural manner and intimate revelations, was offset by the distancing effect of their transformation into flat, truncated, black-and-white images.

Juice laid out in non-narrative form Monk's profound and ongoing interest in quest as theme and source of structure. The notion of residue, sketched out in *Portable* three years earlier, took an archaeological turn that was also to inform her later work. It was part of the work's enigmatic charm that the "artifacts" in the loft exhibit were almost coeval with the events that generated them, and, instead of stimulating hypotheses, awakened actual memories.

The audience for *Vessel* did travel—by bus from Monk's tunnel-like loft to the Performing Garage, and on foot from this small black-box theater to the parking lot. (Some evenings only Parts One and Two were presented; some featured Two and Three; and at a couple of others, audiences saw all three parts.) As a disruptively fantastical touch, the pageant of activities in the lot swirled around the rug, furniture, and lamps from Monk's living loft (transported and carefully set up exactly as they had been). *Vessel* reversed *Juice*'s progression from large to small; cryptic events in the loft germinated the drama of the theater event and expanded into spectacle in the parking lot. Information fell into place like pieces in a jigsaw puzzle. Two little boys dueling through the loft with rakes were revealed, in the last part, as harbingers of the rake-wielding adults Monk offered as the French and English armies.

Such large-scale works were not only expensive, but virtually unrepeatable (Monk did restage *Vessel* for Berlin's Schaubühne in 1980). Reviews from the first tours of the company she named "The House"

show, however, that modules and themes from these and other pieces were reconstituted to form elements of new site-specific works. Monk has remained sensitive to the interplay between what she creates and a particular performing space (and fastidious about her choices of sites), but she began, with *Education of the Girlchild*—first a solo (1972), then a group work with the solo as Part 2 (1973)—to balance epics with theater pieces that were smaller in scale and more portable.

Because Monk is drawn to the idea of layering past and present within the same physical space, it is tempting to consider her work in relation to Martha Graham's mythic theater of the 1940s and 1950s. Yet it differs profoundly from Graham's in both method and aesthetic philosophy. Graham designed her onstage persona to be both mediator and actor in guilt-drenched but empowering recollections; eras and locations swam onto the stage with the flexibility of film and dream's disregard for linear logic. Monk's technique—equally cinematic—is less psychologically charged and less personally aggrandizing. As a performer, she does not, as Graham did, situate herself in a liminal present to remember the past and prepare for the future. Like a sorceress, she stands slightly outside her own magic. Her characters themselves rarely develop in the traditional theatrical sense; the rub of past against present kindles in the spectator's imagination a mythic sense of continuity, of the cyclical nature of time.

In *Quarry* (1975), which many consider Monk's masterpiece, she played the dreamer, the sensibility through which events filter, but the "story" was not about her. In this mosaic of images of the Holocaust, she lay at the center—the artist as feverish child—while four discrete, intercut scenes rayed out from her like points on a surreal compass, occupying different imagined zones of place and time: a woman (Lanny Harrison), playing the child's mother, moved around her dressing table and studied a script; a "biblical couple" ground grain, inked a scroll, and fled an invisible oppressor; a European university professor and his wife in apparently trivial conversations obliquely chronicled the tightening of Nazism's net; three young women sat around a table and ate food brought to them by a visitor (the reference seemed to be to Anne Frank and families in hiding). Although these scenes and others swam into prominence one at a time, all the performers remained visible and in character.

More often Monk literally builds time in interlocking modules or horizontal layers in space. The 1994 *American Archeology*, her first site-

specific piece in many years, acknowledged the evolution of New York's Roosevelt Island from wilderness to farm, fever hospital, prison, and its present status as a community of apartment dwellers. During the first part, Monk's singing chorus (dressed in black clothes from different eras) was surrounded and backed by other nearly simultaneous scenes in which a seventeenth-century landowner inspected his property, and contemporary joggers, commuters, doctors and patients from the present-day hospital went about their (or Monk's) business. Spectators experienced one layer *through* another, as if a palimpsest had become transparent.

Monk's predilection for this kind of structuring may be linked to how she actually sees. Because her eyes don't converge on a single point, she doesn't perceive the world in three dimensions. Judging distance is a matter of comparing the relative sizes of objects. Coping with what could be considered a disability, she has developed an extraordinary sense of design and a passion for deep space.

She also sees double, with one image flickering or cutting out from time to time. Her sensitivity to this came into imaginative play in *Specimen Days* (1981), a Civil War piece, when she set a Southern household and a Northern one side by side, eating at their respective tables. The activities differed, but the groups were reminiscent of the twin images on a stereoscopic picture, waiting for a lens that would merge them. In *Paris* (1972), one of several pungent, small-scale works billed as "travelogues" that she made in collaboration with bricolage artist Ping Chong, she wore trim boots, a skirt, a jacket, a cap, and a mustache, as if photos of a man and a woman had converged into a single entity.

In effect, Monk sees the world the way it appears through a camera's lens or on a movie screen. In an article in *Millennium Film Journal*, Joan Driscoll Lynch suggested that in *Needlebrain Lloyd*, subtitled "a live movie," Monk "played with creating the experience of close-ups, medium, and long shots by drawing the geography of the screen on an open field with a truck full of performers whose surrealistic acts were staged at different distances from the audience."[7] Lynch suggests that Monk's early large-scale theater pieces "aimed at discovering . . . the cinematic potentials of live theater."[8] Whether or not this was always Monk's aim, it was certainly one of her achievements. And she herself has remarked that the first piece she showed in New York was already quite cinematic.

Film—with its flat surface and its lexicon of close-ups, montage,

chroma-key, and dissolve—has proven marvelously susceptible to Monk's way of imaging and restructuring reality. In *Ellis Island* (1981), Monk's performers, representing immigrants of long ago, are superimposed on the bleak, contemporary ruin in New York Harbor. In both this film and *Book of Days* (1988), scenes occurring in the present are shown in color; the past is black and white. The latter's first breathtaking scene pictures helmeted workmen blowing up a wall; through the breach, drained of color, a medieval Jewish community awakens, with dark figures emerging from doors and windows of a narrow, cobbled street to shake out white linens.

Music composed and sung by Monk cropped up in her pieces early on, although audiences at her 1967 *Blueprint / Overload,* listening to a pop song called "Candy Bullets and Moon," may not have realized that Monk had written it, collaborating with Don Preston of The Mothers of Invention (Preston appeared in *Blueprint / Overload* and *Juice*). Monk has said that music was almost always the glue holding her pieces together. Gradually her writing for the voice became more prominent. Although she had called some of her works "operas" before, *Atlas* (1991), commissioned by the Houston Opera Association, could be defined as an opera in anyone's sense of the word, even though it was utterly unconventional both musically and theatrically.

Sometime during the 1960s, Monk decided that she wanted her voice to be as flexible as her body—capable of handling enormously contrasting qualities and pitches (she is gifted with a three-octave range), and the subtle microtonal shadings and occasional nasal timbres that have led music critics to compare her vocal techniques to those of the Middle East. Her penchant for working between the cracks infuses her vocal style. Just as she often highlights movements usually perceived as transitional or arrests a gesture before it reaches the imagined peak of its trajectory, so her voice can slip between the notes of conventional Western scales or subtly alter, so that it seems, at moments, to be two things at the same time.

The vocal recitals that she began to give in 1970 were often unconventional in presentation as well. Imagine the bemusement of the traditionally minded when confronted with Monk's performance of *Our Lady of Late,* a score she had originally written to accompany a performance by choreographer William Dunas. There she sat on a stool, accompanying herself by rubbing a finger around the rim of a water-filled wine glass to create a drone. A refreshing sip calculatedly altered

the pitch. In recitals and theater pieces alike, her astonishing voice—now growling, now cracking, now squeaking, now pure and sweet and high—powerfully evokes character and emotion. Because she almost always utters repeated syllables—a kind of vocalise—no literal text interferes; we are free to see her transformed into powerful shaman, querulous woman, child, demon, her body molding itself to the voice's demands. In the solo song cycle *Volcano Songs* (1994), her voice itself seems to be quaking, heaving, subject to eruptions from within.

Some of her melodies strike the ear as folk songs, marching songs, or lullabies, but in compositions for her own voice or for the Vocal Ensemble that she founded in 1978 the music frequently takes on unearthly textures and pitches, suggesting the high whine of insects, the chatter of garrulous demons, the creaking of a branch. In her solo suite, *Songs from the Hill* (recorded, like all her music since 1980, by ECM), her voice embodies not just characters, but aspects of the high desert landscape where she composed it.

Monk's musical structures are analogous to her visual ones. She builds theatrical structures by assembling elements—pieces of a mosaic that gradually, incrementally accrue meaning through juxtaposition and reiteration. Her musical forms tend to grow from small, repeating modules. And she layers sound the way she layers images. In the weave of voices in, for example, the conclusion of *Dolmen Music,* each part retains its distinctive identity, sliding now under, now on top of its neighbors.

In a 1989 interview with Rob Bowman, Monk explained her score for *16 Millimeter Earrings* in these terms:

> It was all on tape and there were actually three separate tape recorders going simultaneously and coming through three separate speakers. It was an additive kind of structure. It started out with me singing something with a guitar and when I got to a certain point that song was taken over by the tape, which became more and more distorted, and then that became a loop. That became one reality that went on. Then there was a second sound source which was a text, which then became a second loop. The third source was a crowd doing a chant that I worked on by adding tracks to it. That became the third loop.[9]

David Gere, who examined *Quarry* from an ethnomusicologist's perspective, theorized that Monk's use of repeated "loops" of sound and imagery that resonate against each other may have derived from her interest in folk music and rock 'n' roll, but he also situates the

practice in relation to "the first experiments with tape loops and phasing techniques that resulted in such seminal works as [Steve] Reich's 1966 *Come Out*, the famous tape loop piece that was created the same year as her own *16 Millimeter Earrings*."[10] Gere also makes the provocative assessment that it is "in the friction between spirit and technology, between serious and popular art that Monk's music finds its impetus. By imitating technological capabilities in the human voice, she attempts to spiritualize them."[11]

Monk has repeatedly stated that superficial comparisons of her style to that of the most notable minimalist composers is misleading; she considers the instrumental ostinatos that often underlie her vocal work as a floor that the voice can spring from and return to. I think, too, that Monk has no more consciously imitated technological effects than she has borrowed from the music of the world's cultures (although she did once say she believed the voice could do anything electronics can do). Yet Gere gets at something crucial about her songs. Just as past and future slide together visually in her works, so they jostle each other aurally. One minute the music sounds primordial (song from time out of mind); the next minute, you may think of the whir and clatter of machines. Repetition suggests both human reiteration or a needle stuck in a groove. In "Change" from the album *Key*, sweet female voices (actually Monk multiplied by overdubbing) gradually decay. You are hearing women turn into demons; at the same time you can imagine someone gradually swiveling a knob to adjust the wave pattern of the signal. To hear the phenomenon while watching live singers jolts your sense of reality. It's like seeing a shaman switch on a cassette player.

The absence of words feeds this perception of Monk's vocal work as at once primal and nonhuman. She has stressed over and over in interviews that she considers the voice a language in itself—one that crosses cultural and linguistic barriers and speaks directly to people on an intuitive level. In the "Rally" section of *Quarry*, a horde of people indulges in a vigorous calisthenic dance while chanting—barking, almost—a chorus of rhythmic, percussive "Ha!" sounds. Observing individual effort among the performers, you imagine concentration camp labor, Nazi military exercises, but beyond this, the entire enterprise has the chilling force of an inexorable machine rolling over and flattening individuality.

As a composer, Monk works very intuitively:

Sometimes I'll be walking down the street and start singing something that will just come to me. . . . But sometimes I will sit down at the piano, which I try to do every day. What I really try to do is start from ground zero. In a way, it's a little bit like automatic writing. I try to just let my hands move on the keys and see where they go. . . . Sometimes I'll start with a technical idea, as in *Dolmen Music,* where we were working with vibrato, different speeds of vibrato. . . . Sometimes an image will come up of what the whole piece will be, and then it's a matter of finding the components and structuring it.[12]

Composing for her vocal ensemble, Monk proceeds much as a choreographer does, coming to rehearsal, perhaps, with small modules sketched out, building material in rehearsal directly on the performers, writing a piece down—rarely in traditional notation—only after it is set. In sessions with her Vocal Ensemble, she will have the singers and instrumentalists try a part out, stop them, hustle to peer over a keyboardist's shoulder, alter something, start again, stop, ask a question. A performer may offer a suggestion, and maybe the group will give it a whirl. It's a painstaking way to compose, but it's profoundly organic, and, although Monk is clearly the creator, clearly in charge, the feeling is collaborative. That unity of purpose always illumines the finished work. Singers and musicians who have worked with Monk's Vocal Ensemble from the beginning, those chosen from among the hundreds who auditioned for *Atlas* who have become new members of the group, are part of a process that takes into account their special qualities.

Monk has always selected performers carefully. Although personnel may vary from piece to piece depending on the requirements of the work, a flexible core of gifted and devoted actor-singer-dancers has worked with her on and off for years. Lanny Harrison and Pablo Vela, for instance, do not have the highly trained singing voices needed in some of Monk's recent projects, but Harrison has returned to recreate her original roles in revivals of *Education of the Girlchild* and *Quarry,* and in 1986, Monk and Harrison together created a duet, *Acts from Over, Under, and Above.* Vela assisted Monk in the direction of *Atlas.*

During the late 1960s and 1970s, Monk's The House functioned very collaboratively. Individuals might contribute material or ideas. Elements from the histories or day-to-day lives of the performers might also, highly distilled, find their way into Monk's compositions. The round table where the women "Companions" in *Education of the*

Girlchild sit echoed the kitchen table in Lanny Harrison's farmhouse in Upstate New York, where the performers sat to hash over plans and the fruit of early rehearsals. Monk shared with bricolage artist Ping Chong authorial credit for *The Travelogue Series* (*Paris, Chacon, Venice / Milan*—1972–76) and *The Games* (1984).

The primality of legends or fairy tales, which clings to Monk's theater pieces and musical compositions alike, has to do in part with the illusion of simplicity and the elemental depths she invokes. She has acknowledged that perhaps there's one story she is compelled to tell over and over again—that of the visionary (the artist perhaps) who perceives the world through a different lens. Like Joan of Arc in *Vessel,* like the child in *Book of Days* who can see a future world, like the madwoman Monk plays in that film, this visionary may be misunderstood, an outcast even. But she is also the intrepid adventurer of *Atlas* (Monk's closest approach to linear narrative) who leads chosen companions on an odyssey to four zones of the Earth in search of wisdom and self-knowledge. The women of *Education of the Girlchild* travel, their brief trip carrying symbolic objects on their heads also hinting at the quest scenario. And the great solo of *Girlchild* is conceived as a journey from age back to childhood, Monk's voice and body altering dramatically as she reaches stations in the long road of unbleached muslin down which she travels.

Like legends, Monk's pieces are full of mysterious metamorphoses and apparitions. (It is interesting to note that the extraordinarily vivid dreams she records in her notebooks are not a source for self-analysis, but pictures from a parallel subconscious universe with structural and imagistic analogies to her work.) Like fairy tales, the works create a tension between astonishing manifestations and unartificed behavior and, like them, often achieve a fine humor, akin to the childlike directness with which characters in the tales of the Brothers Grimm accept the fantastic. When the hero of the story "Bearskin"—a man who, to gain a fortune, has not washed, combed his hair and beard, or cut his nails for four years—pays court to a beautiful woman, she says, unfazed, "How can I take a husband who doesn't look human? I prefer the shaved bear who was on show here once and pretended to be a man. At least he wore a fur coat like a hussar and had white gloves."

In an interview with Brooks McNamara for the *Drama Review* in 1972, Monk acknowledged the "wryness" that she guessed her works possessed. One could catalogue many instances of this: the moment

in *Education of the Girlchild* when all the women seated around the table don spectacles and stare carefully around; the scene in *Atlas* when the travelers, seated with host farming families, politely attempt to copy the curious gestural patterns that stand for dining etiquette; the section of *Volcano Songs* into which Monk, singing in a proper-little-girl voice, inserts unexpected pauses, as if her brain has gotten temporarily stuck. The matter-of-fact approach to the marvelous (whether funny or poignant), the imaginative simplicity of decor and costumes, the diversity of the performers, the sense of tale told around the fire —these blend bewitchingly with the sophistication and precision of Monk's style.

Until the 1980s, Monk achieved her theater magic with the simplest and most homespun ingenuities. The title of the "Handmade Mountain" section of *Vessel* alludes to the set, the result of many hands laboring ingeniously with unbleached muslin. Only since 1980 has Monk made use of professional designers (principally Yoshi Yabara and Debbie Lee Cohen). They have extended and polished her basic vision without altering its charm and wit. The cars and planes and tiny train with lit windows borne across the stage in *Atlas* by dark-clad figures may be more elaborate than the white clouds and bombers on sticks paraded through *Quarry,* but they have the same complex naivete. The designers have functioned more like soul mates helping Monk realize her vision than like conventional collaborators. To look at the storyboards for the film *Book of Days* (reprinted below) is to understand the intense communion that passed between Monk and Yabara.

Today, Monk utilizes advanced technology with the same directness that once marked her approach to 16 mm film and flash powder. At one point during the pristine *Volcano Songs,* she goes to a row of three rectangles that lie on the floor. With the carefulness of one performing a ritual task, she removes, one by one, the black cloths that cover the pale rectangles and assumes a crumpled position on each small pallet. As she does so, a bright light flashes on and off. When she stands up, light turns the rectangles luminous green, and, magically, they retain a dark imprint of her body. As each new pose is assumed, the previous one fades. From her quiet, deliberate act burst images of fleeing Pompeians captured in cooled-down lava, of Hiroshima's victims. Who else would turn special photosensitive paper to such poetic and apocalyptic purpose?

Monk's vision is about wholeness and continuity, in art and in life

(she has had the same loft for twenty-five years, the same pet turtle for nineteen, the same companion, Mieke van Hoek, for twelve). She makes us aware of the submerged connections between islands of difference. In some sense, all her works are about communities. And despite the darkness that occasionally threatens these small worlds, her vision is essentially moral, humanistic, and hopeful. She opens our eyes to the prevalence of miracles and the miraculousness of everyday life.

Notes

1. Jan Greenwald, "An Interview with Meredith Monk," (February 28, 1981), *EAR Magazine,* April–May 1981.
2. Marcia B. Siegel, "Evolutionary Dreams: Meredith Monk," *Dance Theatre Journal* (London), October 1986.
3. Alan M. Kriegsman, "Mesmerizing Monk," *Washington Post,* November 15, 1984.
4. Gregory Sandow, Review of *Acts from Under and Above, Keynote* 10, no. 6 (August 1986). (Reprinted below.)
5. Interview with Deborah Jowitt, January 1991.
6. Monk has frequently used this term in interviews. See "Meredith Monk: Invocation / Evocation—A Dialogue with Liza Bear," *Avalanche* 13 (Summer 1976). (Reprinted below.)
7. Joan Driscoll Lynch, "*Book of Days:* An Anthology of Monkwork," *Millennium Film Journal,* nos. 23/24 (Winter 1990–91): 40.
8. Ibid.
9. "Meredith Monk: Do You Be: A Conversation with Rob Bowman," *Musicworks* 42 (Toronto), Fall 1988.
10. David Gere, "Swallowing Technology: An Ethnomusicologal Analysis of Meredith Monk's *Quarry*" (master's thesis, University of Hawaii, 1991), 213.
11. Ibid.
12. Geoff Smith and Nicola Walker Smith, *New Voices: American Composers Talk about Their Music* (Portland, Ore.: Amadeus Press, 1995), 186.

Meredith Monk

Mission Statement, 1983, Revised 1996

My goals:

To create an art that breaks down boundaries between the disciplines, an art which in turn becomes a metaphor for opening up thought, perception, experience.

An art that is inclusive, rather than exclusive; that is expansive, whole, human, multidimensional.

An art that cleanses the senses, that offers insight, feeling, magic. That allows the public to perhaps see familiar things in a new, fresh way—that gives them the possibility of feeling more alive.

An art that seeks to reestablish the unity existing in music, theater, and dance—the wholeness that is found in cultures where performing arts practice is considered a spiritual discipline with healing and trans-formative power.

An art that reaches toward emotion we have no words for, that we barely remember—an art that affirms the world of feeling in a time and society where feelings are in danger of being eliminated.

Meredith Monk

Process Notes on *Portable,* May 10, 1966

A cross-country bus trip. A ribbon of road ahead and behind, sky and prairie on either side and we in an enclosed, self-contained compartment, moving. People pass around photographs of children. The road cuts through seemingly unlimited and unbroken space.

I started thinking about the idea of residue. Something left behind or coming after a process has ended. That which remains after a part is designated. Could it then be a record of what has happened in a certain time and space? The result of an additive process (the whole piece), a record of the journey. I began to think of a piece that had as its material things left behind. At the end of the piece, where I had been and what I had done (my history) would be visibly recorded. The past and the present in one piece. A map. A map is always used as a guide, a reference *before* (sometimes during) travel. In this piece, the map would be a continuous process (during the piece) and a residue of the process of the entire piece. An afterthought and a measuring rod.

I was thinking about material and ways of getting from piece of material to piece of material. I called it transition, but I realized that getting from one movement to another is usually taken for granted or considered another movement. Some dancers, though, are concerned with quick transitions invisible to the audience. I was interested in making the idea of transition a visual element, concretely. Occurring between "blocks" or sections of material. Usually, a dance is a chronological moving from one movement—transition—to the next movement, in that order, in time. A one-plane linear concept. In this piece, the movement material and transition would go on simultaneously. I needed another figure whose main task would be to lay down the transition path while I was doing the material. A formal figure mark-

ing the way with masking tape as the residue-marking-path-track medium. I decided that I would try for a kind of relative and relational motion by having us both move from place to place in a certain time as if we were a unit moving from phase to phase. One piece of material and one transition—a unit. Therefore, if she finished her path before I finished my material, she would have to make another path (go back to the beginning) next to the first, and another, until I was ready to join her before I began my next piece of material. Thus, in time—parallel activity; in space—block-line-block.

In the first version, I carried a bag filled with materials (objects to be left). I used one object for each section of movement and left it where I was before I walked along the path to join my partner. When the piece was over, the floor was a canvas of tape and objects. The purse—too private and hidden, small and personal.

I wanted to use myself as material. Not in a personal sense, but as an objective source for new ideas. Myself in relation to my daily environment. Specifically, my house. I had been working a while with building, enclosed spaces, the house idea, and "entertaining" people in that house. I was to do a concert in a theater with alcoves and closets in the performing room. I thought of using the entire space as a house: the stage—a bedroom; the audience area—the living room; one closet—a bathroom; the other closet—the kitchen. Events in each room. A three-ring circus, but with focus on certain rooms at certain times. The audience zeroing in and out in their attention, but activity all around them. I planned to do the original map piece in the lobby, then invite the audience into the closets, etc. Again, too private and discriminating.

The Rocky Mountains ahead. Now a reality. Patches of snow, postcard scenes of firs (abrupt changes of scenery), grassland, and dead wood. A red-haired man offers fudge. We do not breathe easily.

I had thrown out all my ideas when a large space was made available to me. I thought it would be impossible to fulfill the compartment-house idea without building special walls and closets. There were no alcoves or closets in this particular performing space. Also, the map piece in the lobby would not work well in this situation. The ideas persisted. Why not an all-in-one house-unit that I could carry with me like my purse? A house on wheels. An open, exposed, yet enclosed space. Just the frame of a house on a platform, so that I could be seen from every side. The design, functional and objective so that the idea "house" would be suggested but not offered as the only possibility

(enclosed space, boat, cage, vehicle, mobile unit, trailer, frame, etc., etc.).

The house: white, irregular, compact. Vertical lines. Blue interior. Even-textured, one-color blue. Bright blue—cool and hot. Curtains, chair, brooms, waste container. Not in proportion to the house or to each other.

I became interested in the idea of formality and informality in combination. I was always interested in the difference between a "formal" piece and an "informal" one. One of the main ingredients seemed to be the performing space or situation. What about an audience participation piece at the Metropolitan Opera House? Exclusiveness of the audience and the performance spaces; designed for illusion (Barbra Streisand says, "One must never destroy the magic of the stage when performing by breaking the natural barrier of the stage and the audience. I never forget who I am and who they are."). Another thought about formality: is the audience a group of spectators to a self-contained event, or can there be a one-to-one relationship, with the performers becoming the audience? Two very different performance experiences. Both with the possibility of a certain directness. The first, in relation to the material; the second, in relation to the audience.

The name of the piece: *Portable*. Phoebe [Neville]—my visual counterpart. Same size, weight, hair color.

A formal piece at the beginning. Very organized, with me doing movement material and Phoebe marking my progress. Both of us spending a little time together on a long box that stops the house as it moves along the path (to also break the line from one tape path to the next so that each "episode"-section is clearly defined). Within that regularity, Phoebe is very formal, stepping on the tape evenly and objectively, while I am more informal in my house: shaking it sporadically, dealing with each of the objects, in addition to doing movement tasks (I have a certain amount to accomplish, but I am free to do it when I wish and in what combination). Slightly discombobulated (like the house).

A piece has a beginning and an end (even when the dancer tries for the *illusion* that it has always been and always will be). The audience is included and excluded at certain points in time and space. How are beginnings and endings designated? Entrances and exits; the dancer is "discovered" onstage when the lights come up; the dancer holds the last position. The dancer bows; the curtain closes. The idea of false beginnings and endings interested me. (I thought of those uncomfort-

able times when a dance begins and something is wrong—lights, per-
formers still changing costumes, etc. . . . The curtain closes, and the
dance begins again. The audience does not know what to do. A few
laughs.) I tried one kind of ending in a piece, *Blackboard,* by giving
slips of paper to the audience. On the slips were announcements of
another event taking place *after the concert.* Thus, wheeling out the
blackboard and the tape ending was not really the end of the piece.

Portable: begin more than once. I found a Bob Dylan record in
which he starts a song, cracks up, and has to start again. This breaking
up (or breaking down) of a formal situation, the recording session,
and the clear designation of the new beginning were exactly what I
wanted. Intercut sounds of informal house party—people laughing,
trying to sing on a tape. I considered this as my "exterior" master tape,
played from the balcony outside of the performing area. Loudy, jerky,
rough, formal in terms of recording technique, except when broken
by the laughter (changing the whole context). Each time Bob Dylan
says, "Start again," the lights go down. *But,* Phoebe and I go on with
the piece. The audience is given glimpses of a forward progression.
Different starting points, nothing definite established. Time stops and
moves forward at the same time. Traveling idea. Again, dichotomy of
sound and visual elements. My "interior" tape was Monteverdi vocal
music played on a transistor recorder placed on the floor of the house.
An indoor, chamber music sound. Calm, continuous, cultured. I liked
the contrast of the rickety, discombobulated house-vehicle and that
smooth sound.

After the beginning and the first section, a section of Phoebe wheel-
ing me around very quickly while I do (attempt) the same movement
tasks, without the objects to leave behind. A breaking up of the origi-
nal, regular, structured progression. Phoebe and I are no longer
separate, simultaneous processes in opposition. On the master tape, a
section of endings—Beethoven, Tchaikovsky, Monteverdi, the Dylan
song. I was struck by how long they all took to end. End in the middle
of a piece. In the first section, I *do* to my house (I move it, shake it,
etc.), and the house *does* to me (extending and limiting my movement,
influencing what can be done). Pas de deux. In the second section,
Phoebe *does* to the house and me as unit. I *do* to Phoebe as I reach for
her and transfer some dough (one of the objects) to her face.

It all smells the same in here. We feel very glassed off. Red, jagged
rock and white dust close in. Only up to the gardol screen. A boy is
playing a transistor radio from the back of the bus. Our box moves on

and through, but we do not feel that we are getting anywhere; the red remains; black cliffs wait to be hidden by night.

The third section—invite the audience into the performing area, the middle ground between the house and the audience area, and let them sit around the edge of that space. Breaking up of the audience–performer relationship spatially and in terms of performance attitude. Most informal section. Let them see the rest of the audience *through* the piece. A curved sandwich of audience-piece-audience. A private space open to the public. Then, invite them into the house-vehicle. The invitation in very formal terms mixed with sentences of "homey" cordiality ("sit down and make yourself at home"). Attach strips of masking tape on a diagonal from one wall of the house to another. A kind of magnified one-directional screen door. Correspondences to paths on the floor and means of making the house more private now that it is open to the public. The audience, multicolored, casual, entering in an idyllic blue-and-white environment, and finally entering the small, interior, special space. A way of changing a proscenium space to an in-the-round during a piece. Change of performance energy. I am no longer a separate "performer." "Projection," "strength," "quality" no longer apply. I must talk directly to the audience-guests in order to finish my tasks. I excuse myself, ask for their help, move them out of the way when I need to. There is no mystery, no aura, no detachment. I empty all the interior objects into the waste can, including the tape recorder, still playing the Monteverdi. I carry the insides of my house into the outside environment and leave them. For a few minutes, I am standing outside my piece, looking in (through the audience). The displaced interior has been replaced by people. Phoebe and I (now as one unit with each other and with the house) wheel the filled house along the last path.

Macrocosmic environment: the audience and the master sound tape. Middle ground: Phoebe and the performing space. Microcosmic environment: the house, the Monteverdi tape, and me. Exterior costumes: the blue plastic raincoats. Interior costumes: my blue dress-bra-slip-skirt-bathing-suit-playsuit—an unspecified woman's indoor garment. I think of the whole piece as a stripping down. Of formality—a journey from a highly structured, self-contained progression to a loose, spontaneous, public situation. Of the house itself—from a specific image, "house" with house objects, to a pure white structure (frame, platform, etc.) filled with people.

John Perreault

Monk's Mix

Meredith Monk's new dance theater piece, *Blueprint (1) and Overload / Blueprint (2)*, is complex, emblematic, enigmatic, and problematic and yet thoroughly successful in its theatrical impact. The skill and inventiveness indicated by Miss Monk in her earlier intermedia work, *16 Millimeter Earrings*, has enabled her again to create a uniquely significant work that defies traditional categories. Her new work no doubt offended some purists and "dance for dance's sake" puritans. It contradicted the literalism now a full-fledged cliché in several of the arts. Nevertheless, its effect upon Judson Church audiences here in New York, long accustomed to avant-garde outrages, was overwhelmingly positive.

The first section, *Blueprint (1)*, was given twice each evening for two weekends in the small Judson Gallery, once the scene of Claes Oldenburg's *Ray Gun* environment during the birth of Pop.

After watching a loop film projected upon the door of the gallery, the audience was ushered into the pitch-black gallery itself, one at a time, and seated on floor cushions with the aid of flashlights. The audience was left in total darkness for five or ten minutes (the time varied with each performance), and when the lights were switched on, Miss Monk and her partner, Alfred North, were discovered sitting on straight-back chairs, staring into space.

The "ritual"—perhaps a rite of passage—began. It proceeded in slow underwater movements and fragments of movements that, set against the stark white gallery, introduced a new mood of serenity and elegance into Miss Monk's work. A girl in white, functioning in a manner related to the "black" figures in traditional Noh theater, emptied a

Originally published in *Artscanada*, April 1968.

23

basket of stones at their feet. She then blindfolded them and after a long pause they unfolded their arms, revealing puppet-like gloves. After another long wait, the blindfolds were removed.

All of this movement, but mostly nonmovement, was accompanied by a loud, hypnotic rock 'n' roll composition called "Candy Bullet and Moon," which was recorded by a group with the unlikely name of Aunt Jemima and the United Pancakes. Miss Monk, it should be noted, has obviously not lost her sense of humor nor her Dada delight in flagrant incongruities. The music itself was quite effective.

The remainder of this first section was accompanied by the taped sound of someone knocking on a door. Monk and North moved in dream time to the door and eventually exited. The audience was then invited to get up and look out the window. Outside in the church courtyard were two seated figures with their backs to the window, creating a mirror image of the beginning of the piece and of the two dancers when they were seated in the gallery itself.

The remaining sections were presented two weeks later in Judson Church itself. The first part, *Overload,* to some extent based on a work given last summer at Expo, was made up of a series of marvelous blackout fragments and episodes. Alfred North poured feathers, then chips of foam rubber, and finally metal springs from a bucket, making visual rimes with the stones in the first section. A child played several long, discordant notes on the church organ. Meredith Monk improvised vowel sounds that were taped, distorted, and replayed later, along with the organ notes; in traditional ballet costume, she danced "The Dying Swan" to the sound of a scratchy phonograph recording; in a long, diagonal, flashlight-lit walk across the performance space, she carried a crying infant toward and through a projected film of children riding escalators. I could go on and on. A mere listing, however, gives hardly any indication of the overall effect of these juxtapositions of textures and levels of meaning. It was simultaneously beautiful, emotional, and absurd.

The third and final section of the work was given in the church gymnasium and was more clearly related to *Blueprint (2).* Here, as before, the audience was gently ushered into the darkened performance area and seated on floor cushions.

At first it seemed as if the "blueprint" was going to be filled in. Instead, the audience was offered a blueprint of a blueprint, as if the essence of an event or series of unknown events could only be described by the essence itself and not the mundane literary facts. Mem-

ory was the message, in the form of visual rimes and metaphors that referred to previous "metaphors," but never to anything outside the elaborate and somewhat musical structure of movements and images.

Miss Monk sat above the audience in a cage-like room, at the front of which was a projected film of a window. There was also a film of the escalator children lying on a floor moving their fingers and toes, very slowly, and a film of amoebas. Below, in another cubicle, Alfred North walked back and forth. The rock 'n' roll and the electronic music from the previous sections were repeated. To the accompaniment of the sound of knocking, a procession of all the other performers moved slowly across the floor.

This final section was nonlinear in form, even more so than the earlier sections that it echoed. Allusions to textures and events in earlier sections piled up, one on top of another, creating a rich theatrical density that defies verbal description.

That Meredith Monk's new work is not pure dance or pure drama is irrelevant. The freedom and complexity with which she has combined elements of several arts was a measure of her success.

Meredith Monk is in some sense a post-surrealist. Dream imagery is part and parcel of her neo-expressionist New Dance, New Theater. She has utilized filmatic and electronic tools with cool efficiency, not as ends in themselves, but as means to her ends, which are theatrical and perhaps visionary. Beneath the surface of her new work, she is as apsychological as most straitlaced literalist, but she is not afraid of the irrational imagination, nor of presenting and stimulating those experiences that can be labeled "poetic," but only in the toughest, most nonliterary sense of the word.

Sali Ann Kriegsman

Elephant, Dinosaur, Whale, and Monk,

March 7, 1969

I was in California during the Judson dance thing. Read everything I could about it. Finally, saw Rainer and Monk at the Billy Rose. Was this what Judson was like? Composer John Herbert McDowell, who was there, says yes, hooray, it's happening again, isn't it beautiful? I shrug. Reading about it is more interesting than seeing it, I think. And it's somehow incongruous on the stage of the Billy Rose. Why are they performing in a conventional theater? But I love Monk's use of the lobby during intermission. Her compartmentalized humans breaking out of their corrugated cartons, nestling protectively against each other.

Back to Washington, a city of museums, shrines, monuments, archives, tombs. A friend arrives from New York. Wants to see the Capitol. We do the tourist bit. Start with the Smithsonian. Pass through the rotunda of the Museum of Natural History without even a thought to the Elephant. She wants to see the Hope Diamond. Next to all those minerals and rocks, Hope looks prissy. What's all the fuss about anyway? On to History and Technology building. First Ladies in their inaugural gowns are a gas. Out into the cold fresh air to escape the musty vaults and embalmed artifacts.

The Smithsonian is beginning to groove on new art forms. They have a series called "Perceptions" and Tuesday (March 4), Meredith Monk will do her thing in the Museum of Natural History. She calls it *Tour: Dedicated to Dinosaurs.*

Hundreds of people seated on the floor, gazing up at the Rotunda's sole resident—an enormous stuffed Elephant, dead center. Monk has brought eight dancers from New York and added forty or so local kids, some dancers, some not. Amplified voice announces Section I.

Three groups of fifteen walk slowly onto separate balconies above

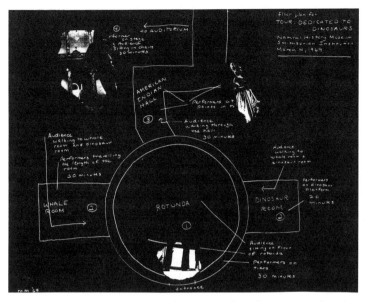

Floor plan from program for *Tour: Dedicated to Dinosaurs* (1969).

Elephant and spectators. When all are in place against balcony rails, low sound of "Ah" begins, going from E to B and back again to E, forte then pianissimo as groups walk away from, and back toward, the railings. Sounds are terrific, echoing through Rotunda. Bodies drape over railings, arms and legs dangling—elephant trunks. This isn't chaotic; it's highly organized, yes, choreographed. A boy and girl on small balcony do slow-motion, warm, tender embrace. The best Romeo and Juliet I've ever seen. The three groups begin to huddle on their balconies, making sound like wind rushing through Rotunda. Scraping, primordial sounds. One figure in red extends over balcony and wraps around marble column. The beasts start to pant. Look at the Elephant! He's ferocious, alive. This is *his* space. Screams, then braying sounds. Le Sacre de Pachyderme. Groups move forward to railings. Each initiate intones, "My name is . . ." Overlapping. Counterpoint of identities. Lights dim, and on topmost level stands Marie Antoinette (Meredith Monk). A fragile figurine. Groups march off, stamping down staircases holding tiny flashlights. Enter dark, cavernous Rotunda. Jungle yells and whoops. Throbbing ritual sweeps away the cobwebs. The Muses have returned to their temple.

Section II begins. Clearly, Meredith did not count on the size of the audience. She wanted them to move freely between the Blue Whale

Hall and the Dinosaur Hall, where activities are going on simultane-
ously. The crowds are too dense to see much, let alone move. Under
the Whale, a group measures out the space; around the skeletal Dino-
saur, heavy, padded bodies nuzzle each other. At the end, figures from
both Halls enter the Rotunda, cluster around Elephant, and stare at
the spectators. The audience is getting restless. The mysticism of Sec-
tion I has been dissipated. But I notice we are all talking with each
other, sharing a new experience. Trying to make sense of it.

Section III. Dancers form tableaux in the North American Indian
and Eskimo Hall. Snake-like space. Takes too long for crowd to move
through. Looking at an eskimo scene is Marie Antoinette, standing
perfectly motionless, her hands held gracefully up toward the exhibit.
History scans history. Boy sits to Marie's right with girl lying in his
lap. On her stomach, a tape recorder plays voice of tour guide. The
girl has a copper penny on her head. (A penny for your thoughts.)
Move on to next tableau. Norman Rockwell family group. Ma and Pa
and two kids pose in front of exhibit. Next come bodies propped up
against the glass, some looking into exhibit, others falling away and
onto floor. Last tableau, hippie types sitting on floor under Totem
eating popcorn, jelly beans, pretzels, and a bag of fresh strawberries.
Offering them to spectators, spreading joy. Meanwhile in Rotunda, a
solitary figure moves step by step around Elephant; three others join
and crouch beneath, feel Elephant's legs, and leave.

We're last to arrive in the auditorium for Section IV, which is almost
over by the time the crowd has emerged from the North American
Halls. Outside the auditorium some society types are doling out lem-
onade in paper cups from glass bowls with silver ladles. Who let them
in? Inside Meredith fields questions from the audience (mostly inaudi-
ble, as are her answers) while dancing, standing on her head, gulping
water out of a pitcher. She looks klutzy. Hair all askew, blue sweatshirt
over green-checked skirt. Heavy red boots. Someone asks about her
dress. She smiles shyly, curtsies, and asks rhetorically, "Do you like it?"
She's the polar opposite of Suzanne Farrell in diaphanous tutu. The
crowd obviously would rather see Farrell. Monk's dance looks so sim-
ple anyone can do it. But can they? She throws away "technique" and
dances out of sheer pleasure. No pretensions. It's a new way of moving,
maybe even a new technique. Continuous, floppy, blatantly graceless,
like a rag doll wound up. The audience doesn't know what to make of
her. Some want their money back. Are they really angry, just confused,
or bored? It's a blast for the kids. Meredith stops the questions and her

dancing, gives the stage up to the spectators—"It's yours." (Come on, all you taxpayers, and boogaloo at the Smithsonian.) After an embarrassed pause, some of her kids get up and let loose.

The local dance people are predictably uptight. "Why call it dance?" they'd like to know. Why not? It's bodies moving in space and what more do you want? We've seen this particular space many times and never seen it before. That's worth $5.50 any day.

Meredith Monk

Journal Entry, January 1970

My work is like a colored liquid; it keeps changing. Sometimes it is a pure white, sometimes muddy. Mostly it is nameless and it changes sizes. Sometimes it freezes into a shape for a certain time and space; then it has a name: it is called a piece. It is poured into a certain spatial container and freezes into that shape. Then when that is over, it vaporizes, turns into gas, then back to liquid and flows on and on again. Most people think only of the containers, the names, the certain times, the repeatability, the objecthood. In theater process, mixture—category-lessness—is not understood.

Sometimes inconsistency is actually consistency. The product seems inconsistent but the approach is consistent. It is the conscious effort at inconsistency which is its consistency.

Meredith Monk

Journal Entry, June 26, 1970

Some writing about *Juice* done seven months later after thinking oh fuck I would like to do this piece again and about records and history and how it all keeps moving along. A coming together after a year of despair and at last love for every element. A coming together. I remember the desperation and making millions of lists. This writing is for me because I feel like it, not for posterity. I remember talking to M. and J. about the meat and J. saying great! and telling us about his monster piece and how he wanted to show it how it is (whatever that means) and how they both said why don't you just live your life right now and really enjoy it and then the work will be faster and will still be there. But I didn't listen thinking that all good artists suffer, suffer, suffer and all day long on the beautiful island I thought about red lights and red body paint even when we were riding bikes with the ocean on our left and delicate houses on our right. I knew *Juice* somewhere had to do with cunt and that felt good for once because I was getting sick of all my dry, paralyzed, supertight intellectual ideas and I wanted some guts in it. I mean a whole life. Right down the middle, right on through, right in there. Red. Then the first few excitements—when I was in the airplane from Chicago and thought of P. when I told him about my ideas, saying yeah red is really your color. I remember coming back from Washington seeing the buildings and thinking of miniature houses and cities. When the song, the red mountain woman song came, I knew I had found something. Linkups of the fall and singing that song over and over. A. saying why do you keep singing that song about poor women? and feeling something about mountain, poverty, wails, violins screeching and then J. and her violin coming into my life out of the sky. Knowing that it was right to work with her, she would open some doors and I had to

break through my mistrust. She was always right there. It meant so much from the beginning like opening up the clam shell and letting in a little more light at every rehearsal. I did respect her so much. P. was giving behind his own back. I did take in the good things as well as the bad.

For *Juice,* cunt was good. And sloppiness, good, raw, drooling, messy, clumsy, fuzzy red. And white cathedral elegance. A balance. Lots of charts and drawings and lists and trying to figure it all out on paper and it never working. Not life on paper, never, until I taught L. the material and it was flesh in front of me. I knew that everything could go even further this raw feeling and then putting the Guggenheim away from my mind except in the mornings and thinking my life will be over, I will die if this doesn't happen and not daring to think about my piece because of the disappointment lurking even though the I Ching said O.K. yeah it will happen.

Meanwhile,

Laura Shapiro

Fantasies (Nearly Nude) in the Arboretum

Meredith Monk and James Cunningham took over Connect-
icut College during the second weekend of the 23rd American Dance
Festival. Cunningham was in Palmer Auditorium and the Crozier-
Williams gym with two dances, and Miss Monk in the college Arbore-
tum and the college Green with a four-scene theater piece.

Meredith Monk has described *Needlebrain Lloyd and the Systems Kid*
as a live movie, I've just called it a "theater piece," and the 23rd Festival
seems to think it's a dance; but it's bigger and better than any of those.
The first part took place at 4:00 p.m. in the Arboretum, in a clearing
that was the main playing area. There were trees on three sides of the
audience, and just past the clearing were two low stone walls beyond
which we could see the lake. For about an hour things happened in
front of us, and then we walked to the college Green. There the audi-
ence sat on one side of a paved walk, facing an enormous lawn that
sloped sharply in the middle. Around the outside of the field and
behind us were the college buildings. More things happened, some-
times too far away or too much to one side to be seen very clearly by
everyone. At 9:15 in the evening the third part began, in the field, and
took half an hour; we then walked in the dark back to Arboretum for
the final section.

As for the things that happened, Miss Monk has called them fanta-
sies, or storybook events; and I heard many people in the audience
mention "Fellini Satyricon." She has evolved a pattern of events, fanta-
sies certainly, but so much a part of the clearing, the walls, the lawn,
and the buildings that they lost any never-never-land detachment they
might have possessed in a movie or storybook, and took on the scary

Originally published in *Phoenix,* August 1, 1970.

and immediate validity of a dream. "Once upon a time there was a princess," announced one of the members of The House, Miss Monk's company, and as she rambled hysterically on, the heads of six girls appeared on the stone wall as if impaled, with blank eyes. Four more members of The House waddled in, hanging together like a centipede and painted entirely red. "My name is Meredith Monk," Meredith Monk told the audience. "I live at 109 Great Jones Street in New York City." The others introduced themselves. Girls in long flowing dresses came and went; one lay back on the wall and nibbled grapes. The red people writhed and tumbled, screams were heard from across the lake, the grape girl rearranged herself closer to the audience, and two nude girls shuffled sideways slowly across the clearing. A black boy dressed in a few laurel leaves flew rapturously about, a king in a plastic cape sat very still on the ground, and a monster like a huge rainbow Slinky wiggled heavily into the clearing and out again. Opening and closing this array was a bony couple, straight and beige, who passed through the clearing with expressionless stares, once carrying a rowboat.

Each event was at home in its particular position; no agitation or uncertainty ruffled the atmosphere. Colors, spacing, the concept of approach and retreat, the use of time and distance, all governed the little world in the Arboretum. On the college Green the same laws were employed, but turned to the exigencies of a new place. Distances became alive: a tiny croquet party played gaily, far across the field; a band of gypsies inched along the center slope, with families breaking away to either side; a Land Rover moved down the pavement, pausing three times to let people out in front of us, wait for them to dance, sing, or stare, and then gathering them up again. Figures from the Arboretum passed; and the bony couple sat with their rowboat, oars in hand, gazing into far away. They were the ones to remain behind when five horses galloped by and the whole population went screaming after them.

Both field and Arboretum took on a mysterious gloom in the dark. On the Green after dinner we sat in the opposite direction, facing an indistinct building. Since vision was lessened, Miss Monk increased the sounds, and did her peculiar noise-singing at the organ. Lighted windows appeared eerily in the house, illuminating tiny dramas one after the other. The bony couple led a crowd of people down the front steps of the house toward the audience, like a ghoulish marriage ceremony. In a lighted grove, white-gowned figures hung from heavy

branches and drifted among the tree trunks. Six motorcycles roared by and the whole population went screaming after them.

Everyone reappeared together in the torch-lit Arboretum, dancing slowly in place to Miss Monk's singing. They dropped to the ground as the monster swayed out from the woods; and then, singing themselves, they followed the monster in a rhythmic procession, disappearing behind the wall. The bony couple emerged from the woods with a lantern, held it searchingly to the audience, and walked to the lake. We followed their lighted journey as they rowed to the opposite shore.

That experience, so specific in time and place and incident, could have happened anywhere, including your own mind and body. It would never be the same but it would always be inevitable.

Marcia B. Siegel

Virgin Vessel

You could think of Meredith Monk's *Vessel* as a ship of fools. Or, since its theme is the story of Joan of Arc, you could interpret the title in the biblical sense to mean a person who carries the word of God. Or you could find in the gigantic course of this three-part "opera epic" various water images or various cooking receptacles to support various senses of the title word.

But I'll leave the literary exegesis to the music critics or theater critics who probably saw the piece during its two-week run here. *Vessel,* like all of Monk's work, was enormously complex and dense in its layers of imagery, and—also like all of her work—some of it was inaccessible to me, some of it seemed overintellectualized, and some of it was unimaginably beautiful.

There's no easy way to describe *Vessel.* It begins in Monk's garret in a Great Jones Street loft building. Part Two takes place in the Performing Garage, erstwhile home of Richard Schechner's *Dionysus in '69,* and the last scene is a downtown parking lot and adjacent church. All of these locations are in the absolute bowels of New York City— the decaying industrial core that is worse than any slum, because it's been abandoned by everybody but the scavengers.

Vessel is so determinedly literary and symbolic that I was acutely aware of the distance between the real, raunchy world Meredith Monk inhabits and the make-believe one she wants to create. In fact, this distance may be one of the crucial things about Monk's theater.

The piece begins as the audience is led into the pitch-dark loft a few at a time by someone with a flashlight. You sit on a backless bench

Originally published in the *Boston Herald Traveller,* November 14, 1971, and included in Siegel's *At the Vanishing Point* (New York: Saturday *Review Press,* 1972).

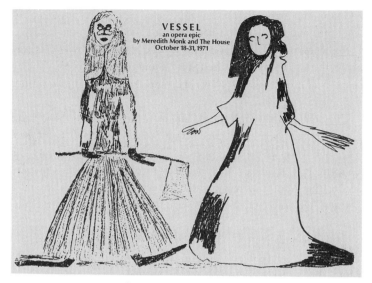

Program cover for *Vessel*. Drawing by Meredith Monk (1971).

waiting for the process to be completed, and you hear a woman's voice somewhere in front of you, reciting a surrealistic story in a very peculiar, melodramatic *sprechstimme* style, like a bad actress doing the Duchess in *Alice in Wonderland*. As your eyes get used to the dark, you see a smoggy glow from some windows, and another from a barred skylight. You've entered inner space.

A match flares, and in a thin spill of light from a partly hidden candle you can just make out a woman in profile, seated at an organ console. She plays a series of syncopated, repeating chords, and after a long time she starts to crow—a single note pitched high, higher than a person can sing—in a complementary rhythm. Staring straight ahead, she sings and plays and rocks back and forth from the base of her spine.

Other lights come on and we see a group of people dressed in black seated casually around a living room. They begin doing tiny things with their hands—pantomimed games of catch, outlining shapes in the air, wiggling their fingers. Facing us with their backs to the living room group, a pale, naked couple with long fuzzy hair sit side by side at a table.

The people in black disappear one by one and come back dressed in different costumes as if to announce a previous incarnation. A man in a suit and derby becomes a king who throws money on the floor

and intones portentous French words. Later a girl comes out in a plaid wool shirt and a long cotton-batting beard and rakes up the money.

A procession of peasants comes up the stairs and makes its way across the loft, stopping as though on a long journey to rest and play snatches of music on a Jew's harp and flute. Another man follows after them, scattering ashes along their trail.

The organist (Meredith Monk) stands at the far end of the loft and gives, very simply, a brave speech from Scene V of Shaw's *Saint Joan*. Then she whispers the same speech. The living room characters line up formally, and, one by one, they each repeat a movement sequence, accelerating into near-frenzy, until they are stopped by a clap and a guttural "tee hee!" from a sort of stage manager identified in the program as Host.

Part One ends with a vision: a bushy-haired girl, white-robed and flooded with saintly light, gazes in at us from the fire escape while Monk shrieks her way through another primal solo.

Parts Two and Three contain these same elements, sometimes in different forms, always increasing in size and sweep. In the multilevel scaffolding of the Performing Garage, the living room characters have one long vocal ensemble; later they do solo bits and low comedy in a blue spotlight. A girl juggles oversize money in Part Two; she becomes a whole troop of clowns who tumble out of a microbus at the parking lot. Two peasants wearing silver hood-masks duel with rakes in Part One; in the last act, two peasant armies charge at each other.

Each section culminates in a striking apotheosis, with Joan / Monk finally immolating herself—dancing, twitchy and frenzied, into the blue-white-yellow blaze of a welding torch.

I always find Meredith Monk's pieces more interesting in the aftermath than in process. I think this has something to do with the restraint she imposes on her performing canvas. She only allows one thing to happen at a time, so as a spectator you know you must wait out each episode until the next one begins, while in thinking it over later you can make the events flow and intermingle in your mind.

The point is, the separate event as it happens is static. It's as if Monk were showing you a picture album of her trip in the Joan of Arc vessel—now here are the pioneers, she seems to say, and these are the children playing a-tisket a-tasket, and then the dragon comes in. Everything is done very slowly and deliberately and the phrasing—whether vocal, motional, or theatrical—seldom gets more complex than a repetitive, bare in—out sequence or a ring, swept clean of rhyth-

mic emphasis. Although the images are sometimes startling, strange, even occult, they are always maintained at low intensity; the performers are composed, they're artificial.

Monk's raw materials are simple, even childlike, but so brilliantly controlled that they can become universal. A character who looked like a fifteenth-century monk to me reminded someone else of a rabbi. Little touches of costume—heavy boots or an apron—place the character, not specifically but according to type. The pioneers could be crossing the American plains or medieval Europe. The vividly dressed, well-behaved children might belong to a French court or an English country house. The vocal sounds, virtuosically produced, are at the same time unheard-of, unearthly, and evocative.

Meredith Monk's imagination is so clever, so far-reaching, yet so careful. With a sacrificial purity, an unaggressive assurance, she drags us down into the city's viscera, only to transport us out of the grit and the garbage in an elaborate, watertight fantasy. It's her detachment rather than her involvement, I think, that fascinates people. What a cool, permissive saint she makes, offering Nirvana to a decrepit city!

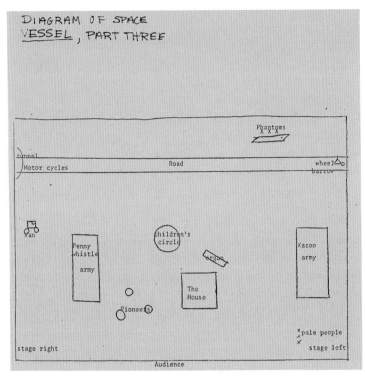

Vessel, Part Three. Diagram of space by Meredith Monk (1971).

Meredith Monk

Notes for *Vessel*, Part Three, 1971

Sequence and Cues of Action

1. Preset (meditation, fetal position, humming "ah" in different voice tones).

2. Pale trio enter stage left and walk across field.

3. Screamers (John and Ping).

4. Sign unfurled; and narrator speaks (Meredith and Lanny).

5. Meredith sings and plays organ (Epic Song). The House enters, takes places, and stands still.

6. Horn sounds seven times.

7. Pioneers start activities, light fires, and continue until Sybil Song.

8. Mill Song—The House dances.

9. Children begin ring game and continue until Sybil Song. Bicycles come after children's game is established and ride same path as koo-koo van.

10. Tower Song and The House.

11. Phantoms lighted.

12. Sybil Song; all slowly rise, face back wall, sing, and slowly wave. Meredith at organ.

13. When Meredith stops playing, everyone freezes.

14. Kookoos enter in van stage right. Van stops three times. Each time the kookoos get out and freak out. Van exits stage left. When van passes each group, the group resumes activities: pioneers do their activities, children resume game, pioneers put out fires, phantoms' light goes out.

15. Horn blows three times.

16. Kazoo army starts.

17. Pennywhistle army starts after a while.

18. Horn blows and the armies retreat.

19. Two generals dance—Lanny and Monica.

20. Torch is lit.

21. Pale trio waves from the side.

22. Kookoo procession comes in and passes out carrots from wheelbarrow (distributing to Pennywhistle army first).

23. Everyone starts dancing.

24. Monster enters stage right after everyone is dancing, and makes oval path through the crowd.

25. Monster exits. Horn blows. All freeze.

26. Meredith plays "Do You Be."

27. All crowd (with baby steps) to center.

28. The House crowds and does "sword voices," and then motorcycles roar, circle crowd five times, accelerate, then exit stage left.

29. All crowd runs after motorcycles, stop, run, stop, run . . .

30. Meredith dances to welder. Stands in front of welder.

31. Meredith and welder exit.

Costumes and Props

Pale People—off-white or light-colored clothing. Regular street clothes.

Phantoms—brown or green clothing.

Children—costumes provided.

Pioneers—jeans, work clothes, long dresses, aprons, braces, leather jackets, scarves on heads. Bring props—pots, pans, hair brush, guitar, Bibles, etc.

Kazoo Army—blue clothing: blue workshirts, navy overcoats, bluejeans.

Pennywhistle Army—any sort of red clothing (from trousers to bathing costumes).

Kookoos—crazy, freakish, clownish, bright-colored clothing.

Mark Berger

A Metamorphic Theater

The concept of an abstract and purely formal theater extends back to the turn of the century and the kinetic visions of Gordon Craig. Based on an integration of light, sound, color, and movement, his Theater of the Future eliminated plot and verbalization. The Bauhaus in the 1920s similarly experimented with ideas of an abstract dance theater as a form of kinetic art. The technological orientation of Gordon Craig virtually eliminated the performer, while in the Bauhaus dance productions, the "dancer" was essentially little more than a highly stylized marionette. These experiments in formalism reached their recent apogee in the 1966 marriage of art and technology, the Nine Evenings: Theater and Engineering, presented at the 26th Street Armory in New York.

While Meredith Monk was aware of this objectivist stream in contemporary dance and theater, her work is better viewed in terms of the development of the Happenings. These performance events of the late 1950s and early 1960s were the productions of a group of visual artists concerned with extending the boundaries of object-oriented art which was discrete, static, and timeless into an environmental, kinetic, and temporal format. They began to realize one of Antonin Artaud's major aims: to create a kind of environmental theatrical space in which all forms of art—music, dancing, mime, painting, sculpture, lighting, chanting, singing, incantation, and gesture—could be combined into a new theatrical experience. The unique quality and strength of Meredith Monk's theater derive from her ability to explore and expand upon this aspect of nonverbal collage theater within a narrative format. Elements of character and interpretation, heroes and heroines,

Originally published in *Artforum*, May 1973.

plots and subplots, development and climax are all present, but kept in a state of flux: a metamorphic ordering of segmental parts that shift focus, disassemble and reassemble, spreading out in a multidimensional, musically organized tableau.

In the first part of *Juice,* four performers painted blood-red, clutching each other to form a single multipedal figure, lumbered up the ramp of the Guggenheim Museum. A humming chorus of one hundred white-robed figures hovered over the edges of the ramp, expanding and compressing the space of the red figure's journey. A simple repetitive phrase on a violin filled the space with a neutral density, underscoring the contrast between the earthbound red figure and the airiness of the white chorus. A sense of watching a ritualized reenactment of some epic myth or legend was evoked. As in the transformations wrought upon verbal histories passed through generations of a culture, the symbolically evocative images of the performance presented themselves as an archetypal synthesis of dimly remembered tribal realities.

The second and third parts of *Juice* dramatically shifted. With each change of location and environment, the journey spread and expanded itself on a horizontal plane, literally as well as metaphorically, bringing other levels of reality content to bear on each of the preceding parts. Part Two took place on a conventional proscenium stage, with its characteristic picture space and planar barrier between audience and performers. At one point, the red figure segmented itself and became four distinct people: real persons with names, addresses, likes, and dislikes—an abrupt transformation from theatrical artifice to daily reality. A performer from stage front declared, "My name is Meredith Monk and I live at 9 Great Jones Street and I have a cat named Isadora . . . etc.," confronting the audience with a set of ambivalent apperceptive demands. Likewise, others of the group came forward with a similarly personal recital. Was this Meredith Monk, and Daniel Ira Sverdlik, and Madelyne Lloyd, and Dick Higgins as realities, or the artifice of theater that was being presented? The mystery in this metamorphosis is as if someone wearing a mask slowly peels it off, only to reveal the exact same face beneath the mask. The relationship between the Greek word for actor's mask, "persona," and our own word "person" for individual becomes meaningfully clear.

Part Three of *Juice* peels away another layer, or, depending on the perceptual set of the spectator, adds another layer. In an unfurnished loft, costumes and props of the previous two parts were arranged as if

on exhibit in a gallery. Physical objects were presented in their literal aspects as prime materials divorced from their previous roles yet retaining their associations with these roles. Like the shed exoskeleton of a molted spider, they presented a similitude to the original form but without the life substance itself. The four red performers were present at one end of the loft in videotape vérité, conversing on the phone, frying eggs, talking, singing, presenting another aspect of themselves as reality content, but in a new context. The intimate activity viewed on the video screen as reality was created through the timespace illusionism of electronic imprinting.

The concept of narrative format is intrinsic to Meredith Monk's theatrical structuring, but within it there is some degree of variability and indeterminacy that relates her work to the Happenings. For example, in Part Two of *Vessel* during the series of journeys of the Traveler around the ramp of the Performing Garage, each of the main characters performed definite activities, the ordering of which was left to the individual performer. Thus, a different arrangement of contiguous states of activities occurred in each performance. Seeing such compartmented activities, in varying series, each spectator structured relationships between them differently. This open-ended situation would then be radically altered by a cue: a stamped foot, a shout, a knock, a sung note, a plucked instrument, or a musical passage, which reordered the performers into a "matrixed" ensemble.

Also central to Monk's work are permutations wrought upon the environments of a performance. *Needlebrain Lloyd and the Systems Kid* was performed out-of-doors at the Arboretum and college Green of Connecticut College. In Scene 1, the two neutral gray figures seemed to rise out of the Arboretum pool carrying a rowboat and gave the isolated nature of the space an even more hermetic and fairy-tale quality than it initially had. The disjunctive quality of the images and the activities of the performers in this scene, and the appearance of a papier-mâché monster, reinforced an unreal atmosphere. The red multiple-figure group seen previously in *Juice* appeared again, and as in *Juice,* broke the continuity of an illusion. The relationship of painted red figures to the natural green of the environment dramatically altered when the performers were presented to the audience as personalities, particularly at one point when each of the red figures mimicked the characteristic walk of another red figure who was named.

The activities in Scene 2 on the Green presented another set of contrasts: within the realm of real activity in the outdoor setting in a

large open field, the garden party playing croquet, and the horseback riders had a certain naturalistic connection. Another group of performers, the pioneer group, however, while in character in terms of place, gave an ambivalent edge because of its "other-time" quality. Many of the activities began across the open field, at some distance from the audience, and were out of focus and ambivalent in the setting, being seen primarily as spots of activated color in an open field. As these activities moved down the field, closer to the audience and into focus, they became more unreal. The resultant tableau of lawn party, screaming and falling black figures, crawling and running white figures, horses and riders, a lumbering red multipedal figure, a monster, a jeep of performing clowns, a yellow figure on stilts, and so on, completely transformed the Green into a hallucinatory collage.

The manipulation of the environment was likewise intricately developed in the three parts of *Vessel*. In the first act, performed in Meredith Monk's own loft, the character of a real, contemporary living space gave an oblique focus to the "unreal" performance within it. The loft evoked the interior of a dark and dank medieval castle, not through effects of costuming and props, but by the activities of a group of dimly lit and black-clothed figures, engaged in a set of arcane tasks, whose ambiguous and involuted nature gave an aura of suspension and mystery. This diffused and nonmatrixed collage of activities was intermittently broken as each performer individually left his or her tasks and disappeared into some undefined space. Reappearing in another costume, as a new character, each performed a short scene and disappeared again into the undefined space, reappearing in the original black outfit to resume his or her original activity and role. The character of the environment as a space and a set was abruptly shifted when a group of pioneers entered the loft. As they moved, they alternated between a stylized plodding gait, and settling to the floor, engaged in naturalistic activities such as eating, reading, cooking, playing musical instruments. The performing space was refocused again when Meredith Monk rose from the organ that she had been playing, and, cutting through the darkened room with a brusque walk, turned on an overhead electric bulb, then recited a passage from Shaw's *Saint Joan*. This passage was repeated in a whisper, the bulb was turned off, and Meredith Monk returned to the organ. Duality became layered upon duality.

In Part Two of *Vessel*, the costumed characters performed by the black people of part One now appeared as the main characters of

the Mountain, in a theatrical setting. Once again this set was broken, paralleling the dualities of Part One. At one point the Mountain people took on new roles as a third set of performers, articulating a section of the Performing Garage space as a proscenium stage within the illusory space of the Mountain. In Part Three, in a final and infinitely subtle layering of artifice and reality, the black-clothed House people reappeared, but in a mood and amid props which were similar to, but not the same as in Part One, and most unexpectedly, in the outdoor setting of a parking lot.

The constant shifting of focus between varying layers embodies itself as a field of vectors in a fugal relationship. The allusion to musical form is not gratuitous. *Vessel* is subtitled "An Opera Epic." It is not merely the use of singing voices and musical instruments that defines it as such, but rather the clear polyphonic and polytonal structure underscoring the narrative content and the textural field. Though not referred to as an "opera," *Needlebrain Lloyd and the Systems Kid* is, at least, an orchestration of phased activity clusters and flowing images. From the simple, repetitive violin phrase, humming chorus, and vocalizations of *Juice,* Meredith Monk's musical ideas have expanded greatly through *Needlebrain Lloyd* and *Vessel.* Beyond accompaniment, the music and singing become another form of generative activity.

Like a musical composer elaborating musical themes, Monk weaves images from one work to another. The multiped red figure of *Juice* appeared again in *Needlebrain Lloyd.* The monster of *Needlebrain Lloyd* climaxed the action in *Vessel.* The pantomiming fairy-tale narrator of *Needlebrain Lloyd* continued her dream stories in *Vessel.* The thematic elements, though altered from piece to piece in the narrative content, become potent archetypal images that carry us on an ineluctable journey.

Marianne Goldberg

Personal Mythologies

Meredith Monk's *Education of the Girlchild*, 1995

In *Education of the Girlchild,* Meredith Monk and members of her performance group, The House, provoke fresh ways of perceiving, thinking, and imagining. Monk believes that theater offers "a possibility of opening people's eyes and ears and showing them reality in a fresh way so that if you go back out into your own life you might see something differently than you had before. Theater is a place where the psyche is activated . . . where imagination is allowed to be alive."[1] Monk's theater brings insight through personally created myths and archetypes. Many of the themes in *Girlchild*—journey, initiation, feasting, death—are reminiscent of ritual, which traditionally responds to important changes in individual or social life. As in ritual, the structure of the performance is nonlinear, based in juxtaposition, fragmentation, and associative thought.[2]

Monk's first images for the piece related to her grandmother, ancestry, and blood connections. She composed a solo that traced an old woman's life backward in time and paired it with a portrait of a group of women she describes as a female version of the knights of King Arthur's Round Table. In its subject, the journey of a community of women, *Girlchild* explores new possibilities for female roles onstage.

When The House began work on *Girlchild* in 1972, most of the performers had been with Monk for about four years. The group was familial and affectionate, a community with shared concerns expressed through performance. Monk notes, "Even though *Girlchild* is sifted

This essay was originally published as "Transformative Aspects of Meredith Monk's *Education of the Girlchild,* " in *Women & Performance: A Journal of Feminist Theory* 1, no. 1 (1983). Adapting it for republication is like taking an old trunk of treasures out of storage, sorting through them, and pausing in the face of the gaps in time, the shifts in perspective.

49

through my sensibility, there was a certain kind of agreed sensibility. . . . At that time, we were all interested in ancestry and mythology." Monk evolved much of the material for the group scenes through improvisation. She would bring ideas into rehearsals and ask company members to develop movement and character based in their own lives. In a 1975 interview she explained that "The interior richness of each performer contributes to the making of sequences and I want the audience to have a profound relationship with their female personality. Each person . . . uses her own familial, childhood, social, and ethnic backgrounds."[3]

Monk built archetypes from the personalities of the women, mythic roles such as warrior or scholar. Performer Blondell Cummings describes her process of evolving a character with sources in black cultures: "I tried to find a way of representing an archetypal character that I would understand from a deep, personal, subconscious point of view that at the same time would be strong enough to overlap several black cultures." Cummings identified with certain details from the lives of black women and translated them into specific ways of moving, such as a sway she developed for the group traveling sequences. Performer Lee Nagrin used the image of a Mexican woman with a flayed back as a source for her character.

For company members the characters became enlargements of themselves rather than fictitious personae. Nagrin does not think of the piece as separate from herself but rather of herself "existing in it." She describes working on *Girlchild* as "making in the world what exists in my being. . . . The performers are the life of the script. They inhabit the work. Ideally, the play is being written as though it were alive." There was an intimate connection between the characters in *Girlchild* and the performers' daily lives. A scythe that Lanny Harrison swings is one she has used on her farm. Monica Moseley sits immersed in a book, reflecting her love of reading in the morning. *Girlchild* transforms such details of personal experience into performance.

Awareness and trust developed during rehearsals. Because the structure of the piece was not predetermined, the process involved discovery. For Nagrin, working in this way "allows things to enter the piece that would never be there if everything is already known to you before you begin working." Monk's metaphor for the artist is the sybil or oracle—one who is available to receive images and able to create from them. She conceives artists as "the antennae of society . . . connected to things that are underlying what is going on at the emotional, psy-

chic level of the culture." For her the process of structuring a piece is "beyond thought":

> It is a deeper kind of insight, something I know in my gut—a knowledge that is not necessarily thought-knowledge. Then, I sit down and work structurally to find the sections and transitions to make the message clear. There is another part of the mind that is used to make a lucid form that will communicate to other people.

Monk sees herself as a mythmaker, but not in the sense of recreating already existing myths: "In a way we were were creating a kind of personal mythology. It involves trying to get to the essences of those elements that occur in fairy tale, myth, stories, and dreams." The mythic iconography in *Girlchild,* unlike that of ritual, does not reflect collectively assumed traditional meanings. Monk's myths do not reinforce the predominant models of her culture. A woman's puberty ritual is conventionally a rite of passage that transforms young girls into their society's model of womanhood. *Girlchild,* by juxtaposing cultural symbols in new ways, reshapes traditional identities of women.

Although there are no prescribed meanings for the imagery in *Girlchild,* the basic theme concerns the spiritual journey of a group of women who overcome obstacles together and who share moments in the ritual of the girlchild. The piece presents women as companions in a utopian society who, as Monk describes it, "undergo transformations and adventures having to do with growth, journey, coming of age, and rites of passage." The journey that she structures is an hour-long collage, each scene like a mosaic, built of movement and sound motifs that are fragmented and arranged in a sort of three-dimensional poetry, with scenic shifts seeming to parallel the characters' psychic states. The sensibility is visual, spatial, and rhythmic, the effect a portrait of the women and a panoramic view of their travels.

Over the past ten years, *Education of the Girlchild* has toured the United States, Europe, and Japan with the same basic cast. Because the characters stem so directly from the performers' experience, the piece has made room for changes in their lives. Nagrin points to the way the passage of time affects the characters' shifting identities:

> I remember Coco [Pekelis] looking up at me in Japan and saying, "You know, you always used to be so fierce when you looked at me at the table and now you're ecstatic—you're in some other place completely." And of course this happens to be true. We're there in ourselves in the way that we are now and not as we were then, but that material is still part of our

history. This is very different than performing a character. You fill it in a different way.

This kind of change also happens in subtle ways from one night's show to the next: minuscule improvisational variations give a new texture to an individual's performance or to the group interaction. Harrison says that life events have affected *Girlchild*, "What people have been through—pain, suffering, happiness, childbirth":

> You define the piece and then it defines you. Through performing and through making something you find out a lot about yourself. It has been totally important for me—everything in my life led up to and is continuing through some kind of creative process that has to do with imagination.

Cummings says of her own process in performing the piece over the years, "It is like growing through it, as another way of rechecking myself to see where I am." Monk feels that the creative growth of those involved in *Girlchild* is perhaps even more important than the creation of the work itself. The piece has incorporated and made manifest performers' life changes the way ritual does.

Company members experience an intensified awareness when onstage. Harrison describes her improvisation of a monologue:

> I let my imagination do what it would during the time of the monologue. It was improvised every night and I really let it take me. It has to do with opening the mind so that you do not hold onto any safety zone—with letting your subconscious and your stream-of-consciousness, your intuitive mind and your imagination, carry you along.

For Moseley, the audience–performer rapport has elements of spiritual communication: "You are very much awake when you are onstage—it is a very special state of awareness. There is a particular energy that a group of people who are sitting there watching gives you." She speaks of the importance of "creating a living situation each time and making it accessible to the people who are watching."

Monk and The House suggest that audience members bring an openness, a meditative presence, and a willingness to suspend usual constructs of space, time, and structure—a state similar to that engaged in many rituals. Nagrin would like an audience to attempt not to "understand" the work but to "receive" it. She believes that if this occurs, the viewers can have a "deep, internal, sensation-feeling experience."

Monk has spoken of the necessity for the audience to "open up enough to let the imagery inside."[4] She leaves *Girlchild*'s imagery

open-ended and always somewhat ambiguous, so that it can evoke multiple connotations.

I always want my work to have a clarity and a logic—a luminosity from lucidity—but I also want the audience to have enough room to be able to move around within the level of connotation and meaning. I give them evocative nuggets of information that radiate.

She describes theater as a spiritual cleansing of the senses, a renewal of the way the spectator perceives the world in a society that often represses feeling and imagination. A performance creates a space of temporary openness where reality can be refashioned, a place where people can become more conscious and better able to survive psychically in their environment. Monk and members of The House make theater that feeds everyday life and, like ritual, sustains and transforms its communities.

Notes

1. Unless otherwise noted, all quotes of performers and information on working process are from my November 1982 and May 1983 interviews with Meredith Monk, Lanny Harrison, Lee Nagrin, Blondell Cummings, Monica Moseley, Daniel Ira Sverdlik, and Sybille Hayn.

2. For an analysis of creative process, tradition, and innovation in ritual and theater, see Victor Turner's "Liminal to Liminoid in Play, Flow, and Ritual," in *From Ritual to Theatre* (New York: Performing Arts Journal Publications, 1982), 53–54.

3. Interview with Philippe de Vignal, Monk clippings, Lincoln Center Dance Collection, New York City.

4. Interview with Linda Winer, 1974, Monk clippings, Lincoln Center Dance Collection, New York City.

Tobi Tobias

Arrivals and Departures

Twenty years after its creation, Meredith Monk revived her landmark multimedia work, *Education of the Girlchild,* for a week of performances at the Joyce. Miraculously, she was able to reassemble nearly all the original cast members, and, astonishingly, they don't look much older. Perhaps living knowledgeably and at ease with your personal and tribal history—an attitude the piece depicts and affirms—safeguards the vitality of the body as well as the spirit.

Suggestive rather than literal, *Girlchild* is a wildly, sometimes antically, imaginative piece. Its movement consists primarily of mime-style gesture disconnected from specific meaning and the folk-dance motifs of a tribe the anthropologists have overlooked. Its costumes, props, and set pieces might be the detritus of suburban attics, Third World bazaars, and fly-by-night theaters. Its most striking feature is the unearthly form of primal song that Monk has evolved: strings of repeated syllables that never form words, intoned in a voice that slides from the guttural to the angelically pure. Monk calls her work an opera, perhaps because of her epic intentions and the primacy of music among its elements; I'd call it an incantation.

First in ensemble vignettes, then in a marathon solo for herself reminiscent of the esoteric interior monologues and transformations of Noh drama, Monk explores the span of human life. Back and forth she ranges, from the child's first experiences—in which events register as pure sensation and indelible image—to the terrifying but inevitable moment of recognizing personal annihilation as the sole content of the future. Throughout, she recovers for us the kind of intimate history, so important to what we become, that the conscious mind forgets, con-

Originally published in *New York Magazine,* May 31, 1995.

verts, or abandons. At the same time, her spectacle reenacts the communal bonding—significantly, in this case, female—that offers the solitary individual affinity and support.

The most telling scenes in *Girlchild* have the strangeness and vividness of childhood perceptions; they're kin to the paintings and fantastical narratives of preschoolers. For instance: a tall, gaunt female death figure appears in one brilliantly conceived spectral costume after another—how do *you* envision the fatal usher?—to claim the members of a decrepit sorority of the aged. The next-to-last survivor chants in anxious defiance: "I still have my hands. I still have my mind. I still have my money. I still have my telephone. I still have my allergies. I still have my philosophy." This figure, no more imposing than a tiny, wizened doll, represents the pitiful, perhaps tragic, absurdity of the human condition with whimsical wit. The figure is unmistakably Monk's.

Meredith Monk

Notes on the Voice

1. The voice as a tool for discovering, activating, remembering, uncovering, demonstrating primordial/prelogical consciousness.

2. The voice as a means of becoming, portraying, embodying, incarnating another spirit.

3. The dancing voice. The voice as flexible as the spine.

4. The voice as a direct line to the emotions. The full spectrum of emotion. Feelings that we have no words for.

5. The vocal landscape.

6. The body of the voice/the voice of the body.

7. The voice as a manifestation of the self, persona or personas.

8. Working with a companion (the accompanying instrument: organ, piano, glass, etc.): repeated patterns or drone creating a carpet, a tapestry of sound for the voice to run on, fly over, slide down, cling to, weave through.

9. The voice as language.

10. Chronological discoveries:

 Beginning—
 1967, duet of solo voice with Echoplex reverberation unit *(Blueprint)*, the free voice as electric impulse.
 1968, voice (voices) and violin, Jew's harps *(Juice)*, the raw voice (rough, plaintive, primitive, brash), repeated chants; the voice as

Originally published in *Painted Bride Quarterly* 3, no. 2 (1976).

an indication of character—the red mountain woman, how does she sound?

Continuing—

1970, solo voice with electric organ *(Raw Recital, Key: An Album of Invisible Theatre)*, the traveling voice (moving through dreamscapes).

1971, opera epic *(Vessel)*, the voice of God (high, transparent, piercing), cosmic telegraph; the voice as a supernatural phenomenon— Saint Joan's voices, how do they sound?

1972–73, opera *(Education of the Girlchild)*, the voice of the 80-year-old human, the voice of the 800-year-old human, the voice of the 8-year-old human; Celtic, Mayan, Incan, Hebrew, Atlantean, Arabic, Slavic, Tibetan roots; the voice of the oracle, the voice of memory.

1972–73, duet of solo voice with glass (wine glass filled with water), *(Our Lady of Late)*, the naked voice, the female voice in all its aspects; gradations of feeling, nuance, rhythm, quality; each section another voice (character, persona), each section a particular musical problem, area of investigation; the full range of the voice (pitch, volume, speed, texture, timbre, breath, placement, strength); the voice as the vehicle for a psychic journey.

Now—

1974, solo voice with (acoustic) piano *(Anthology)*, the morning voice, the voice softening as the sun rises, the voice melting and reforming many times within one song; the voice as messenger or sibyl; the soul's messenger.

1975, solo for unaccompanied voice *(Songs from the Hill)*, the voice a reflection, a mirror, a receptor of nature; voices of animals, plants, insects; signals, calls, hieroglyphics; an offering to nature; the voice, totally alone, unaccompanied, unadorned.

1975–76, opera *(Quarry)*, thirty voices, songs of all people—lullaby, marches, requiem or lament, hymns, love songs, work songs; a memorial; eight- and sixteen-part rounds or canons forming an invisible circle in the air; voices of men and women circling, soaring, sliding, striking; voices as a wave of energy, a wash, a healing.

Arthur Sainer

A Report on Meredith's Notch

1. But what about the air war? 2. But do only certain kinds of bodies count in body counts? Does winding down mean changing the color of death's victims? 3. The theater not only can't help the war (the peace); it can't seem to help itself. Uptown and downtown it's mostly business as usual. Even if business is lousy. Business as usual for two thousand or so years? Perhaps not much longer.

I want to talk about Meredith Monk, who along with most of us on this planet CAN'T STOP THE WAR, but who DARES. Is one of the few who takes RISKS. I've watched her career, without realizing I was doing so, for just about a decade. Watched her in the early 1960s floating between the Sarah Lawrence dance department and Judson Church, solid, quietly determined. Watched her as an almost female puppet but finely sensitive in several early Kenneth King dance pieces. And began to watch her coming into her own in the middle of the decade and then, while I was living in Vermont in the late 1960s, heard rumors about Meredith breaking into epic, Meredith sculpting several-day pieces that needed several locations around town to happen. And running into her on occasion during the past year, heard her say to me things like, "I'm into theater," "I'm giving a concert," "I'm doing an opera." And I thought, where is she going? What's possessing her?

And I believe it has to do with needing to tunnel into another part of the world and of self, to become another part of one's relationship to self, turning the screw of the spirit two violent notches to the left. Thus we have Charles Ives turning to painting, Rauschenberg turning to dance, Mailer turning to theater and film, Warhol turning to everything.

Originally published in *The Village Voice,* January 20, 1972.

58

I reported on Meredith Monk's *Vessel* earlier this winter, a towering two-day, three-location theater piece that used space and sound to drive an aesthetic ice pick into the human heart, and now want to say something about what Meredith terms her "invisible theater," a record album called *Key*. Why invisible? Because sound, which is the phonograph record's natural element, drives out sight? I think not. The sound conjures up images. Hearing those voices, those instruments, those speeches, the mind's eye textures them with insubstantial images. It's as if the voice takes to itself not a face but some kind of indeterminate fleshiness, and also it seems to make a space for itself; the sense of place, of distance, of physical perspectives in the recording is very strong.

Elements include sometimes speaking or singing voices, an electric organ, a Jew's harp, and something which has been named a mrdingam. The speaking or verbal elements, performed by Lanny Harrison and Mark Monstermaker, are referred to as vision monologues. In the vision monologues, a series of short sentences are rung out, stretched out, pierced, bent, and driven. The lines are banal, gossipy, essentially uninteresting but the tortuous development colors them with the kind of high-fever rhetoric that seems to insist on capturing all our faculties but at the same time tells us nothing that we can make any use of. It breathes its insistence of some important communication at us but leaves us with nothing but its own insistence. It sets out and succeeds in clouting us with its world-shaking shallowness and then stops, its shallowness drained in a rush. What it does is to affect us without resonance; it is statement without reverberation, communication without message.

One of the more remarkable moments of *Key* is the sound of Meredith at the organ, shaken by the sounds in her head (which she makes). These are the sounds of St. Joan's voices, from *Vessel*. The organ in the lower registers is dredging at something; it is partly a beat of meditation and partly a beat of submersion, but against these steady dredging-meditation thumps is suddenly uncoiled the high-pitched, insistent cries of Joan's voices. They drive at the head in leaps; they spring at us in an astonishing, inhuman cross-breeding of the primordial and the electronic.

Sections of the recording are devoted to footsteps, to scratchings of shufflings. And always there are the senseless monologues and always there is the haunting organ reentering the landscape of the record, and the voices following hard on the organ sounds.

If *Key* is getting at anything, it is at the inexplicable (which, ultimately, art is always dealing with). It is very much a physical work, kinesthetic, creating the sense that we are confined with it in close quarters while it drives at us aloofly but maddeningly. There is a sense in the work of a deliverance, that we have mistakenly let something into the room that is going to try to free us whether we like it or not.

The war had made this writer impatient with "private" statements, including my own, but another part of me recognizes the constant value of the work of art that brings self closer to self and the community closer to itself. The Meredith Monk record seems to be one of those liberating forces if for no other reason than that it has created its own life; it is a highly original statement that elicits an original response. There is no way to prepare for this work, to bring to it what we have brought to other works. What it demands is a purity from us, and that purity is invaluable in any clime, in any war.

Tom Johnson

Hit by a Flying Solo

Meredith Monk's *Our Lady of Late* at Town Hall on January 11 was the closest thing to a perfect concert that I have heard for some time. She has as much control over her singing as she does over her dancing, and her music shows as much originality and genuine inspiration as her choreography. Not that there is anything special about the notes themselves. In fact, a conventional score of her music would probably not look particularly impressive. But when her relatively simple melodies are sung the way she sings them and embellished with the many ingenious vocal techniques she uses, they are indeed impressive.

Dressed in white, she looked very small and distant sitting alone in the middle of the Town Hall stage. In front of her was a little table with a goblet on it. Her only accompaniment was a soft drone created by rubbing her finger around the rim of the goblet. Throughout the hour-long performance, her eyes were focused down on the little table. This visual image changed only a few times during the concert when, in a ritual gesture, she lifted the goblet and drank a small amount of the liquid, thus raising the pitch slightly for the ensuing music. The concert was beautifully framed by offstage solos played on some sort of bell by Collin Walcott at the beginning and end of the concert.

The singing is split up into perhaps twenty short pieces. There is not a great deal of contrast between the pieces, but each has a slightly different character. Most of them are sung with a relatively nasal sound, but some are more open. Most of them follow simple scales, but some veer off into unpitched guttural qualities or speech-like patterns. Most of them have a clear pulse, but some are more free rhyth-

Originally published in *The Village Voice,* January 18, 1973, and included in Johnson's *The Voice of New Music, New York City, 1972–1982* (Eindhoven, Holland: Apollonuis, 1991).

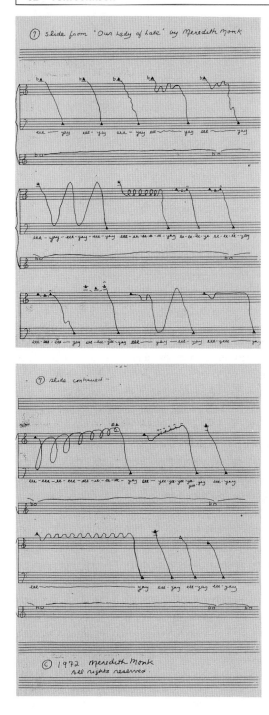

mically. Most of them follow a consistent line, but one remarkable one does not. In this piece Monk sings contrasting phrases, alternating between a rather gruff voice and a meek, high voice. This lion-and-mouse dialogue verges on humor, but the atmosphere is so strange and severe that one doesn't feel much like laughing.

Perhaps what makes *Our Lady of Late* so extraordinary is not so much Monk's approach to voice placement as her attitude toward language and phonetics. In her previous big vocal work, *Key,* one can pick out an occasional word or phrase. But here, Monk completely avoids anything that might be taken as intelligible English. Most of the time she doesn't even use familiar vowels and consonants. Occasionally there is something that might pass for an "n" or an "o" or some other English phoneme, but most of the time her singing has nothing to do with English or, so far as I can tell, with any other language. She has found her own vowels and consonants and evolved her own very personal language.

Notated passage from *Our Lady of Late* by Meredith Monk (1972).

Meredith Monk

Dreams

From Meredith Monk's Notebooks, 1970–1975

[?], 1970

I am at a big rally or performance in an outdoor ring theater. Isadora Duncan is the performer. She is dressed in a green-black tunic with pink underneath and a belt in the middle. She looks very puffy. She comes over to a group of us. She makes a motion over the heads of some of the people, marking them off. I think surely because I am a dancer she will come to me. I think the reason is that I have my glasses on.

April 24, 1971

I am in a suspense movie as an actress. A man dressed in a suit with a vest that has a chain coming out of one pocket, spats, and a hat is walking up to the window. He throws a typewriter in the window. Then he easily and quickly walks in one door. I am frightened. He is portly. He is carrying three objects: a guitar and two others. I start screaming for help. He turns to a tape recorder that has an echo. I say "help" and he plays the tape, which sounds like "help, help, help, help, help." I think that is very clever. I walk up to him and tell him that I like him, thinking then that he won't hurt me. There are lots of other people in the room. I suddenly notice that they are having a hard time breathing. I know that he has done it. I wake up wondering if I was acting in the movie or if it was real.

October 18, 1972

I am sleeping in the sleeping loft at 228. Suddenly Charlie opens the elevator door and a gigantic crowd of kids with giant heads streams out of the elevator. I had been dreaming that this was going to happen. First I tell them that it is the wrong floor, but soon I panic because

Prototype for Death Figure in *Education of the Girlchild,* Part 1, with puppets on head, shoulder, hand. Watercolor by Meredith Monk (1972).

they are beginning to knock things down. I scream, "Get out of here," and then they begin to tear up everything in the loft, studio, living room, etc. Soon, with Charlie's help, I get them back in the elevator. Then I cool down. There are a few people left. I tell them that I'm sorry for screaming, I was just sleeping before. Then they show me what they do. They put on a glittering puppet show across balconies across the loft. It is all emeralds and gold and silver. There is a woman in a long black waitress dress and other people with green emerald puppets on their heads.

April 1973
Bessie Schönberg gives me a piece of white paper with very important secret information about the United States on it. I go to Africa and I take it along. At the airport I meet Celeste Holm and a German soldier. There is a war going on in Africa at the moment. The man is

very suspicious of me and says he will search me. I get terrified. I buy postcards and some envelopes in a coffeeshop postcard kiosk so I can send the paper and card to Lanny at home. First I write a message on a 3-D card. You can hardly see the message. A man comes over and says, "I'll give you the correct pen to write with." Celeste Holm is sitting at the next table and she keeps signaling me not to put the white paper in the envelope right there because there are other people watching me. I am getting very impatient to get rid of the paper because I know I'll be killed if the man finds it.

I am a child wandering down a road looking for mailboxes to mail the letter to Lanny. There is one in town and one near the house. I am walking along a sidewalk shaded with trees and a big red stone fence along it. Suddenly two hands reach down and grab me by the head and pull me into the trees. It is a man wearing earrings. I smile at him, trying to protect myself. He smiles back. He is with a woman. I know I am captured. I am put into a cage with some birds. I get along very well with the birds.

June [?], 1973
I am in a little cabin that is a recording studio. It is snowing outside. Jeff, the engineer from Vanguard, is there in the studio. I go outside and Helen Goldstein is sitting on a bench with a green creature who she introduces as her grandmother. She is all green and shriveled with dry hair sticking out from her head. Helen says, "My grandmother would like to see you and the other women dance." I sit down next to the grandmother and say, "You look very much like me. I have a long face too." Lee, Lanny, and all the women from *Girlchild* are there. We dance for them. The next time I see the grandmother, she is turning flesh color and is unshriveling.

November 22, 1975
The House people are there and I start playing a scale on the organ. They begin singing, but I want to just practice. My hands are very slippery with cream or something like that. I'm a little anxious. Merce is rehearsing. He says, "What is the emotional meaning of what you are doing?" Or something like that. I am totally shocked. I say, "Are you for real?" He says, "Yes." I say, "I can only say it with a few words. I am doing some songs with the voice alone, not the organ. The word is SNOW." He says, "That's perfect." He says, "Here is something that is like that." He hands me a clip or pin with a blue rose on it carved

from ivory. The whole thing is blue, but a dusky-gray blue. It is very mysterious.

November 24, 1975, Marrakesch

Ping and I have returned from one trip. We go to a restaurant or a terminal or an office. There are two Europeans there. I speak French to them. They are nice, but I tell Ping later that they seem bitter to be in the United States. A group of older men takes us to a big arts festival; it's all taking place in one building but they don't tell us that at first. We see all these women with veils and robes, but bikini satin underwear. Each makes an entrance smiling and stands in line like in a beauty contest. The men say that that is a Spanish wedding. I am very angry about it. Then suddenly we go into the building and all these different events are going on in different spaces. I say to the older man-waiter in French, "Aha, c'etait une satire"—about the Spanish wedding—"J'ai pensé que c'était realité." Now someone gives me little soft slippers to put on my feet. A number of people say hello to me. We go to a concert of Mauricio Kagel, where the audience jumps and stamps all the notes he is playing. They are the visual counterpart to the music. There is a kind of mattress-trampoline for them to do it and we are on a platform. We all do it. It is great fun . . .

Signe Hammer

Against Alienation

A Postlinear Theater Struggles to Connect

Emotion has been the problem for modern theater as it has been for the twentieth century. The channels for feeling that remained serviceable, with various repairs and alterations, for centuries—religion, language, tragedy, for instance—burst. Emotions were variously fragmented, congealed, or simply blocked off for lack of a pipeline. People stood aside from their emotions, because nothing they had learned in their history prepared them, it seemed, for the events they had accomplished. Artists took to portraying the burst pipes, as with Expressionism and Abstract Expressionism. Or they showed the pipes clogged with ice, the congealed emotions, as with a rectangular lump of metal, perhaps a compressed car, on a gallery floor. The frozen or burst pipes have been the center of all our attention; the twentieth century, one might say, has been obsessed by the emotions it could no longer experience.

After I saw Meredith Monk's *Quarry* for the first time last spring, I reread Aristotle's definition of tragedy: "Tragedy is a representation of an action that is serious, complete, and of a certain magnitude . . . in the form of actions directly presented, not narrated; with incidents arousing pity and fear in such a way as to accomplish a purgation [catharsis] of such emotions."

For the better part of this century, art of all kinds has been preoccupied with form: taking it apart, exploring isolated aspects of it, rearranging it. The English-speaking theater was preoccupied with realism until the 1950s, when European absurdist playwrights—Beckett, Ionesco, Genet, and others—began to be produced here. In the 1960s, as everyone knows, there was a thorough dismantling of traditional

Originally published in *The Village Voice*, December 20, 1976.

68

forms. Words, in which everyone had lost faith, took second place to bodies and images. Theater became as much the province of dancers, painters, avant-garde composers as of playwrights. Elements of dance, nondance movement, mime, pageantry, voice, and sound were combined and recombined, sometimes with words, sometimes without. Many of these experiments turned out to be blind alleys, like the Living Theatre's attempts to fuse art and life by removing the aesthetic distance between performers and audience. Yet their experiment, with all the others, has become part of a new vocabulary for a postlinear theater.

This theater reflects the fact that realism has lost its power to inspire new work. The linear narrative form that provided a vehicle for many of our most powerful playwrights no longer connects with the sense of reality that has been evolving in our century. That sensibility is holistic rather than linear: it sees the whole instead of isolated parts. For example, it is aware of sensory input on a variety of different levels, as in mixed media. It knows that the intuitive and the rational are not always mutually exclusive, and that a straight line is not always the best way to "see" events, or how they work. It knows that man is part of a matrix that includes nature, man, and his products, and that they all act on each other. The new theater vocabulary is an expression of this mentality, but it is still fragmentary. It must be integrated with feelings to produce a true postlinear theater.

Formalist experiments, beginning with Ionesco's attack on language and his idea of projecting emotions onto objects, "to make the stage setting speak," have been necessary and honorable, but in the end they derive their force from protest—against old forms, fossilized language, and theatrical realism. Such realism was a primary vehicle for feeling; inevitably, formalist experimentation attacked feeling as well as form. For many years now, "content" has been out of fashion. It has been called "literary" and has been connected to the idea of telling an old-fashioned, linear story, complete with cause and effect and resolution. Too often, formalist experimentation has dealt with fragmented emotion or with emotion as an internal state so private it can hardly be reached. (Ionesco wrote of art as "the expression of an incommunicable reality.") So theater has increasingly cut us off from our feelings when it ought to provide a means of experiencing them.

We are not whole until we have connected with our deepest feelings and experienced them fully. Then we can integrate them and grow. Ultimately, Ionesco's "incommunicable reality" is hermetic, even autis-

tic, because it provides no connection between internal and external realities. The crucial fact of content is that it provides such a link; it enables us to complete that connection by organizing a theatrical reality that evokes and structures our emotions. We can then complete an internal connection by experiencing both the theatrical reality and our emotions.

The greatest theater has been produced when there has been maximum connection; when the private, internal experience and the public, external experience cross at many points—Shakespeare, for instance. In a time of cultural fragmentation, we get fragmented connections. Ionesco and the absurdists were making powerful connections, but the form itself had no place to go. (Only Beckett, with *Godot*, really succeeded in making a full-length absurdist play.) The same has been true of many of the experiments of the 1960s. For instance, the Open Theater, for all its real power, never managed to resolve the problem of relating words and bodies.

In other cases we have been led into sentimentality, Joyce's "failure of feeling." At the end of *Einstein on the Beach*, words of love (paraphrased from Elizabeth Barrett Browning!) are juxtaposed to a vision of the apocalypse. These words do not grow organically from the piece, which consists of gorgeous images of isolation. *Einstein* connects only to the disconnected, alienated, passive aspects of ourselves; it perpetuates the same radical dislocation of emotions from which the century itself has suffered. The words at the end are as remote as everything else in the work, as remote as it leaves us from ourselves. Beautiful, static sets—objects—form a backdrop to the rigid, compulsively repetitive movements of the performers—dancers whose paths never cross, who never deviate from their diagonals. *Einstein* is profoundly violent in the rigid formalism of its disconnection. When the impersonal is carried to this extreme, when Ionesco's concept of emotions projected onto objects is developed to the point where performers are left to behave in a fashion that can at best be called autistic, when everything is outside ourselves and we can connect neither with external reality nor with ourselves, we are at the end of a line. *Einstein* does not help us heal our disconnection. Rather, it perpetuates the retreat from feeling that formalism has become in our time.

Quarry works in the opposite direction because Monk understands the interplay between internal and external reality; in an important sense, she is unafraid to deal with feeling. Her roots are in dance and music, and for the last ten years she has been intimately involved in

formal experimentation as a dancer, composer, and maker of environmental theater. But she has been using the theatrical vocabulary she helped create to explore connection rather than disconnection.

In *Quarry*, which began a three-week run at the Brooklyn Academy of Music's LePercq Space Tuesday, Monk confronts the question of postlinear tragedy. That is, she uses the vocabulary of dance theater—much of which developed partly in opposition to content—to present "actions which arouse pity and fear." The form of development is like a spiral. (Monk herself has expressed it in terms of a crystal in which all the facets are gradually revealed, and this, in one way, is an excellent description of her form. But I keep thinking in terms of a spiral.) Cause and effect no longer run in straight lines.

Some experimental psychologists talk about the "masculine" mode of rational thought, a linear mode in which the point is to group objects and events in isolation from their background. The "feminine," or inferior mode, has been to consider objects and events as one with their background. This has been considered a primitive mode, one shared supposedly with children and disadvantaged blacks, for instance. My favorite example is one in which a black child, asked to choose related elements from a group of objects, associated an apple and a horse instead of grouping apples and oranges in a series called "fruits." Those who opposed the Vietnam War were grouping apples and horses, too, only it was napalm and babies. Certainly a child's view might be developmentally "primitive," but the integration of this sensibility on a more sophisticated level is essential to our survival as a species, and is an important aspect of postlinear theater. It consists of taking into account the background as well as the foreground, with apparently trivial or unrelated elements as well, and seeing how they all interconnect.

The spiral suggests development and integration. The feminine mode is inclusive; it is no accident that Meredith Monk, a woman, is working to integrate the flow of feeling with the new vocabulary of theater. And war as a public and private event is central to *Quarry*.

The war is World War II, the great formative war for all of us now in our thirties or older. The private events are those of the family; Monk plays a little girl who may be ill, or possibly having a bad dream. The traditional unity of tragedy is observed; the action takes place in the course of a single night. The events are set up in small vignettes around Monk, who lies on a blanket in the center of the space, and in group events (a cloud dance, a fascist rally, a concentration camp)

which take up the whole area. As the events of the child's dream become real, we are moved from a private world through terrifying external events that are then taken back into the child's body, reduced and concentrated into her own movement and voice—the "primal elements," as Monk calls them. At the end, a requiem involves the entire cast, and that in turn is assimilated by the child as she looks at a picture book on World War II and sings alone.

The piece builds by increments: small domestic events on the periphery—women eating, a man and a woman talking. Figures move through: a maid is comic, a photographer in a jumpsuit gradually becomes menacing. The child's mother appears as a radio announcer in a lighted booth; her voice has already been on the radio. Monk dreams in movement. Five dictators appear and are gradually killed off by a sixth, who presides over further events. These dictators are private as well as public: two of them also play the mother and father. The piece builds to a terrifying fascist rally which turns, in stillness, into a concentration camp. Single figures from the periphery silently drop their personal effects on the floor—an earring, a purse.

To describe the elements separately is to show how Monk utilizes an enormous variety of them; there are film, voice, movement, theatrical vignettes with dialogue, a radio, giant clouds. There are changes of pace, with a lullaby, comic bits, different speeds of movement. The point is the way these elements relate organically as they spiral through the public and private, the mass movement and the solo, dream and reality. Small repetitions do not merely repeat; they change slightly or echo themselves or combine with other elements to advance the spiral, a movement of circles through time. The effect is to draw us into an experience of our own feelings, our own sense of the way public events are structured by private ones and vice versa. The tragic flaw that leads to tragic action lies not in heroic individuals, but in all of us; the final sense is of surviving terrible events. The question is not of guilt, but of participation and release. The piece, finally, is about connections. It helps give us back to ourselves.

Meredith Monk

Digging for *Quarry*

March 25, first chorus rehearsal
Great to see the six old *Quarry* chorus members again after such a long time. Also twenty-three new ones. Everyone looks wonderful, full of life. We do a long physical and vocal warm-up. Teach a canon. Many people know it from working in *The Games,* Carnegie Hall, workshops. I talk a little about the piece.
I see a lot of anxiety in the bodies. Does this have to do with the first rehearsal, or is this lack of flow built into the kind of defense we need to get through the 1980s? Thinking about how much harder it is to get by than it was in 1976. Is this reflected in the tension of muscles? It's hard for people to trust that flow can be direct, forthright, and not sentimental. Flow without attitude.

April 9, first group rehearsal
We're all nervous, excited, curious about our first rehearsal. We just stand by the door waiting for the next person to arrive. Pablo [Vela], Tone [Blevins], Monica [Moseley], Lanny [Harrison], Danny [Ira Sverdlik], Mary [Schultz], Coco [Pekelis], Gail [Turner], Steve [Clorfeine] enter to laughing, talking, hugging. It's a reunion. Micki [Wesson] and Bradley [Sowash] are welcomed as the only new members. It's poignant, *pungent,* to see everyone again. Children have been born, family members have died since our last performance in 1977.
I realize right away that it will be better just to look at the old video and dance and sing a little together than to start working. That's plenty for tonight.
We watch the tape from our BAM performances. I'm amazed at the

Originally published in *The Village Voice,* May 14, 1985.

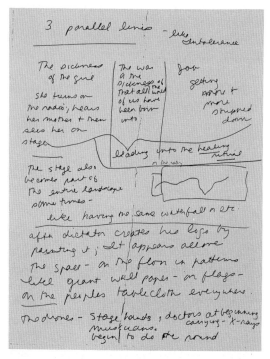

Notes for *Quarry* by Meredith Monk (1975).

amount of detail and the complexity of the form. How bits of material are introduced and then are seen later as developed sections. How it goes forward and backward in time. How the details accumulate to form a huge mosaic. Lately, my strokes have been broader and bolder. If you saw *Quarry* as a painting it would be formed with tiny brush-strokes on a huge canvas. Pieces like *Recent Ruins* or *Turtle Dreams* would be more like huge slashes of color on a plain background. Is this an indication of the times or just a way for me to try another way of putting things together?

We do a movement and vocal warm-up, including a canon. Then we dance together—just getting used to each other's energy again. A kind of party.

April 11, group rehearsal
We start working on the piece from the beginning. Everyone writes down their questions as we work. We decide to take only a short sequence and work on it instead of slonking through the whole piece.

The process becomes a kind of archaeology. Things that are not on the tape become mysteries to be solved. How did I get from there to there and at what precise moment? The piece is like a piece of Swiss cheese with many holes.

April 12—rehearsal with Nick Paradis (who is playing Ping Chong's role of the dictator for five performances) and assistant director Rob McBrien
Ping's character—slinky, reptilian, rubbery, changeable, evil in a casual way. Human life means nothing. Never showing fear or feelings although a kind of anguish shows through as if it were there without the character knowing it. Someone totally possessed and in control at the same time. Dictator as businessman. Nick's character: a Khmer Rouge general who has gone to Oxford for his education; strange dignity and ruthlessness combined.

April 12—chorus rehearsal
Many of the new chorus members are professionals trying to make their living in theater while the original chorus members seem to do a variety of things—they are therapists, work at the UN, etc. For the young people working now it's a hard balance—working out of love and needing to make a living from it. It seems that to sustain a life of performing, creating, etc., and not get worn out, one has to return always to the reason for doing it: the joy, energy, engagement of working, the daily work, which is a gift.

April 14, chorus rehearsal
Great rehearsal. I always thought that singing together was the fastest way to form a group, but now I see that the kind of physical commitment "The Rally" demands in using movement and voice together creates an energy field that everyone can partake of. The rally starts to feel like the old rally. I am almost crying, I feel so good about the chorus.

April 15, group rehearsal
Lanny's four-year-old daughter, Hannah Pearl, comes to rehearsal. When I am in bed as the child saying "I don't feel well, I don't feel well," she is next to me. She "helps" Pablo tuck me in after my dance. I love having her in rehearsal—another reality bumping up against the work. I watch her movement/posture for inspiration even though my child character is more like eight than four. The rehearsal has an easy-

going discipline about it. Everyone participates in the investigation. Micki (who is doing Lee Nagrin's role) and I talk about centering, internal strength, and clarity of gesture.

April 16, group rehearsal
Gaynor [Cote] comes in to try Annie's [Gentry] part of the black market/spy/food procurer. She is more like a robust Red Cross type than a shrewd Southerner. Wholesome and tough. The thing is: do we stick exactly with what we had, try to reproduce it, or do we try for a new version? It seems best to stick initially with the old form, like an armature or skeleton. By nature of the fact that it is nine years later, it will be fleshed out in a slightly different way. It's hard to find the balance—since structurally *Quarry* had a kind of perfection by the time we did the last performances. Now, we have to find a way to make it live again while maintaining the things that were good about it.

April 17, rehearsal with Nick and Bob
Nick is realizing that power can come from a quiet place.

April 17, chorus rehearsal
I come in sick with a throat infection and leave feeling great. We work on "The Wash." I say, "Can we in the 1980s do something that has a quality of purity, innocence? Not naivete. Eyes wide open so to speak but a kind of cleansing. . . . Can we drop the irony and cynicism for ten minutes?" Working with this chorus, I realize that the irony and cynicism which seem to be part of the vocabulary of the times are only that. That everyone has the possibility of letting them go. Now is just a harder time than in 1976. The anger and irony are a cultural way of covering up pain and disillusionment. Judging from this chorus, it seems that there is a possibility for everything again. That feels great.

In "The Wash," the wit is in the movement itself—how it is put together. Each drop in a stream is unique but is part of the whole. The chorus in "The Wash" is like that. I explain that "The Wash" is like a filmic wipe, a horizontal procession wiping away one section of the piece and bringing in the next. Working on the waiting room section after "The Rally"—images of people forced to leave their possessions and lives behind, herded into a room to wait for the unknown, the destination that will probably mean their death. It's touch-

ing to see a generation that has only heard or seen World War II on TV working through these images.

April 18, group rehearsal
We try running as much as we have and then go on. I don't do much directing. I know the performers need to find their own way.

April 19, group rehearsal
We try change number 17,000 for the ending. Everyone agrees that the transition from the child crouching down to the beginning of "The Requiem" was never quite right. We work on it together—people putting their two cents in. It seems that the child should start the singing crouched over the way that kids sing to themselves. Then she gradually gets up and starts walking. I try it and it gives me the feeling of memory—as if the singing were a metaphor for memory. It feels nice to work with the group conceptually again, not just on reproducing a form.

April 20, chorus rehearsal
Strange to be doing *Quarry* during this crisis about Reagan visiting concentration camps and Nazi cemeteries. Realizing that *Quarry* is still very contemporary. Fascism as a form can happen anywhere—Africa, the East, America, Australia, South America—and under any name.

I see how much I used layering as a compositional method. The piece is really put together like a piece of music. Themes and variations, recapitulations, phrasing, etc., etc. We work on "The Requiem." Everyone remembers it a different way. Josh [Sippen] says: "I know it ended in one big oval." Chris [Gaul] says: "I remember everyone clapping in rhythm at the end." I check the tape and can't find either of these ideas. Perhaps that was the feeling of it for everyone—that it came to some kind of unity—even if it wasn't the configuration.

April 21, rehearsal with Coco, Rob
The dance of the little girl and maid round and round the bed. My body hardly remembers the movement. Where is this muscle memory that everyone talks about? It feels like muscle amnesia. I get very winded very quickly. I haven't been concentrating on aerobics in the last few years but more on alignment and movement close to the bone. It looks like I'll have to run twenty-four hours a day for the next two

weeks to get back my endurance. Coco and I realize that if we just get back the situation then the movement will follow. I'm asking myself, Can this old carcass do it?

Coco calls me up the next day and leaves a message on my tape: "Meredith, I CAN'T MOVE, I CAN'T EVEN GET TO MY ANATOMY BOOK!" The day after that she feels fine.

April 22, rehearsal with Nick, Rob
We're working with basic movement principles to give Nick a vocabulary for his character. Changes of weight; suspend and fall; rocking in a circle. We make up exercises to illustrate the principle. I've asked him to write a few sentences of what the dictator would be saying if the movement talked so that he has internal images for the movements and gestures. For his abstracted vocal "harangue" I ask him to do the same thing so that he is very clear about what he is saying even though the audience will not hear any words but more a vocal language that hopefully will include many dictators or essential dictator-ness within it.

April 23, rehearsal with chorus and group
The more I work on this, the more I realize that first comes memory; then you see if you can actually do what you remember in a very rigorous and accurate way; then, you have to let it go and let any new insights, material, ideas come into it. It's like starting all over again.

Meredith Monk: Invocation / Evocation

A Dialogue with Liza Bear

April 20, 1976, at 228 West Broadway, New York.

LB: Okay, it's on.

MM: You mean, why did I end up doing an opera right now?

LB: An opera is a form that hasn't been used very much recently in the art/performing context. . . . And even before *Quarry*, you used it as a form for several works which you can specify better than I can.

MM: Well, ever since I really started working in New York, in 1964, I've wanted to find a form that would integrate a lot of elements. Actually, there are personal reasons for that.

LB: What?

MM: I guess I have multi-interests or multitalents or something. Even as a child I was doing music, I was doing acting, I was doing dance . . . I was interested in theater.

LB: What was your training, exactly?

MM: My mother's family are all musicians, so I have perfect pitch,[1] natural rhythmic ability. . . .

LB: Classical musicians?

Originally published in *Avalanche,* no. 13 (Summer 1976); slightly abridged.

MM: My great-grandfather on my mother's side was a cantor in Moscow, my mother's father was a classical bass baritone who sang in the czarist court in Russia. And a violinist. He had a music conservatory in New York, in Harlem. My mother's mother was a concert pianist and they met here: she was his accompanist. My mother was a classical singer but she also sang on the radio, did commercial work. So music was very strong in my family, and I was singing very early. . . .

LB: How early?

MM: I think at eight or nine months; I was singing before I was talking. . . . I would sing back melodies, I had a fast ear. I was reading music before I was reading words, and that language is very primary for me.

LB: Uhhuh.

MM: But I wasn't terribly physically coordinated, so my mother sent me to Dalcroze Eurhythmics. I studied with Lola Rohm. Dalcroze was a very interesting man; he did movement choruses, linking music and dance: three beats with the feet, four with the hands, that kind of thing. Nancy Topf was in my class.

LB: Really!

MM: When we were three. Lola was extraordinary with children. Then I moved out of New York and studied with a woman named Ernestine Stodelle, who taught Humphrey–Weidman technique. And at ten I studied ballet.

LB: Did you have a particular take on classical opera?

MM: No. . . . In 1964–66 I was thinking more about Chinese opera and Kathakali, Kabuki theater, and trying to get back to a sensory integration that we don't have in the West. A sense of theater as a ritual or a celebration, of wonder—a triangle that included drama, music, and dance. In 1966, when I did *16 Millimeter Earrings,* I wanted to integrate those elements into one form, not a mixed media kind of approach, but one in which the elements would rhyme visually.

LB: Visual rhyme? What does that mean?

MM: In a sense it's almost a montage concept, developing visual motifs, orchestrating them. What I'm happy about in *Quarry* is that the form is not linear; it's more a circular, layered form. At Sarah Lawrence I was singing in opera workshops. . . . My first opera was *Vessel,* in 1971. That was an opera epic, in a literal and figurative sense, because it was done in three different environments. The audience moved from place to place in a bus. The first section was in my house on Great Jones Street, then they got the bus to the Performing Garage, then walked down Wooster Street to the parking lot. In 1969, I did *Juice* at the Guggenheim—the first theatrical event on the ramps—which I called a theater cantata, because it was built on a chorus of eighty-five voices; they did movement and singing. It didn't have enough of a sense of narrative to be an opera; it was more abstract. The reason why I call it opera now is because the base of the work is the voice.

LB: The base of your work?

MM: Yeah.

LB: Is that the part you get the most out of?

MM: I think it's where everything starts for me. I usually have the music written before I start working on the images.

LB: Was that hard to achieve, what you're able to do with your voice now?

MM: I work on my voice every day. I did have some classical (voice) training in high school, but I resisted it. At nineteen and twenty I was trying to dance and sing at the same time, but I wasn't strong enough physically. My voice hadn't really matured; it was a true, clear voice, but it was still weak. Two years after I came to New York, I started singing again, doing exercises.

LB: Who with?

MM: Just by myself, I'd be doing movement, and then I'd sit down at the piano afterwards, and make up crazy voice exercises, trills, slides,

glottal breaks, to produce vocal sounds that I liked. I had done the movement first so my body was really warmed up and I was really connected to my gut. I had this flash, a complete revelation, that the voice could be as flexible as the body. It could be like a spine or a foot and have that kind of motion and impulse. That was a complete breakthrough for me, and I started working on the voice from that point on.

LB: What's the origin of the songs in *Quarry?*

MM: Some of the stuff has been developed straight from breathing exercises.[2] Last July I spent two weeks in New Mexico, sitting on top of a hill and singing. I found a spot that I really liked, went there every day with my tape recorder, and just sat there until I was ready to sing. . . . I felt very shy about singing in nature.

LB: Was that the first time you'd done this?

MM: I'd done performances outdoors before, but this was different. . . . What happened was that a lot of the ambient sound affected what I was doing with my voice—although I didn't realize it until I listened to the tape a month later, just before a concert at Goddard with Steve Paxton. I sang two of them for the first time with Steve and then both of them were also used in *Quarry* after "I Don't Feel Well."

LB: When did you start playing the organ?

MM: 1969, 1970, right after *Juice.* A friend of mine in the piece gave it to me. I played piano my whole life . . . but the sound texture of the organ is more even, closer to the voice, and you can sustain notes. . . . Anyway, right at the time when I was sitting at the piano, making this discovery—I was twenty-three, twenty-four—my voice was really maturing, my apparatus was getting very strong. I felt what I could do with the voice had a close connection to dancing, and also I saw it as an independent physical instrument.

LB: Well, it's emotive too.

MM: I thought a lot about singing as invocation and evocation at that time. 1964, 1966, those were very important, formative years for me.

LB: In what way? About how you wanted your work to be?

MM: Things were a lot different then. I wanted it to deal with the whole human being.

LB: Did you work with any of the Judson people?

MM: I performed in one very big group piece by Elaine Summers, and I performed in Happenings by Al Hansen, Dick Higgins, Carolee Schneemann and a dance work by Jackson McLow. The person I was closest to in those days was Judith Dunn. I took her classes and she was very kind to me. When I was in college I'd come to New York once in a while and be shocked at the Judson performances. . . . In the early 1960s there was a modern dance tradition to deal with. Even going from ballet to modern dance was a big shock for me. I was shocked but also stimulated by Judson; it was hard not to be. I admired what I saw but when I started doing my own work, I wanted it to be more emotionally inclusive in my terms, and I didn't want to deny the magic of theater.

LB: The theatrical conventions that you use are . . . well, how would you describe them exactly? You do use acting or miming conventions. Do you really think they're derived from Japanese theater?

MM: No, because I've never really seen it. It's more something in my imagination, what Japanese theater might be like. What I meant by going against that other sensibility was somehow acknowledging my own temperament as being more mystical and more romantic, in a sense.

LB: More romantic?

MM: Yeah. Romantic in the sense of getting back to childhood vision.

LB: Fantasy-oriented.

MM: And primitive.

LB: That other attitude has a strong reality base, wanting to incorporate things as they really are into the work, people's natural movement. You never felt drawn to that?

MM: No. I understood that positivistic approach. When I saw *The Mind Is a Muscle* in its completed form in 1968, I had such admiration for the work. I remember thinking how Yvonne had been able to get magic out of the ordinary. But my reading and thinking at that time were working toward transcending reality. . . .

. . . **LB:** Was your work seen as reactionary at the time?

MM: No.

LB: It wasn't?

MM: I don't think so.

LB: Since you were going counter to the prevailing tendency.

MM: I don't think it was reactionary because I don't think anyone had used a form like that. A nonlinear dramatic mosaic that incorporated film, dance, music, and image. The people who were closest to it formally were Whitman and Morris's theater pieces. They'd worked with image as a primary element, rather than movement. Coming from a dance background, that was a breakthrough for me. I felt images had a greater crispness, and I wasn't interested in movement for its own sake at the time.

LB: But you said music was your earliest discipline.

MM: Yes, but I let that go. My musical training was more sporadic.

LB: When you first came out in public in 1964 it was as a choreographer?

MM: Yeah. With a solo called *Break*. The structure was like a piece of broken glass. When I finally got back to music, it was like coming home, in a sense. But I'd wanted to turn my back on it.

LB: Because it was part of your past?

MM: Yeah.
Pause.

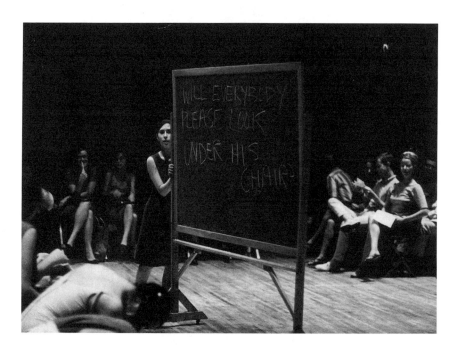

Meredith Monk in *Blackboard*. Photograph by Peter Moore (1965).

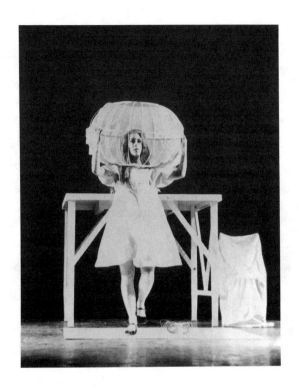

Meredith Monk in *16 Millimeter Earrings*. Photograph by Charlotte Victoria (1966).

Coop at Loeb Center, New York University (1968).

Meredith Monk and Phoebe Neville in *Portable*. Photograph by
Charlotte Victoria (1966).

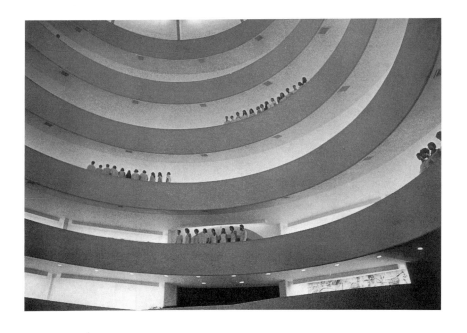

Juice, First Installment. Choirs along the ramps of the Guggen-
heim Museum. Photograph by Vladimir Sladon (1969).

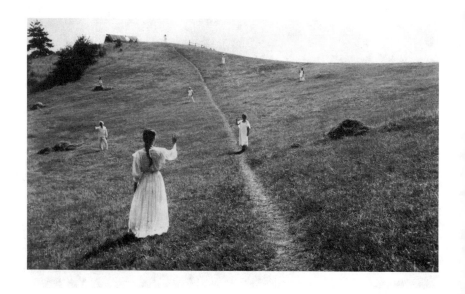

Mountain, filmed at Goddard College, Vermont. Photograph by
Monica Moseley (1971).

Vessel, Part Three, *Existent Lot*. Armies with rakes; pioneers in right foreground. Photograph by Peter Moore (1971).

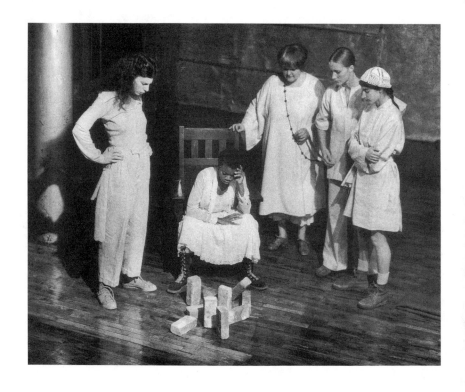

The Companions, *Education of the Girlchild,* Part 1. *From left:*
Lanny Harrison, Blondell Cummings, Lee Nagrin, Sybille Hayn
(added to the cast for the 1974 season only), Monica Moseley.
(Meredith Monk and Coco Pekelis are out of the frame.) Photo-
graph by Philip Hipwell (1974).

Meredith Monk and Isadora. Photograph by Ping Chong (1972).

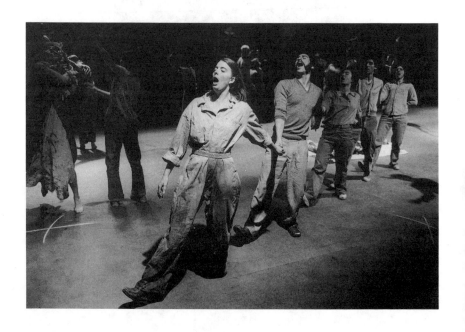

Rally from *Quarry. Foreground from left:* Susan Kampe, Avi Davis,
Gail Simon, Eli Pollack, Ellen Fisher. Photograph by Nathaniel
Tileston (1976).

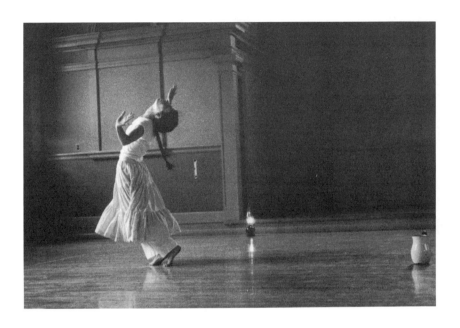

Meredith Monk in *Plateau #2,* the Naropa Institute, Boulder, Colorado. Photograph by Betsy Cole (1976).

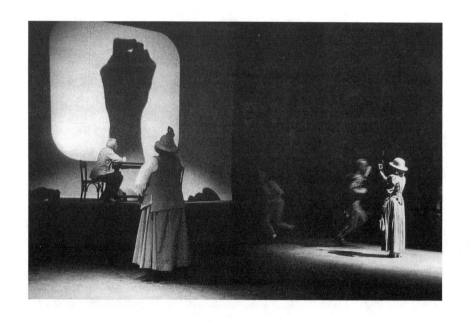

Recent Ruins in Milan. *From left:* Pablo Vela, Lee Nagrin, Robert
Een, Ellen Fisher. Photograph by Pietro Privitera (1980).

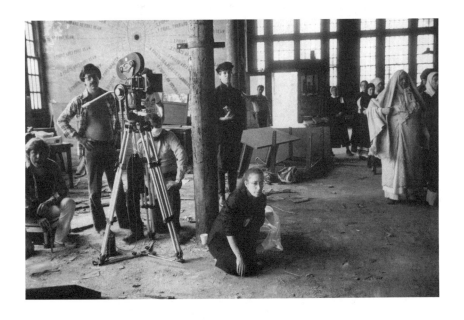

Filming *Ellis Island* (1981). *From left:* John Bollinger, associate pro-
ducer; Bob Rosen, producer and co-director; Jerry Panzer, camera;
John Sennhauser, cast member; Meredith Monk; *right foreground:*
cast members Lee Nagrin and Jolie Kelter.

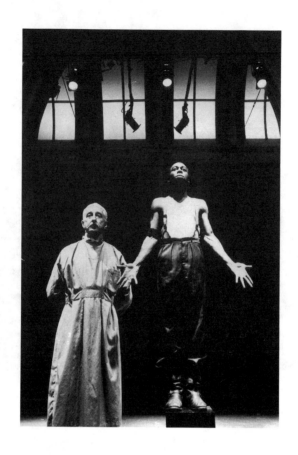

Pablo Vela and Christobal Carambo in *Specimen Days*. Photograph
by Lois Greenfield (1981).

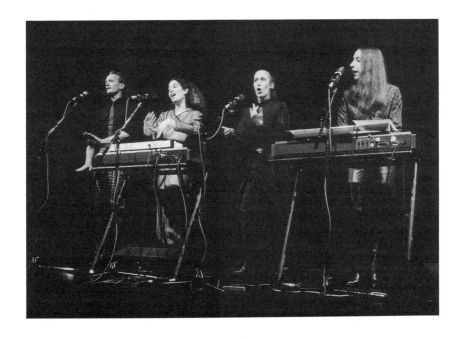

The Vocal Ensemble performing in Frankfurt. *From left:* Robert Een, Andrea Goodman, Meredith Monk, Nurit Tilles. Photograph by Andreas Pohlmann (1986).

Ping Chong and Meredith Monk in *Paris*. Photograph by Doug
Winter (1973).

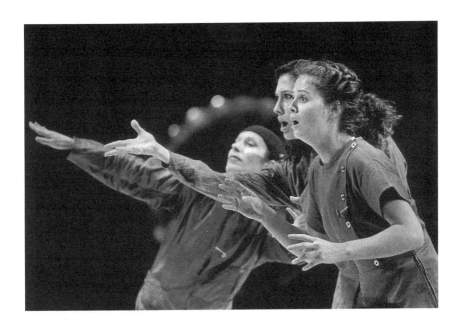

Meredith Monk, Heike Falkenberg, and Margaret Gibson in *The Games*. Photograph by Beatriz Schiller (1984).

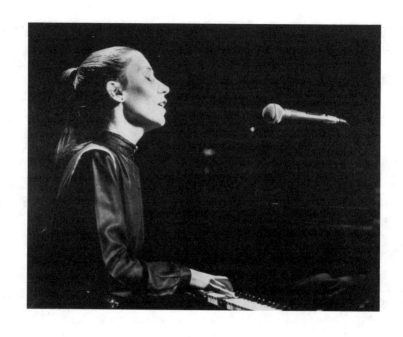

Meredith Monk at the keyboard. Photograph by Johan Elbers
(1981).

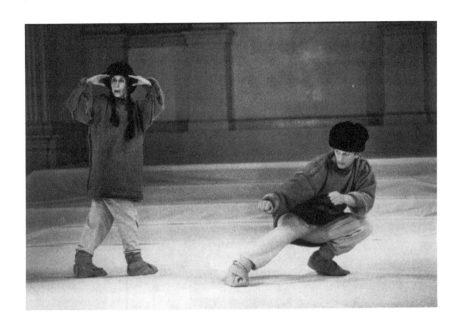

Meredith Monk and Robert Een in *Facing North*. Photograph by
Joyce George (1991).

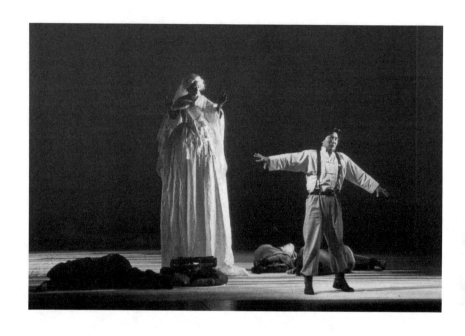

"Hungry Ghost" scene from *Atlas* (Janice Brenner, atop Wilbur Pauley, and Shizheng Chen). Photograph by Jim Caldwell (1991).

Meredith Monk in *Volcano Songs*. Photograph by Dona Ann McAdams (1994).

Meredith Monk at the beginning of *Education of the Girlchild*, Part 2. Photograph by Beatriz Schiller (1993).

Meredith Monk at the end of *Education of the Girlchild,* Part 2. Photograph by Vladimir Sladon (1974).

LB: What do you feel has happened to your work in the last ten years? Has *Quarry* brought some things together, or . . .

MM: I'm happy with its structure and its conciseness. *Vessel* was an incredibly large-scale piece but there were some things in it that could have been eliminated.

LB: What about *Education of the Girlchild?*

MM: The strength of that was more as portraiture than landscape. I do, I see my work in those terms.

LB: Oh, in painting terms. So for this, did you start with an image of a quarry?

MM: Actually, in this work the landscape and the human beings are pretty integrated. In *Vessel,* I thought more of an overall gestalt. The scenic element, the mountain, came first, and I made the people fit into that, into this gigantic tapestry. Whereas in *Girlchild* I started with the people, and the overall structure was giving me a lot of trouble. It was very linear and clunky, one section at a time, sharp breaks between them. The solo was different, that was a one-image idea.

LB: What was it?

MM: I started with the image of an old woman. It goes backwards in time. The image I had was of a road or river in white muslin, and that was also its limitation. But the group part of it was a tribe of women, which I'd been thinking about before I did the solo.

LB: Were they women you knew well?

MM: They were from The House, Lanny Harrison, Monica Moseley, Coco Pekelis, Lee Nagrin, Blondell Cummings, and I'd worked with them for a long time.

LB: Was the character of *Girlchild* closer to how you see yourself?

MM: No. At the time I didn't see it as autobiographical at all. I was just one of the six women. In *Vessel,* the scale was so gigantic that the

people seemed very small. In *Quarry*, what I was trying for . . . and I think it happened . . . was both.

LB: Both what?

MM: Both landscape and portraiture.

LB: I thought the conception of *Quarry* was more ambitious, that it grew out of being in Europe and having a war consciousness.

MM: It did. I was just talking about the visual structure, not about the content yet, about a way of working on the canvas.

LB: Oh, on the stage.

MM: *Vessel* had a theme too, a medieval Joan of Arc thread running throughout, but in a way that was easier to work on, because we don't know that period well, and I could identify very strongly with Joan of Arc as an archetype. I saw her also as the artist. I saw that woman seer, someone who received information and acted on it, as being like the artist's role too. That's why I called the work *Vessel.*

LB: Your role in *Quarry* is an interesting one for someone who conceived and directed the whole work, choreographed it, designed it, wrote the music. Then you put yourself in the middle of it as a sick child, someone who's pretty helpless.

MM: I wasn't too happy with the fact that I ended up playing that role.

LB: Oh? . . . I liked the way *Quarry* started, with a sense of unease or discomfort, vague irritation, and the vocal songs afterwards.

MM: Well, the casting for *Quarry* was giving me a lot of trouble. There were ten or twelve main characters and then a chorus of thirty people. When I was in Europe two years ago, I remember saying to Ping, there's got to be a child in this piece, then while I was sitting in a bus a few months later I thought of the singer in the booth, and I had the dictator. Those were the initial three roles.

LB: What did the dictator represent?

MM: It was an obvious World War II stereotype.

LB: Doesn't it have anything to do with the relation of a choreographer to a cast?

MM: Well, that's why I want to mention the casting. I definitely did not think I was going to play the child. I thought there'd be a real child, and that I would play the dictator. While I was working on *Quarry,* I also worked on a shorter piece, *Anthology and Small Scroll,* to distract myself, but my heart wasn't in it. I was afraid to start *Quarry.*

LB: Why?

MM: Oh, on a content level, bringing up those memories of World War II. But while rehearsing *Small Scroll* I got different people to try out dictator characters, to find out what kind of human being ends up in that position.

LB: Well, everyone has those elements in them, if they want to get anything done. So why didn't you play the dictator, finally? It might have had comic potential.

MM: Yeah, very much. But it didn't feel right for me.

LB: You didn't feel comfortable in the role?

MM: Yes, but I felt it would balance the piece incorrectly. The thing about *Quarry* which in one way is incredible, but in another way is *difficult,* is that all the elements are balanced. There wasn't anyone else who could have played that child. I auditioned four people for the role, and a real child. Vocally no one else could do it.

LB: Maybe the dictator image is another kind of performing persona you wanted to get into. After all, if you've been running a company for several years and getting people to do what you want, you must have a certain amount of power.

MM: Yes, but I didn't *have* to. The whole vision was there. Why did I have to play the dictator if it's implied in the piece, in a sense?

LB: It would have made it too loaded.

MM: In *Girlchild*, at the youngest I was playing an eighteen-year-old. In *Quarry* I think of myself as eight. For me it wasn't that great a challenge, but if I really want to challenge myself as a performer I'll do a solo. The real challenge in *Quarry* was the overall structure. My performance wasn't the primary focus. I could also have played the singer, I could have played all three roles. That's the kind of crazy situation you get into being a director and a performer.

LB: Was that a source of tension?

MM: There were maybe a few performances out of the sixteen that I couldn't enjoy because I was lying in bed, worrying about cues and lights and other people's performances.

LB: I thought maybe one source for that role was so that, after doing all the work, you could rest during the performance . . . say what you felt, and also express a certain malaise that is fairly widespread.

MM: In a sense, that's what I was doing. As a child . . .

LB: A malaise about what artists are doing, and who they're doing it for. It's being discussed a lot. . . . Performing for a wider public at La Mama, rather than for a tight art audience, that might be . . .

MM: I know exactly what you mean. I thought of the child in *Quarry* more as a microcosm for the disease of the world: the sick child; you don't know whether she's very ill, or diseased, or slightly uncomfortable, or pocked. The sets in the four corners of the space dealt with human beings in their intimacies and their innocence. Then there's the malaise of the world, so you get an interplay between those two worlds within the same space. As for La Mama, I chose to perform there because the space was physically suitable. I wanted the audience on two sides, that rectangular meeting hall kind of look. As far as having a wider audience, I'm not sure how I feel about it. I don't feel I want to be limited to this one social structure, but on the other hand . . .

LB: Well, have you ever been?

MM: I don't know what my audience is, to tell you the truth. Maybe there are some people who go because it's the thing you're supposed to do, and really don't have any business being there.

LB: Where have most of your works taken place?

MM: I've always worked within concrete architectural spaces and stayed off the stage. The other thing that disturbed me was the price of tickets.

LB: Was that set by La Mama?

MM: Yeah, but I understand it from their point of view, in terms of what it costs to maintain a place like that.

LB: How long did you work on *Quarry*?

MM: I first thought of it two and a half years ago. Last May I started working on material with the company and Ping shot a solo videotape of me playing the dictator, the singer, and the child. That was the first time I used video as a sketchpad, which was very interesting. And last spring I'd written the round for the Requiem, which was a big breakthrough. It's an eight-part round that is like an auditory mandala. It's completely symmetrical. But when I start working on a piece, I have elements all over the place . . . I had this round, this idea of the war . . . and I can't see how to fit them together. When I'm in a good state I accept everything that comes up at that time; when I'm in a bad state I start editing right away before I've even finished gathering the material. I'd done a lot of research . . .

LB: Which was unusual.

MM: Which I'd never done before. So in a sense I was starting from reality. And that was what I was most scared about in this piece. I wrote a note to myself: "I always work from imagination, and I don't know how to imagine from this kind of material." So that was a challenge. I read *The Rise and Fall of the Third Reich* from cover to cover and looked at a lot of photographs in the war museum in the Marais area of Paris and talked to a man who'd come back from Buchenwald—Henri Michel. It was a discipline, to force myself to overcome my squeamishness.

. . . If I was going to do that kind of work, I had to confront those photographs straight on. And I was really in a great deal of sorrow; it was very emotional. What can I say? It's a level of sorrow that's beyond any one person . . . there's almost no words for it. [It's not that different from seeing pictures of Vietnam except that I am Jewish and I know my family would probably have been taken away.]

LB: Didn't you feel one of the dangers might be to fall into war clichés, or sentimentality?

MM: Yes, I didn't know whether it could be done for a number of reasons. First of all, this war is within the iconography or the memory of people that are still alive, so you can't make a myth of it that easily the way you can with Joan of Arc. So we didn't know whether we could get any mileage out of it. On that level it was very hard to deal with, to look at it in a new way. And to have it make some kind of sense in contemporary terms.

LB: How did you look at war in a new way?

MM: By making a theatrical piece out of it that was not a documentary or a play, and also by conveying a sense of distance from it. Which was the way I had to do it to make there be any kind of truth, because we did not experience it firsthand.

LB: You had some older people in it.

MM: Yes, Lee. She was about eleven when she saw newspaper photographs of the atrocities. But, still, she's in America.

LB: What about the old man?

MM: Paul Vela. He's Chicano and was in college at that time; he remembers kids being drafted. But it's not like living in a country that's been ravaged.

LB: How did you pull the structure together?

MM: I wanted *Quarry* to answer some questions that still haven't been answered—I guess the question of theatrical content.

LB: Theatrical content.

MM: Yeah. There's a part of me that feels it's much better to get up and do my singing and dancing and that's that. It's more direct. I know how to do it. Nobody says, "What does this mean, I don't understand this, what am I implying," all this underlying jungle of . . . that's still a conflict, pure form and content. I probably think that for me there's room for both, and I tend to do both, and to alternate.

LB: So in *Quarry* you felt you set yourself a tough structural challenge?

MM: Well, I guess why I do a thing like this is to challenge myself. The solo work isn't that challenging structurally, one song after another, one dance after another; it's very clear.

LB: Don't you think with solo work you're forced to go deeper into yourself—to deal with your sense of yourself and how that conflicts with what you put out, because except at high peaks of performance, there might be a discrepancy. . . . Maybe that's an early stage.

MM: I like to do things where *I'm* surprised. . . . I like to work alone, take myself for better for worse. But the solos are more like concerts, and I've done them since 1969.

LB: Were you happy with the theatrical content of *Quarry?*

MM: Yeah, I felt good about that. I feel I was in touch with something that's in the social consciousness right now, or will be soon, and that's important to me.

LB: How tightly did you direct the performers?

MM: Well, most of the characters in *Quarry* are people I've been working with for eight or nine years. The characters in the piece evolved from the people themselves—a combination of the way I see them, and the way they see themselves. Lanny is a character actress and I'd had her in mind as the singer in the booth for a long while, but ultimately she figured out her part for herself. She's a real Laurence Olivier kind of character—get the costume and you have the character.

Actually, she and Steve Clorfeine got all the costumes together from thrift stores and the Salvation Army.

LB: What about the dialogue?

MM: I didn't script each word. I set the overall timing, but for instance last night Ping did a very long solo. I work with Ping most how I work with myself in my vocal work. He really did it differently every night. At the piano I'll notate songs, anything that's more melodic, but some of the more textural things for the voice, I'll have the overall shape of it, the phrasing, but I couldn't write it down note for note: that's the way Ping's vocal solo was. And the movement also we'd worked on, but he changed it. He knew he had the room to change it, and he knew that I was going to be in the dressing room and I wouldn't see him anyway. But I like that very much. There's your improvisation, a possibility for performers to grow and change within the overall structure, which is what satisfied me in terms of building something and which I can't do through straight improvisation. . . .

. . . **LB:** What about the biblical couple?

MM: That was a bit of a red herring, on purpose. It did a time warp, which is what I wanted to do, put an edge on it.

LB: It wasn't a reference to Jews, specifically?

MM: Well, during the rally they turned into middle European Jews, into Chasids. But ultimately in this piece I used Jew as a metaphor. I was trying to get the four corners of the world, in a sense, of different people existing simultaneously before a catastrophe of that size hit. For a while we worked on the material simultaneously, so that nothing had any more importance than anything else, and at a certain point, about a month and a half before we did the piece, we started a point-by-point rehearsal. Then everyone had their fingers in the material, and as a working process it makes it much more exciting.

The decision about the chorus was an interesting one. I work with a company of people who have very particular talents and wonderful personalities on stage and have incredible spirit. But for this work, I also wanted to work with people who could really sing. I was being

held back in terms of what I could do vocally, and even in terms of movement, on some level. So I finally got the nerve to audition for this chorus. I auditioned 175 people for the best singers and dancers I could get. And I want to continue working with them. It gives me resources that I need for my own growth.

Notes

1. In 1996, Monk cannot understand why she said this; she has good relative pitch.
2. By this, Monk meant breathing exercises she herself devised.

Guy Scarpetta

Meredith Monk

Voyage to the Limits of the Voice

Easter 1978. Meredith Monk receives me in her loft on West Broadway, in the depths of Soho. A time of auditions and rehearsals. Various odd people file through, a bit freaky, looking as if they've come from another planet. I think she has also invented the "soft punk" look: a fusion of the homely, the mild, the monstrous, and the seductive. This thought comes to me at the sight of her slightly cross-eyed, with her hair in African braids, a Borsalino on her head, overalls, Chinese slippers embroidered with dragons: superb.

We begin by talking about dance in America, the continent of Cunningham and all that followed from him: Viola Farber on one hand, on the other, the members of Judson Dance Theater—Trisha Brown, Lucinda Childs, Steve Paxton, Yvonne Rainer. Judson: the Happenings of the Bobs Morris and Rauschenberg, the aesthetic of Cage, the discussions on Gertrude Stein, the fantastic interchange of experience among painters, dancers, musicians. When I ask where she places herself in connection with all this, she says, laughing, "Somewhere else. . . . For me, theater is, first of all, something magical."

The importance to her of folklore, of "simple forms." At the age of eighteen, she was a member of a company that performed Jewish folkloric dance. I think of Kafka's intense passion for Lowy, for Yiddish theater. . . . Would Kafka have liked Meredith Monk? "My first piece," she says, "combined fragments of folk dance with abstract movements." With her, one senses a sort of spontaneous, immediate cosmopolitanism. . . .

In *Quarry,* her recent opera, she touched on anti-Semitism, that

Originally published in *Art Press International* 32 (October 1979); translated by Deborah Jowitt.

nexus of the modern tragedy. The last World War, the exodus, the Holocaust, the grotesque whirlwind of bloody-minded dictators—these were seen through the eyes of a sick, feverish little girl. Probably never has the *regressive* dimension of fascism been so precisely illuminated as in her bas-relief of living flesh. For *Quarry,* she composed a Nazi "march," hallucinatory, guttural, animal. A "mother" of the 1940s—vulgar, all dressed up—speaks and sings over the radio. During the performance, a photographer snaps pictures of people who fall dead at the click.

Before this, in 1968, came the creation of her troupe, The House. The actors came from just about everywhere: Ping Chong from painting, Lanny Harrison from mime and movies, Blondell Cummings from dance. What Monk demands of her actors, she explains, is not only technique: she needs presence, singularity. She was seduced by Lee Nagrin's monumentality, by Lanny Harrison's Rita Hayworth looks.* With a respect that is rare, she speaks of her actors as engineering the performance. She's capable of making enormous demands on them, and at the same time she encourages them to leave her as soon as she senses that they perceive her as a barrier to their creative expansion.

We speak of the performance she put on at the Guggenheim in 1969, in which the actors were arranged in living tableaux along the spiral ramps of the museum, the spectators being invited to travel from one group to another. She had created, she tells me, thrilled, a giantess two meters high. These spectacles—*Juice, Vessel*—were performed in several locations and the public moved from one space to another. In her mind, theater is born from a dialogue with space, from a game between continuity and fragmentation. *Quarry* was more "homogeneous"—that is to say, the ruptures were more internal, playing at first with the conflict between the assembled codes (from cinema to dance, from song to visual tableaux). "The right space for the right piece," she says, to summing up her agenda. She acknowledges herself little satisfied with the Bouffes du Nord in Paris, where she presented one of the versions of *Girlchild* four years ago. *Girlchild* should have emerged from blackness, with the lighting coming from the depths. . . .

*In 1996, Monk regrets that her more complex thoughts on Nagrin and Harrison did not appear in the article. It is not just Nagrin's size and weight that interest Monk, but her strength, her intensity, her buoyancy. Harrison's "Rita Hayworth" aspect is not an accident of birth; it's part of her disciplined gift for transformation and transcendence.

At this moment, she's preparing a theatrical work from already created instrumental and vocal pieces: *Tablet, Plateau, Songs from the Hill*. It's a matter of passing from music to dance, from dance to theater. The subject? "The creation of the world," she says, smiling. At the same time, she's developing another piece, inspired by *Trilby*, a novel by George du Maurier. It's a tale of hypnotism, with an anti-Semitic underpinning that she would like to treat ironically; there's a character who dies from not knowing how to sing. . . . The piece may also, she tells me, have to do with the American Civil War. *Tablet's* point of departure is the music. *Trilby*, on the other hand, comes from images, patterns, spaces. As if she were testing a need to approach theater from both ends simultaneously.

She brings up, too, the film that she created as part of *Quarry*, admitting herself to be more and more haunted by the music. She assures me that she would like to "change" it without knowing exactly how with the air of someone who knows very well.

I find her at the end of December in a recording studio on Broadway, where she is finishing the record she made of *Songs from the Hill* and *Tablet*. A very surprising atmosphere, where the most elaborate technological sophistication seems in thrall to voices coming from another time, another universe. Gigantic speakers, consoles with hundreds of switches and buttons. The whole night is spent there; she puts two hours into correcting a defective tenth of a second. By morning, the technicians are harassed. Monk's voice never ceases resonating—amplified, fragmented, the same sequence repeated a hundred times. We are beyond fatigue; it will never be finished. Until the end, she maintains, with the help of coffee, an incredibly awake ear.

You'll see her in February, in Nanterre, where she'll show two recent short pieces. Meanwhile, she's coming to present some of the songs from *Tablet* (alone and with two women singers) in the series of performances that go on all autumn at the Sorbonne Chapel. Not to miss for any reason: music coiling on itself, waves of voices, repetition in movement, swells, vertigos; her voice can split in two, multiply itself, become oriental, nasal, guttural, ventral, explore all registers at once. Plunge to the heart of regression, of babble, of animal rumbling, and suddenly rise into the most miraculous, heavenly, vibrating intensity. This is like nothing else. It's completely mad. It touches what is hidden deepest within you; it possesses you, engulfs you, without the least atom of hysteria. Perhaps the most astonishing voice in the world.

Kenneth Bernard

Some Observations on Meredith Monk's

Recent Ruins

1.

Meredith Monk's work aspires to and achieves the solidity of monuments, or memorializations. The titles of her work frequently suggest this—for example, *Vessel: An Opera Epic, Quarry, Songs from the Hill / Tablet, Recent Ruins* (already implicit in *Quarry*). Even *Education of the Girlchild* reflects the monumental and enduring rather than the small and particularized. Her choice of spaces in which to perform also frequently reflects this quality: the Guggenheim Museum (with its concrete, its primal curves and spiral), which like all museums is already a memorialization; St. John the Divine Cathedral and Judson Memorial Church, another kind of memorialization; the large rectangular hall of the La Mama Annex; the Smithsonian Institute; the Ellis Island buildings, which were gateway for a monumental migration and to a monumental "dream." The rubric under which Monk lives and creates is called, simply, "The House." There lies in all of this a profound reaching for something monolithic and unshakeable, a bedrock to withstand, in particular, the ravages of time, and in general, perhaps something less manifest, less dramatized—finitude, mortality, evanescence.

2.

Recent Ruins is built around the idea of archaeology, excavation. However, although the title specifies "recent," the work is also about past, present, and future ruins. Archaeologists, in excavating recent ruins, are themselves in the process of becoming present and

Originally published in *Yale Drama Review,* Winter 1980.

future ruins for future excavators. The process of archaeological excavation reaches backwards and forwards at the same time. Hence the drawings on the screen in Section 2 of quite contemporary artifacts (e.g., a vacuum cleaner part) while two archaeologists dust the shards of an older civilization, others pace and mark off digging sites, and still others "browse" among the ruins—all to the music of Viennese waltz, another memorialization and perhaps also ruin. There is a vision in this antiphonal direction that might be frightful to some (i.e., life as a preparation for ruin) but which Monk, I think, perceives as comforting (i.e., life as a continuity; to be "excavated" is to be absorbed into). True, there is some irony in the ignorance of Monk's archaeologists to their status as "fossils"-to-be as they dig "fossils"-that-were, but the portrayal is gentle and humorous, not malicious or bitter. What matters is the monumental continuity of it all, a sacred process of which we are a part and which it is essential that we experience. In such a spectrum, life and death are minor concerns.

This continuity operates on several levels, each one folding within the next. The section filmed on Ellis Island, which immediately follows the drawings, is about the "recent" immigrations to America, the absorption of Europe and its past into America. "Archaeologically" we have "excavations" (the archaeologist's measuring standard is omnipresent on the screen) of past faces, clothing, environment, and (less directly) hopes, aspirations, and histories. Ellis Island itself, its large buildings now empty (but not without echoes), a relic of something gone, is a prime excavation, a token from which, as with the shards of ancient civilizations, we can reconstruct and absorb what was.

This in turn is enclosed within the larger continuity of contemporary excavators of the more distant past in the process of becoming material for future excavations. Reaching further than either of these is the incorporation of the primitive into the civilized. This is not to say that the civilized is superior; merely that civilization is further along in the process of excavation: civilization has "excavated" the primitive. It might, however, seem that Monk elevates the primitive over the civilized, particularly where she has the earth-mother figure pick up, then fling away contemptuously, the various measuring rods of the archaeological (modern-technological-scientific) enterprise; also, none of the archaeologists has anywhere near the force and dignity of this figure. This, if so, would be an unfortunate (and easy) sentimentality. I think, however, she has something larger in view, akin, let us say, to Ahab's destruction of the quadrant in his search for

the white whale or Ike McCaslin's abandonment of the watch, the compass, and the gun in his desire for epiphanic confrontation with the bear in Faulkner's eponymous story—namely, that what is sought is, simply, beyond the measurement of material "things," specifically the instruments of scientific rationality. In *Recent Ruins,* the instruments of archaeology merely measure, ennumerate, catalogue, and sometimes reproduce or reconstruct, but they in no way capture the essential being of what they excavate nor do they in any way reveal and transmit the sacred continuity implicitly, nor the encompassing largeness of which the artifacts are a part. This explains the fun poked at them in the Ellis Island sequence; it is an unholy presumption to think, for example, that they could in any way "measure" the faces, the character, the being of the immigrants. "Excavation" is a far deeper process.

In *Monk*, this encompassing largeness goes beyond the civilized and the primitive, beyond even the human and the historical, to the animal and invertebrate past, and beyond that to undifferentiated time itself. Her inclusion in the final scene, amid the lightning flashes of a more primeval and cataclysmic time, of large insects and huge white tortoises, along with the archaeologists and the primitives, is testimony to this. The archaeologist barely scratches the surface of what is to be uncovered and recovered, but he is emblematic of an essential process by which we can achieve that calmness of spirit that comes from a total sense of unity and cohesion.

3.

All of this is in the service of a distinctly all-embracing religious sensibility. All of Monk's works that I have seen are sanctifications of the oneness and continuity of life (and beyond life). Each work is a monument whose intent is to slow down, immobilize, "excavate" a slice of the process (or the process itself), to let us look at it, feel it, and reverberate reverentially. Her major anxiety or fear is that it is all going by too fast, that we cannot slow it down enough to see it, to savor and know it; and hence her frequent threnodic mode. (Cf. Marcia Siegel's observation, *Watching the Dance Go By,* p. 245: "Both Monk and Robert Wilson lead semicommunal groups of people who live and work together, and their theater-pieces stress the continuum of lives in that kind of community. You are meant to be aware of growth, of their pasts and personalities that have contributed to the theater event.") Monk's choice of large white tortoises—so slow but

solid, reminiscent of the sea, rocks, age, the sun, silence, endurance, mystical infinitude—is therefore particularly apt for her, as is her monastic costuming. The participants of Section 3 are described simply as "People in Yellow."

Her music in particular serves this end. Just as the various "epochs" of man and life are enclosed one within another, so the music encloses all, giving the ritual the aspect of a monumental hymn. Although her essentially harmonic structures, both musical and dramatic, are interrupted by aharmonic primitive sounds and acts (e.g., animality, pain, hostility, fear, inchoate utterance), these sounds and acts are never beyond assimilation and our powers of relevant ascription (i.e., we can find them "meaningful") and are always absorbed and incorporated into a harmony, a final structural unity and cohesion. The sounds of the "creatures" under black veils in Section 3, for example, although gibberish, communicate vulnerability and a tremulous seeking for "light." The long vocal solo that makes up the second half of *Education of the Girlchild* is completely without conventional articulation, but in no way detracts from the ritualistic intensity and cohesion of the work. The earth-mother figure of *Recent Ruins* (now myth's "mother-queen" figure of the sacred wood), although destroyed by the young of her "tribe," rises phoenixlike to execute the climactic destruction of the measuring standards cited above, pointing the way to some entity larger than human intelligence (but not, it might as well be pointed out, any historic conception of God). This action is prelude to the concluding scene of transcendent amalgamation with the insects, tortoises, and entire cast.

4.

Odd as it might seem, Monk reminds one of Whitman with his love of the universe, all time, and all life—including disease, ugliness, brutality, and death—but without his programmatic vision of America resplendent at the apex of it all. (Interestingly, Monk's next work is titled *Specimen Days* and is to be performed at the Public Theater.) Monk's "love" is equally celebratory, but less physical, nondiscriminating, without end, and ultimately possibly even inorganic, a kind of music of the spheres; a good deal of her voice recitals, it seems to me, attempts to render, in addition to many *human* nuances, a sense of the nonhuman (e.g., wind, rocks, time, earth, etc.). The only evil is lack of recognition and lack of pious immersion based on that recognition. She is at the opposite end of the scale from an artist like

Beckett, who is reduced to the permutations of stasis in the face of the human dilemma. Yet one wonders whether both might not be propelled to their opposite extremities, each in its way frightening, by the same reality.

5.

Recent Ruins, utilizing the arresting metaphor of "archaeology" brilliantly, is a monolithic, suprahuman hymnal to time, absorption, oneness, and, above all, *flow.* Certainly difficult material, and a difficult concept to *stage,* but Monk has succeeded.

Marcia B. Siegel

Exhibit A and Possibly B

Meredith Monk's *Specimen Days* has been in the making for three years; maybe that's why the piece seems to have several unrelated themes. Monk's method of operations is fragmentary anyhow, and with elements of different scale, pitch, and character comfortably butted up against one another or laminated in sometimes baffling simultaneity, it doesn't much matter while you're watching that the ideas don't quite mesh.

Nothing less expansive than entire cities, wars, or historical eras seems to satisfy Monk's panoramic vision, and this time she turns her attention to the Civil War. As usual she views it with the microcosmic eye of a poet, the sweep of a high-soaring bird. Images so familiar they're almost clichés seem new again in the sketchy, childlike outline or theatricalized miniature of her staging.

One possible center of the work is two families, one Northern and one Southern, who live similar lives though each has its own customs—gestures so well-known they've become repetitive and barely functional. At dinner the Northerners spoon their soup toward the outside edge of the plate, make elaborate preparatory motions with knife and fork before attacking their food. The Southerners say grace with hands folded on the table and heads bowed, eat with many flourishes and gracious social asides. The children carefully copy everything their elders do, and later, when someone is dying, try to keep back their terror by reciting what they can remember from their lessons. Both families lose somebody in the war, but somehow both return intact to their dinner tables after it's over.

Originally published in *Soho News,* December 23, 1981–January 5, 1982, and included in Siegel's *The Tail of the Dragon: New Dance, 1976–1982.* Durham, N.C.:Duke University Press, 1991).

These are not any particular people, notable for their individual histories, but symbolic types—specimens, I suppose. And they are observed and recorded in various ways. There's a photographer (Gail Turner, dressed as a man) who comes and sets up a big box camera on a tripod, ordering his subjects to hold still for fifteen seconds while he makes a picture.

Monk herself plays the composer Louis Moreau Gottschalk, who lived in the South but was sympathetic to the Union side. Gottschalk made a great success touring as a concert pianist, and then wrote all the local color he'd seen, but almost none of the agony, into his light, danceable music. Monk, dressed in black trousers and a velvet frock coat, sits and ruminates at the piano, plays, writes a few notes, sings, but the music is her own chanting, rocking distillation of gut feelings—musical belly laughter, soothing murmurs, sobs. Once she dances a long, shuffling journey accompanied by abstracted gestures of piano playing, receiving the applause of an audience, greeting well-wishers—duties of a touring celebrity.

Then there's a technocratic type in a lab coat (Pablo Vela), who's sometimes a lecturer demonstrating the statistics and assets of the actors. "Number 1 and Number 3, step forward please. Incline from the waist. [Numbers 1 and 3 bow.] Thank you. You may retire." He brings on a black man (Cristobal Carambó), gets him to display his teeth, measures his head, reporting 16 centimeters ear to ear, 22.4 centimeters from crown to chin. Is he offering a slave on the auction block? Giving an anthropological paper? Suddenly Vela places his hands on Carambó's midsection, pauses dramatically, and pronounces, "Hunger." At the end of a long war scene, Vela coolly walks over the battlefield, spraying the havoc with disinfectant.

Vela seems to represent the sanitizing, alienating effect of science on history—but then Monk's Gottschalk illustrates that art can do the same thing, and so does the objective journalism of Turner's Matthew Brady. From time to time a screen is brought in, once so that Vela can show a series of slides made of picture postcards—Paris, France; Peking, China; Easton, Pennsylvania. What begins as a travelogue suddenly incorporates those pictures of the families that were taken earlier, and also pictures of battlefields and exhausted troops.

It's mostly through Monk's music that the passions and sorrows of real people keep breaking through their fixed, flat, tintype representations. From time to time the cast assembles to sing wailing, summoning, whimpering solos and choruses, sometimes from offstage,

sometimes ranged in neat rows. Feelings flame to the surface, then quickly burn out. Robert Een sits completely still for a long time, as if posing for the camera, then he slowly gets up and smashes the chair. Contrasting with the formality and stillness of these abstract characters is the montage of scenes showing the war itself. Turner and Vela, dressed like dime-store Abe Lincolns, stand on soapboxes and orate silently while the chorus chants from different parts of the room. Een and Carambó, dressed as soldiers, dart in and out, shooting, falling, carrying one another off, managing to represent both the Union and Confederate armies by changing from blue to gray caps when they're offstage. Meanwhile stage managers are setting up tiny tents all over the space. Then the Abe Lincolns and the soldiers are gone, and from the wings big black rubber balls are rolled across the space, knocking over the tents. The effect of a room full of broken toy tents in a pale light is devastating, not at all cool or scientific.

After the war, the deathbed scenes, and the reassembling of the families, Monk has interpolated her movement-singing piece *Turtle Dreams*, perhaps simply as a return to severe formality. There *has* been a turtle in *Specimen Days*, actually—the star of three short films by Robert Withers. This engaging reptile is first seen plodding through a swamp, then hovering over a map of the United States, and finally blundering down the streets and over the elevated tracks of a miniature city. I couldn't figure out any way this went with the Civil War, though I enjoyed the films.

The last turtle film interrupts Monk, Een, Paul Langland, and Andrea Goodman in the middle of their dance, but their singing goes on behind it in the dark, with musical cries of pain and confusion and mourning. When the turtle's journey has finally taken it to the moon, the screen is cleared away to reveal an unfolding tableau in which the quartet continues singing, now with small fluorescent lights hanging across their chests.

Vela and Turner, now in modern dress, stand on soapboxes and exhort, sometimes clutching their sides as if they've been wounded, but continuing their silent orations. Four women in hoop skirts revolve at the periphery of the space. The other characters walk backwards, slowly, across the rear of the space.

At this point there are about three different sounds—the *Turtle Dreams* quartet singing, the chorus in the background, and Steve Lockwood's organ ostinato underneath it all. Nicky Paraiso leaves the other organ he's been playing and crosses to Monk's piano, where he

sits and plays a lilting Gottschalk waltz. And that's the way the piece ends, in a cacophony of clashing sounds and people in motion, in which each sound, each group has a distinct character and a clearly perceived pattern. Only a mind like Meredith Monk's could have no qualms about putting them all together.

David Sterritt

Notes: Meredith Monk

Like an increasing number of artists in the New York area, Meredith Monk sees many disciplines as her own. Crossing traditional boundary lines, she looks for new aesthetic forms and combinations, obeying no rule but her own sensibility. Though she began her musical life as a singer, pianist, and composer, her travels have led deeply into dance, choreography, stage direction, and filmmaking. The unifying factor has been her strong musical sense, her instinct for profoundly formal yet thoroughly intuitive expression in whatever medium happens to be at hand.

In short, Monk is always a composer, whether the tool of the moment is a vocal trio, a movie camera, or a stage full of costumed performers. "Even when I use images, I'm an orchestrator," she has said. And just as her theater pieces are musical in structure and impact, her music is inherently theatrical, even when performed "straight" on a bare stage. This is partly due to her novel means, which include microtonal pitches, unusual vocal configurations, sounds ranging from glottal growls to keening ululations, wordless syllables instead of lyrics or vowel sounds, and evocative effects ranging from folk song to bird song. It's a dizzying mixture, but it seems to communicate readily with new listeners as well as those already familiar with Monk's work. Finding a receptive audience has never been a problem for her, even in the early days of her career.

The first and most obvious characteristic of the Monk style is her enormous variety of vocal resources and the contrasting austerity of instrumental elements. These traits are at the heart of Monk's work, rooted in her wish to strip away the limiting factors of Western musi-

Originally published in *San Francisco Symphony Magazine,* January 29, 1982.

cal practice and find an idiom that is at once personal and universal, primordial and futuristic. This has meant stripping away years of training—not technique, which is more necessary than ever, but incrustations of habit and conventional wisdom—and substituting new methods based on the artist's own discoveries.

The result is far removed from the classical and popular traditions that comprise Monk's own background. Whether for solo or ensemble, her music is arrived at through a living process of trial and error involving actual voices, rather than an isolated act of composition. Equipped with a clear idea of the overall form she wants, she works out each phrase on an empirical basis, in full collaboration with whatever colleagues may be involved in the piece. Describing her method, she says, "It's very alive, like something from the oral tradition." She treats voices as if they were solid bodies and takes a choreographer's pleasure in manipulating them toward predetermined but flexible goals. Even when a work is finished, some sections may call on the performers to play with their own ideas and interpretations, inside a carefully defined framework. Since there is room to stretch and move within these parameters, some passages in Monk's work are virtually impossible to score. This is not aleatory music in any real sense: the chance element is small, and Monk knows exactly what sound she's after even when the components are loose enough to fall together differently each time they are performed. Still, for another musician to learn such a work, a tape recording of a Monk performance would be as necessary as a printed score. Likewise, a producer wishing to stage a Monk theater piece would need not only a script, but a videotape of Monk's own production, too.

Monk's music has sundry roots and inspirations. Western classical technique is clearly evident in the strong vocal writing, and the need for trained voices that lean toward the opera house rather than the more speechlike inflections of rock and folk singing. Yet popular influences are also present: folk music in the insistence on a wholly personal and plainly emotional idiom; rock music in the steadiness of the pulse, the simplicity of the harmonic patterns, the artful use of repetition. A one-time rock musician herself, Monk admires the strength and immediacy of that genre, as well as envying its power to move masses of people deeply and instantly. The jazz of the mid-1960s was also a factor in her development, and here she shares a taste with such classical-experimental contemporaries as Steve Reich and Philip Glass. Monk has never emphasized rhythmic process as strongly as Reich

does, however, and her intimate, mercurial style is a long way from the rock-steady beat and assertive textures of Glass's ensemble work or the recent music of Jon Gibson. Though she has minimalist leanings, that term fails to account for the musical and associative complexity that informs her most deceptively simple passages.

Monk's musical development is readily traceable through her recorded work and the pieces in her current repertoire. The 1976 *Songs from the Hill* provides a veritable glossary of her techniques in ten solo pieces, ranging from the short *Mesa,* a collection of folk-like motives, to the longer *Prairie Ghost,* which includes vocal sounds as varied as singing, whispering, and plain breathing. Similar methods are also found in earlier works that she still performs. *Gotham Lullaby* contrasts gentle, intensely melodic passages with yelping, almost animal-like interludes. *Travelling* combines a lusty vocal with an underpinning that recalls folk dance idioms; it's cheering, but a bit obsessive, too, and packed with so many moods (despite a steady meter) that a blindfolded listener might think there were several singers instead of just one. Though *The Tale* is simpler, it amounts to a musical comedy in less than three minutes, with its jaunty atmosphere and rare use of lyrics. The thoroughly different *Biography* is very much about texture, with the deepness of its fabric evoking a darkness of mood that is eventually relieved by a soothing passage, followed by an astringent, harshly fluttering sound with syllables that seem to settle into an almost-intelligible bird-language out of some elaborate fairy-tale world. It's a steadily inventive anthology of surfaces, all served up over an unfailingly austere piano substructure.

The 1977 *Tablet* extends such techniques to other voices—a crucial step in defining Monk's music as a teachable idiom available to voices different from her own. The instrumental accompaniment is fairly busy, by Monk standards, and again the vocal work covers an enormous amount of territory, from full-throated crooning to childlike speechsong, from chattering and even gasping to an exquisite passage in which sustained microtones are shifted in and out of phase with ecstatic precision. All the Monk characteristics are present: the formal balance, the radical textures, the soothing repetition, the melodic invention, and the rhythmic ingenuity. Combined into a single large work, their effect is strikingly dramatic.

Dolmen Music is more ambitious yet, incorporating male as well as female voices along with cello and percussion. The opening, called "Overture and Men's Conclave," establishes an otherworldly atmo-

sphere. The next section, identified as "Wa-Ohs," is just that: syllables playing off the different textures of different voices. It's a solemn moment, like a formal summoning. There is something especially Druidic about the men, with their chantlike line repeated again and again, ending in a sound that's not quite language. The harmony is elementary; this is music consisting almost entirely of shape, timbre, and relentlessly gathering energy. A Jew's harp sound creeps in, recalling the days when Monk actually composed a work for eighty-five voices, eighty-five Jew's harps, and two violins. Then the effect becomes more recognizably human, with a pure counterpoint of female against male textures. Later sections contrast sustained cello tones with quick female voices; repetitive chants with deep, masculine timbres; cello strings tapped with percussion sticks; a sustained call joined by a hard flutter, then rustling female voices (like something out of Ligeti) over a male chant. The climax brings a multitude of elements at once—the richest fabric of all, and a final accounting of Monk's musical inventions to date. The end is resoundingly strong and assertive.

In comparison with *Dolmen Music,* the earlier album *Key* is closer to a minimalist vein, interspersing songs with nonmusical sounds and monologues—a piece of "invisible theater" in which each passage deals with a different vocal quality or problem. Here Monk is particularly concerned with the "emotional palette," reaching for feelings she considers unattainable by any other means or medium. The same impulse seems evident in the lovely *Turtle Dreams* waltz, one of her most recent works. With its moments of ethereal beauty, this piece might be a coda to the firmer sound-slabs of *Dolmen Music,* and indeed, *Turtle Dreams* is performed as a coda to the latest Monk theater piece, *Specimen Days,* a sort of time-trip between the Civil War era, the aftermath of World War III, and today. In its theatrical context—choreographed, accompanied by a film, and interrupted by other music—*Turtle Dreams* manages to evoke simultaneously the primordial and futuristic layers of Monk's work, combining them into a single, seamless experience.

The consistency of Monk's development is paralleled by her lifelong involvement in music. Her mother, grandfather, and great-grandfather were singers, so she didn't have much choice about inheriting a musical tradition. She began composing for voice when still a child. By her teenage years she was studying voice, composing for piano, and dancing.

Her shift away from convention began after she left school, when

her dance training began to influence her musical thinking. She started considering the voice as a palpable, manipulable substance that could be shaped and fashioned just as the body is in dance. It bothered her that the individualism of modern dance—taking for granted the tendency of each person to develop a distinctive style and vocabulary of movement—was missing from the world of music. Determined to develop a thoroughly personalized style, stretching the vocal instrument to its limits, she embarked on a series of experiments with her own voice, treating it as a flexible "spine" that could be moved and molded in a variety of ways. Much of her early activity involved breaking old habits and reaching beyond conventional ideas to new and untried territory. Later, outside sources began to play a part, as she latched onto glottal and ululational sounds she heard in the music of non-Western cultures. She wasn't working from scratch—she was already a trained artist, and knew what she was doing—but she was committed to moving as far beyond received wisdom as possible.

Her work in dance and multimedia performance followed a similar path. Valuing her skills as a trained dancer and choreographer, she worked nonetheless on vaulting past her trained responses and developing a natural, organic, highly personal style. For a while, music became a co-equal element in work that was largely concerned with movement and media manipulation, but her impulses as a creator remained essentially compositional. Later, singing and composing again became her foremost activities. Today she is first a composer, though her other talents can hardly be called ancillary. In such a work as the *Turtle Dreams* waltz, for example, choreography seems as important as sound, and the piece heard without its movements would be incomplete—though benignly so, like a play script that is published after being produced.

The basic physicality of Monk's music is related to her tendency toward a minimal (if not minimal*ist*) style. Like many of her contemporaries, she feels the classical tradition of the 1940s, 1950s, and 1960s became detached from an essentially human basis, becoming all head and no heart. A more vital expression was needed, in her opinion—an expression that was at least primitively present in rock and jazz. Utmost simplicity became a radical route toward renewing the emotions of music—trying to reach the nerves and feelings before the intellect, even when this meant throwing off academic complexity along with academic dullness. Fortunately, her classical training and her own sensitivity ensure that intellect is never absent, even when emotion seems

dominant. And her effects always tilt toward maximalism, even when she is busily paring down musical elements to their essentials.

Monk regards film as similar to music in many ways; her interest is currently strongest in the cinematic and musical facets of her work (at the expense of theater and dance), which she finds rewarding but rather cumbersome. The advantage of theater is its capacity for dealing with different spaces (and therefore different atmospheres, moods, periods of time) simultaneously. But film is more linear, and more concrete in its images, which can be shaped and developed like musical phrases. For Monk, the great joy of music is its utterly concrete quality. "A G is a G," she says, relishing the possibility of beginning work with just a few phrases written down, and the rest wide open to the inspiration of the moment. Results in music can be assessed after a single rehearsal, when the artists can hear for themselves whether the results are pleasing or not. By contrast, theater is less direct, partly because Monk works directly from concepts and images, with little in the way of a script. And theater is bulky, with its dependence on performers, props, and multiple spaces. Though her work continues to have a strongly theatrical quality, her activity leans more and more toward the purely musical side of her artistic personality.

Monk has different work methods, depending on circumstances. At times, she begins a composition with a lot of ideas; on another occasion, she may have nothing more in mind than a few notes on the piano. Likewise, a piece may take just a few hours to work out, or a phrase may bounce around her head for a year before finding fruition. The linguistic element—the syllables that are a crucial part of her pieces—emerge side by side with the music. Monk sees music as such a strong language in itself that English (or any other tongue) is superfluous on top of it. She treats her syllables as pure sound, with no meaning apart from the sum total of the musical gesture. It is a means of approaching the universal communication that music is supposed to be, without bringing in linguistic complications or dilutions. Monk is pleased that she can perform her works anywhere in the world and communicate directly, without having to go through or around language.

In dealing with other voices, Monk calls on the same rigorous discipline and the same sense of play she employs in her solo work. She also pays careful attention to the individual qualities of each voice at her disposal, whether its virtues be "strength and physicality" (her words for Paul Langland) or "sweetness and clarity" (Robert Een). In-

terestingly, the best Monk singers don't always come from elaborate classical backgrounds; opera, it seems, is not the best training ground for the would-be singer of *Dolmen Music*. Yet her colleagues tend to be firmly grounded in vocal technique, and often in movement training as well.

Monk always emphasizes the bodily quality of her music, insisting that it's aimed as much below the belt as above the collar. To write it, she has called on a wide range of resources, physical and intuitive as well as intellectual and technical. To perform it, she has assembled a group of artists who are clearly as versatile as they are sympathetic with the unconventional Monk methods and aspirations. Like a few other ensembles on the new music scene—those of Glass and Reich, most notably—they are succeeding in bringing her music to an increasingly broad audience, initiating and winning over their listeners as they entertain and emotionally move them. It's an impressive achievement, for which Monk and her colleagues are receiving an ever-larger share of popular attention and critical praise. Despite the novelty of her approach, she is fast becoming a fixture—albeit an unpredictable one—among the small circle of artists who manage to combine broad popular appeal with aesthetic risk taking of the most avant-garde sort.

Meredith Monk

Dreams

From Meredith Monk's Notebooks, 1978–1984

[?] 1978

Winston Tong is doing a performance on a train. I go to Chinatown and try to find him a jade dragon-dog. We wait in one subway station for his train to pull in. Lanny is there and also Richard from the class. The doors open and we all go in and sit down. Richard gives him a glass fish or animal and I give him the jade. It is light outside, so when he begins it is a little out of focus. He is doing a character with black under his eyes. A woman next to me says, "Mel Gussow said that using the train was very clever. I read a rave write-up about Winston Tong. I don't usually read theater. But the *Voice* is a really good paper—blah, blah, blah." I don't listen to her. I tell Lanny to get close in order to see him. Now we leave the train and are supposed to get in a bus. I get on the bus. The bus is going over earth with big pockets—arroyos—in it. I decide to get off because it is too dangerous. I am in the city looking for that bus or the address where the performance continues. I am walking the streets trying to find it. I meet some people later and burst into tears. I say, "I was offered higher knowledge, but I was too afraid to accept it."

February 17, 1982

I've just come back from tour. . . . I only have a few hours to get my things to go on a trip to Egypt (Mexico?). . . . I am thinking of not going on the trip that day because I don't have time. Mieke says, "Go ahead. Just pack a few things and go." I do. I get off the plane and onto a bus. An older woman (someone's aunt) says to me, "Welcome to Egypt. Come, come to our water ritual." I am thinking that I want to work with Egyptian things in my art again and that I am glad to be there. It is warm and beautiful, a kind of Paradise. Everyone is moving

toward some water. Andrea is there, Bob Een, and many others. We take off our shoes and walk into the water with our clothes on. There are some little boats, too. There are great fish jumping out of the water. They are silver and big enough that you can hug them. I hug one. I think, "How could you ever eat a fish that you've just hugged?" Then I am back in the sleeping loft after one day. I am looking at a health certificate that shows that three people were sent home because of health reasons. It is a little chart with my name on it. I feel like I did in camp when I was sent to the infirmary, when I was four or five.

May 1, 1982, E. Meredith
I am visiting a town in a community that Ping already visited. We are doing a film or a video there. All the people in the community work in the same factory, including the children. They are all in space suit-like uniforms in red and yellow with boots and a hat and puffy body. I speak to some of the people. They are very warm and friendly. I think the image of the uniforms will be very good in the film. I smile and talk to the people.

Then Ping and I are doing a videotape of *Paris*. We are in a dark ballroom of some kind. We receive a little tapestry with boxes. We don't know who it is from. Later, Charles, Barbara Dufty's husband, tells us that it was from him and didn't we learn something from the small figures about *Paris?*

July 26, 1983
I am doing a new piece. My set is like a boat spread out along the floor. It is painted a light greenish blue. It has ropes up to the ceiling and light all over the room—a kind of yellowish light.

On a tape are sounds of the ropes squeaking and the wind blowing. Mostly the sound is of the ropes moving—the rigging is constantly shifting.

January 19, 1984
I am in a seminar for creative theater work. It takes place in a loft that looks in some places like Great Jones Street. We are supposed to create new pieces. I start by working on a step that makes me glide across the floor, as if I am skating. I put on a yellow, old-fashioned net dress. I practice that for a while and then don't have any more ideas. So I sit in the dressing room. When the time comes to perform, I don't have a new piece. The pieces by the other groups are quite elaborate. One

takes place on a bridge. There is a clown with red clothes and a white face who is juggling red balls. Behind him are other people throwing red turtles back and forth. Another piece by a woman begins with her entering in a kind of space suit balancing a pile of silver things on her head. She puts them down and then sings a very, very high song with the alphabet—a, b, c, d, e—in a little voice. It is very funny; her entrance was also. Now a man steps from behind the pile of silver things and they do a kind of dance together. I'm amazed at all the objects that turned up in one room. I decide that I'll bring in something next week.

Laura Shapiro

Meredith Monk and the Discreet Charm of the Avant-Garde

Meredith Monk has been at it for twenty years now, moving steadily across an artistic landscape that seems to span the world and more. I suppose she should be called a revolutionary, since her work obeys the dictates of no other form or authority; but the events she coordinates on stage never look as though they're rebelling, never look as though they're striving to be new and different. Everything proceeds with calm and certainty, and no matter how weird the accumulated details become, each moment strikes with its own absolute verisimilitude. By the end of the evening we see that in fact it isn't weird—it's Meredith Monk. What we picked up at the box office earlier was a ticket to her consciousness.

Turtle Dreams, a collage of music, movement, and film presented cabaret-style by On the Boards last weekend, seems to be the portable version of several elements from Monk's *Specimen Days,* a 1981 "opera"—as she calls her enormous stage spectacles—about the Civil War. In the operas it's possible to see Monk's special genius at its grandest: her daring but perfect sense of timing and stage space; her startling, unerring way with juxtaposition; and her creation of image upon image until the stage seems to possess the mystery and wealth of a dream world. Working in this outsize format since early in her career, Monk has been employing these and other features of avant-garde theatricality that didn't surface in the rest of the avant-garde until recently: she was doing Philip Glass before Glass was, Steve Reich and Laura Dean before Reich and Dean, Robert Wilson before Wilson.

Turtle Dreams is a package, not a spectacular, and it doesn't have the scope that would permit us to witness Monk's imagination at its most

Originally published in *Seattle Weekly,* May 9, 1984.

expansive. All the same, we get a wonderful excursion into that imagination, and the souvenirs we gather along the way stay with us.

Fittingly enough, we start this excursion on a train: to the sound of an engine crashing along, company member Gail Turner relentlessly massages the air in front of her, thumbs and forefingers clamped in an oval shape. This little dance for her two hands is detached from her body, yet reflects it; and the sight of movement detached from the source of movement will return later in other guises. Then the lights go up at the side of the stage to reveal Meredith Monk, neatly wrapped in silver lame that looks, on her, puritanical. Standing at an electronic keyboard, she begins to sing, first a high, intense, mournful vocalization that might be the memoirs of a mermaid; then a song in trembles and whines, done with Nicky Paraiso. In between she stops and smiles. "Hi folks," she says. "Welcome to *Turtle Dreams*."

Monk's singing is quite beyond categories. There are words, sometimes, and persuasive chords; it's tonal, and it can be followed without a map. But the sounds themselves wander and splinter and groan and sail and soar. Her voice will do anything, apparently, but it's always musical and it's always human. While Paraiso and Andrea Goodman are singing with her, Paul Langland and Robert Een walk onstage for a dance called "Two Men Walking." And that's what it is: they meet and walk, back and forth, torsos leading and sometimes disrupting, slouchy and direct, pelvises leading, back and forth. A long, low bar of fluorescent light illuminates the space with an intense glow.

The central image of *Turtle Dreams* arrives unexpectedly in "Map Film." Maps are shown on the screen, or rather just the outlines of countries all over the globe, neatly labeled with their names. Right over Mongolia, suddenly, we see a turtle. He walks directly to Madagascar, making pretty good time, then leaves Ethiopia and moves up the eastern seaboard of America to Thailand. He's very determined. After he's traveled for a bit, we hear the engine start up again and the film gives way to a dance for Een and Langland. They're in white, with wigs like heaps of noodles plopped on their heads, and hands and faces covered in white. They could be stuffed with straw, and the dance—much of it for their hands, like the first engine dance—consists of fast, uncontrollable shaking. No bodies produce this dance; the shaking is propelled in isolation. Then Gail Turner comes onstage with what looks like a tabletop on her back, and a little film is projected onto the surface. Perhaps these are the bodies missing from the dance—they're lifeless shapes, lying on a beach.

Two events that might be thought of as "real" dances occur in the middle of the evening, before and after intermission; and indeed, Monk has ensured that we will think of these as "real" dances by calling them a cha-cha and a waltz. "Tokyo Cha-Cha" has its five participants wearing on their heads or shoulders little black cones with red lights at the tip. Thus identified, the dancers engage in a cha-cha of sorts, isolated and busy and dazed, a cha-cha with partners never touching each other, the dance equivalent of a silent movie. Later they bow, prance, blow kisses, and enact what might be a dance of welcome from the natives, a ritual that means everything to them and an orderly nothingness to us. "Let's sauna," they sing. "All happy / Me happy / Let's sauna / Oh beautiful day / Oh nice day." It's a secret language but not to the speakers, who seem convinced they're talking to us, like Japanese schoolchildren reciting what they've learned in English.

"Berlin Waltz" is more stripped down, more of a bad night at the Roseland ballroom. The four dancers wear their slightly baggy best and simply face us, stepping obsessively from side to side. Sometimes they turn sideways, sometimes they sketch brief shapes with their arms and bodies, but the side-to-side step doesn't go away until it becomes a box step, just as obsessive. Eventually the dancers make their way in pairs to diagonal corners of the stage, where they keen and sway like peasants at a deathbed. While this is going on, a fifth dancer walks a bit timidly onstage in an immense white, hooped petticoat. She looks around discreetly, a little nervously, then nods and lifts her arms to an invisible partner. As she begins the box step, her stiff petticoat sways with her, rhythmically, side to side.

Turtle Dreams ends with a film—we see the turtle roaming city streets, and pausing at a moonscape to look up at the earth—followed by a song from Monk. Here she sits on the floor at a keyboard and gives a rich, resonant discourse, calming and conclusive.

Inexplicable as all these incidents have been, all of them seem reasonable as they occur. Nothing is tentative here, nothing is off the wall; *Turtle Dreams* doesn't look spontaneous in the least, nor does it look rehearsed and hardened and permanent. It just looks necessary. It looks as though it had to happen. If it needs a name, we could call it classicism.

Deborah Jowitt

Meredith Monk's Gift of Vision

Behind a small white cottage, three people sit around a table in the early September sun. Below them, a small creek runs down to the town, bearing occasional freight of leaves and twigs. In front of the house a road runs up the hill, and an occasional car passes. Between the parallel courses of road and stream, the conversation flows in circles, forms clusters and layers. Sometimes when the visitor questions the man or the woman, their answering voices overlap—he supplying a word she's groping for, she adding a word to accentuate his. They are eating green tomatoes fried with onions; inside the house, more green tomatoes are simmering down into chutney.

This, to my surprise, is how my memory shapes the scene, weeks later, when I'm replaying the tape of my interview with Meredith Monk and Ping Chong in Upstate New York. By then, my mind is saturated with their perspectives on the world—with Monk's way of seeing and structuring reality and dream, past, present, and future, private memories and collective rituals, acts, words, music, and gestures into enigmatic live mosaics for theater. By then I'm considering the work of both Monk and Chong in relation to film: flexible time, montage, events that swim in and out of focus.

Inevitably, the conversation centers on the Monk–Chong collaboration, *The Games,* which they created last year for the Schaubühne am Halleschen Ufer in Berlin (a repertory theater ensemble for whom Monk had previously restaged her legendary 1971 "opera epic," *Vessel*) and which they are presenting with a new cast as the opening event in BAM's Next Wave Festival beginning October 9.

Chong and Monk have collaborated before. He's appeared in many

Originally published in *The Village Voice,* October 9, 1984.

of her pieces—made his performing debut in her 1970 *Needlebrain Lloyd,* an unrepeatable "live movie" that ranged all over the Connecticut College campus, animating lawns, lake, the lit windows of a building, involving a boat, horses, motorcycles, campfires, and hordes of people—and they worked together to create the "travelogues," *Paris / Chacon / Venice / Milan.* But, as Monk points out, the latter came out of shared experiences; "making *The Games* was more like dealing with the imagination from scratch."

Explains Chong with a grin, "Meredith was asked to go back to the Schaubühne to make another piece, and she remembered how hard it was working there the last time, so rather than do it by herself she invited me to go along."

Their dual presence facilitated the working out of *The Games:* he could create the text that is spoken and projected in slides; she could write the music; one could, say, rehearse the five "actors" and the "Gamesmaster," the other the eight-member "chorus." (Expecting to have ten weeks of rehearsal in Berlin, they arrived to find the time pared down to eight, and were pressured into working out costume designs with Yoshi Yabara in advance—a turn of events that horrified Monk, who likes to work slowly and organically.) Clearly too, their differing sensibilities have shaped the piece. They struggle amiably to define each other. "I've gone into real musical theater," says Monk. "Ping's work is more literary." "Narrative," he concedes. "It has something to do with discourse," she tries. He points out that her background in music and choreography gives her work structural aspects akin to poetry, while his background is in film and the visual arts. His last piece, *The Race,* shown at La Mama last spring, despite its cryptic use of time (is this the future? *was* it once the future?), had a clear forward progression, while Monk, in her words, looks "at things like a mosaicist, as if you were looking at everything at the same time—at least as much as you can do that in a time art." We compare the ingeniously handmade look Monk still prefers to the streamlined elegance of Ping's recent pieces. (As their words echo and reinforce each other's statements, I note that this breakfast is a noteworthy collaboration: she scrambled the eggs; he came up with the tomatoes.)

The Games emerges tantalizingly through their conversation and a tape of the Gamesmaster's wordless song—the German actor's voice now wheedling, now sly, now sharp, sliding around in a wild falsetto. He sounds like a futuristic, Monkish version of the decadent compere of *Cabaret.* The icy, science fiction ambience of the piece links it more

with Chong. That the Olympic Games should fall in a year as heavy
with implications as 1984, and that the year should also mark an Amer-
ican presidential election whose possible outcome terrifies many of us,
are facts which have not, obviously, escaped these two artists. When I
go to the Lepercq Space at BAM the following week and watch the
performers in precise unison slashing black flags through the air, the
sound ominous as thunder or distant artillery fire, when I hear the
German phrases that have been left amid the now-English text, these
interplanetary Olympics of the future also become a palimpsest
through which I glimpse the 1936 Berlin Olympics and the dark and
monstrous events that were taking form in German history. The four
"games"—little parables, really—become gradually infused with evil.
On a small scale, in a precise structure, it's as Monk says, "like seeing
the earth go through its cycle again, from the Garden of Eden to the
Apocalypse."

When I watch this early rehearsal, a run-through with pieces miss-
ing, I flash back to something Monk said about in-betweenness, about
being interested in the zones where things cross. As in some forms of
Oriental theater, you can't separate the strands of acting, singing,
dancing, and playing instruments. Musicians Nurit Tilles and Wayne
Hankin march in the opening procession, and Hankin joins the
chorus in a skewed Charleston; dancer Naaz Hosseini has a lovely light
soprano voice, and she and Ruth Fulgistaller leave the action at one
point to play violins; Michael Cerveris, one of the "actors," plays the
keyboard cradled in his arms during the game called "Memory."

Part of what gives Monk's works their curious beauty and marks
them as extraordinarily innovative theater pieces has to do with her
interest in the areas where one thing shades into another. Not only
dancing becoming singing becoming speaking, but the zones between
dream and reality, past, present, and future. This is true of Chong's
work too, and when he speaks of "the strange wavering between reality
and artifice" in her pieces, he might be speaking of his own. In the
collaborative *Paris*, Monk and Chong (the only performers) stood at
the rear of the performing area, backs to the audience, and cried stead-
ily for a long time. That is, their voices sobbed; their bodies didn't
move. The crying, at first quite realistic, became surreal, finally unreal.
During Chong's terrifying solo in Monk's 1976 *Quarry*—a solo of
howls, freezes, dancing like decadent T'ai Chi—we could see him both
as the crazed dictator calling the shots and as a puppet controlled by
an invisible maniac.

The small, meticulously polished acts out of which Monk's works are built are often concrete—a woman scything, a woman washing baby clothes in a wooden tub—yet timing or an unexpected context can transform them utterly. Sometimes mysterious or fantastic actions are performed in a matter-of-fact style, so that they seem familiar even though we have never seen anything like them. In her *Education of the Girlchild* (1972–73), there was a passage in which several women thoughtfully rearranged a little heap of rectangular wooden blocks, while two others faced each other across a table and sang quietly. The deliberateness, the way the women took turns moving the blocks, gave their unusual activity the familiar rhythm of a chess game; the antiphonal singing could be read as "conversation." The idiosyncratic vocabularies of movement and music that Monk has been refining and enriching for about twenty years have their own kind of ambiguity. In 1969, I wrote about her own dancing in *Juice,* billed as a "theater cantata": as the balance of ingredients in her work would shift, she used to clue us in with subtitles. It looked, I said, "as if she were trying to feel innumerable tiny sensations deep in her body or shrug some peculiar substance off her skin without using her hands." Often it seems as if her movement material makes you focus on transitions, rather than on the moment at which a gesture is completed or fulfilled; there's something off-balance, unguarded about it. Her vocal music, based on her own remarkable voice, slides and nudges its way between the notes of the Western scales, voices shade so subtly from a lyrical tone into a howl, from a snarl into a cooing, that for moments on end, they are neither quite one nor quite the other.

Journeys—between places, between states—figure prominently in her/their pieces. One section of *The Games* is called "Journey." In *Juice,* four red-painted hikers, roped together, traveled up the ramp of the Guggenheim. In *Education of the Girlchild,* the women performers then in Monk's The House group put objects on their heads (one was a stuffed alligator), formed a line, and walked in place. *Paris / Chacon / Milan / Venice* was about seeing reality while moving through it, while in *Vessel,* the whole audience took a trip: from Monk's loft, where Part One took place, via chartered bus to the Performing Garage for Part Two, and then on foot to an empty parking lot down the street. Her solo in *Education of the Girlchild,* was a long journey backward (forward?) through time, through the ages of womanhood, perhaps through a gallery of different women, her voice and gestures conjuring

up a querulous middle-aged woman, a happy young one, a child, a crone.

While we're sitting together, we start talking about how artists structure the world. If a work is slowly simmering in Monk's mind, that context "makes you see things in a different way, and everything that comes into my life is possible material." She remembers being here in the country and seeing Lanny Harrison scything in the field. And that had to be in the piece. And the way they sat at Lanny's round table eating ice cream. That had to be in it. We decide that it's always human *gesture* that catches her eye, whereas Chong, as wise as he is about gesture, works more from a situation.

Remembering vividly a workshop Monk gave in which everyone was asked to find a single gesture, a single word or phrase that summoned up a remembered grandparent, I wonder if it's that way of distilling human behavior that imparts such power to her work. "I think," she says, "that it has to do with compressing a lot of energy and information. That's what gives an image its radiance, a sort of luminosity." "You're looking for the eternal or the essential in a gesture," Ping tells her. Juxtaposed or layered onto each other, these small potent modules build structures with a luminosity that transcends that of the individual parts.

How Monk actually *sees* may have a lot to do with how she organizes her pieces. Because of the way one eye works, her eyes don't converge on a single point but present her with two images, one occasionally flickering or cutting out entirely. (I'm given a startling insight into this kind of eyesight quite by accident when, in a rehearsal, Monk jumps up and suddenly there are two Gamesmasters bowing and smirking—she and Branislav Tomich—where a moment before there had been only one.) "Supposedly I've never seen three dimensions," she says, "yet I feel that my work is so three-dimensional. I'm always dealing with deep space." Later she says something about dealing with layers of reality, about wanting to present different aspects of the same thing simultaneously; her *Specimen Days,* which presented the Civil War through parallel images of a Northern family and a Southern one, would have been more striking, she now thinks, if budgetary considerations hadn't kept her from costuming one side in red, the other in green, in acknowledgment of 3-D glasses that fuse two separate pictures into a single image.

The conversation makes me realize how often it's through a build-

up of flat layers of action—people traveling across a stage, say, their gestures staying in one plane—that Monk creates an illusion of immense depth. I link this with interest in cinema—not only with her extraordinary film *Ellis Island,* and the one she's planning now with its medieval ghetto setting and its sort of "Jewish Joan of Arc who can see into the future," but with her filmic way of structuring things, of guiding the audience's point of view. For instance, in the two-dimensional medium of film, we infer depth through the size of objects in relation to other objects, and issues about scale have figured imporantly in several of Monk's works, notably *Juice* and *Vessel.* As the principal performers in *Juice* moved through the three parts of the work, performed in three different locations, they also moved into close-up—from figures in a distant pageant, they became actors in a play seen at medium distance, and, finally, heads on a television screen.

In Monk's work, there are layers in time as well as in space. In *Ellis Island,* her actors, dressed in clothes that suggest the past, are eerily layered onto present-day Ellis Island, with its ruined walls, climbing vines, chattering tourists. "Layers" also exist as aspects of a single subject. It's the word Monk uses when she talks of her early mixed-media piece, *16 Millimeter Earrings.* She wore a long red wig; there were blowing red streamers ("paper fire—a child's idea of fire") and finally a film of real flames, first burning a doll, then projected over Monk's naked body. "I was thinking in terms of visual rhymes. In poetry you rhyme words, but this was like rhyming images." (Was it their common interest in film techniques applied to live theater that drew Monk and Chong together years ago?)

Today's rehearsal provides vivid pictures of the collaborative process, of the building up through the accretion and repetition of small pieces, of layering as a technique. The last rehearsal that I saw was a big sketch, with details filled in here, left out there. Now Monk and Chong are adding more layers to Game 2, the one known as "Journey." The chorus and actors are progressing back and forth across the stage in horizontal tracks ("Spuhr ein, spuhr drei," says the Gamesmaster, laying them out like lanes in an Olympic pool). To the repeating eight-count traveling phrase, Monk adds two more. She has everyone stop to watch how Naaz Hosseini manages the tiny rhythmic quake of her arms, as she curves them toward her face. It's one of those enigmatic gestures of Monk's; the performers might be splashing water on their faces, listening to something, caressing something in memory.

When the new phrases are layered onto the old, a striking visual counterpoint emerges.

New layers build up in the music too. When Monk makes a piece, the music, like everything else, isn't fully worked out in advance. The vivid bits of material are gradually fitted together in rehearsal. Tilles and Hankin at their keyboards experiment with adding various of Monk's small modular melodies from their lists. Monk makes suggestions, approves or disapproves their choices. They nod and scribble down the decisions. "Stravinsky" gets layered onto "basic": terrific. Now, how often should it recur? "Ah-*ah,* ah-*ah,* ah, ah, ah-ah," sing Naaz and Sharon Fogarty in very high, sweet voices. "Wa-wa-wa wa wa-wa-wa wa . . ." croon Ruth and Nancy Alfaro, and, I think, Andrea Goodman. Three or four other patterns slide in. At moments, the intent faces of Monk and Chong light up in pure pleasure at the conjoining of sounds and movements. "That's *handsome,*" Monk tells the keyboardists. "That's rock 'n' roll!" she tells the actors, with a wiggle to accentuate the point.

At slowdowns and hitches, Monk and Chong wade into the piece; he may talk to the actors and set something new, while she works with the chorus. They confer. "Okay with you if we . . . ?" "Okay, but I think we should . . ." "Right, let's go back to . . ." Yoshi Yabara, wearing one of his amazing getups (today: bright blue shirt, tie, blue cloth boots, jodhpur breeches), doesn't like the too sylphish arms the performers are unconsciously grafting onto new material and falls off his chair to make his disgust clear. "Yeah," agrees Monk. "It doesn't kill me." She makes a note to fix it, and gives her attention to a musical problem. After she's turned back to the actors, Nurit plays the altered passage and says quietly, almost to herself, "Now *that* kills me."

The section grows, blossoms, falters, is pushed on again. Mild frustration jockeys with pleasure and encouraging words. Start again. Stop. Someone's gone to the bathroom. Start. Stop. Ping rubs his hands through his spiky crewcut and calls, "Take 32, Scene 12, *The Gates of Heaven,*" in a fake-important voice designed to provoke a little relieving laughter. As the performers, reclining on one elbow, spew out some gibberish, the men talking in growls like slowed-down records, the women in a high, speeded-up chatter, Monk sits erect on the floor, watching them, looking like a little girl with a fantastic array of windup toys she's set in motion.

It's been a long day, and Monk still has not rehearsed herself. (It's

been decided that she will alternate with Tomich in the role of the Gamesmaster.) But they are encouraged. The work has come to mean a lot to them, and I can see why. I think back to that day at the house by the river, when Monk and Chong have finished describing the end of the piece. There's a pause, and then she says, "It's a sad piece." And then she says, "It's about loss, about loving what we have now and fighting for what we have now. Not that it won't change, but that we won't let it be destroyed."

Perhaps with such artists scrutinizing the present from an imagined future perspective, layering the past onto the future as a subtle lesson in history, affirming the cyclical nature of life, the small streams will continue to run and green tomatoes grow on the vines. It would be comforting to think so.

Meredith Monk

Excerpts from Sarah Lawrence Commencement

Address, May 24, 1985

The first thing Bessie [Schönberg]* taught me was not to take myself so seriously—that everything that I came up with was not perfect by any means; it could be thrown away (and mostly should be thrown away) in order to start again. She also taught all of us to be respectful of each other, to appreciate each person's talents, styles, rates of growth for what they were. In other words, not to have a preconceived idea of what a body is, a dance is, a song is, a play is. This basic attitude (a kind of psychic anarchy) has given me the courage to try to find new ways of putting art forms together by working between the cracks; it has taught me never to assume anything; it has made the process of discovery one of the joys of my life and it has kept me curious. Curiosity has a certain vitality to it because at first it seems to lead to the possibility of chaos. Is there a new or different way of doing something? The prospect of trying something new often becomes so terrifying that we move back to more conventional solutions without realizing that chaos is the first step toward creativity. It's hard, but we have to tolerate moments of uncertainty and disorientation to get to new solutions. This initial confusion was always encouraged by Bessie. She knew that flowers and vegetables only come from a garden of dirt mixed with manure—that there is no good or bad in the initial stages of creativity, only material to work with. . . .

. . . We now live in a technocratic period. I see how this is manifest in the performing arts—it produces an emphasis on technique without the underlying values of communication, expression, or just plain heart. What is lost is a sense of magic. At the time that I was doing

*Bessie Schönberg, a legendary teacher of choreography, headed the dance department at Sarah Lawrence when Monk was a student there, and, with Paul Williams, taught the opera workshop.

my early work, many of us were engaged in trying to create a theater or performance place and time that would convey wonder. The wonder of picking up a cup. The wonder of white light going from dim to full. The wonder of the voice. The wonder of time going by. The wonder of laughter. Now, in a period and in a country where attention span is determined by the length of a television show—where most people frankly don't know whether they have received something that has nourished them or not (the only determining factor being whether the newspapers have endorsed it or not)—it seems more important than ever to insist on the real thing. To know that we have the right to experience the magic of theater (either as a performer, creator, or member of the audience), that it is part of our human legacy. What I am saying about the theater, of course, goes for literature, science, medicine, social studies, etc. It is a matter of getting back to and fighting for human values.

Gregory Sandow

Review of *Acts from Under and Above*

The Operatic Meredith Monk

At first I thought I'd talk about new kinds of music theater. This is an opera column, we know, but then what is "opera"? On one hand, it's what you see in an opera house. But, more abstractly considered, it's a theatrical form in which drama is shaped by music. Music and theater have evolved, and in an age when John Cage and Samuel Beckett both are classics, we've got works that don't look or sound anything like the traditional operatic repertory but by my broader definition are operas all the same, though they might call themselves anything from musical comedy to performance art. "Music theater" is a common name for fusions of the two arts that don't fall into any traditional genre; I had planned to review music theater events performed in New York in the spring.

But it wasn't so easy. Some—like so many new operas—just weren't very good. Others would be hard to explain. What would *Keynote* readers think, for instance, of Christian Marclay's *Dead Stories,* performed by six vocal performers (some of whom included singing among their accomplishments), and by Marclay himself, who plays records, sometimes several at once? Sometimes he leans on his turntables' tonearms, grinding needles into his records' grooves. Downtown at the Performing Garage, where Marclay appeared, such things are routine. If I were discussing *Dead Stories* in the new music column I wrote for five years in *The Village Voice,* I might wish that a work already gripping in its darkness—dark performance space, dark mutterings, the dark subject of death—could have been darker still, with

Originally published in *Keynote,* 10, no. 6 (1986).

stranger, more varied behavior from the six sound-makers, and fewer bumps into unambiguous ideas. (They stuck out blatantly from the intuitive flow of the piece as a whole.) But in *Keynote* I might first have to explain that of course there's no narrative. And before *that* I'd surely need to say more about the sound of the piece. A guy grinding needles into records? Forget what opera might be; the first question here—or in any publication that doesn't routinely cover the left wing of contemporary art—has to be "What is music?"

Noodling in a Midnight Style

I'm left with one artist to discuss: Meredith Monk. She's famous, for one thing, so I can ironically insist that we're dealing at least with a substantial cultural phenomenon. And though she, too, doesn't bother with narrative—and though she's so comprehensive a theater artist that we'd have trouble classifying her as a composer, singer, dancer, actress, director, or choreographer—at least her music, taken by itself, isn't enigmatic. Most often she sits at a piano, noodling in a repetitive midnight style reminiscent both of minimalism and a Laura Nyro kind of pop, while in a rich (sometimes keening) voice she wails scraps of melody that might be folk tunes of a culture she invented herself.

A limited style, you might say (symphonies echoing, no doubt, in your ears). But let's be precise. Monk's emotional range, from somber to silly, is surely less limited than the emotional range of some of our stodgier classical composers, people like Brahms, Vaughan Williams, or Hindemith. What *is* limited is her rhetoric, though with Brahms, Broadway, and Elliott Carter echoing in *my* ears I'd say that's a relief. Besides, in her recent *Acts from Under and Above* (which she wrote in collaboration with actress Lanny Harrison, and which I saw April 10 in the East Village at La Mama E.T.C.), Monk seems to be moving down paths first mapped by Schoenberg, no less. The piano music tends to be more dissonant than usual, and the vocal phrases more irregular—asymmetrical, nonrepetitive, full of "glitches," as my companion said.

Why Not Opera?

Is *Acts from Under and Above* opera? Why not? At the start we hear the comforting sound of water, then (in darkness) the drone of Monk's piano. Lights then flash on and off; finally, in normal stage lighting, Monk comes forward like a waif, making sounds that, if

memory serves, were like a folksinger crossed with a baby bird. Music is just one element in all of this, but would anyone say that the flow of the whole wasn't musical? She varies elements in the show as if each were a musical theme. How many ways can she approach a piano? She can approach it directly, then sit down and play. She can approach it cautiously (then, as she sits down, the lights wink out, and the audience laughs). She can sit down, take off her jacket, and stretch before she plays. Sometimes she walks about the stage in silence; the lights go out, and in darkness her walking itself becomes a sound effect. Things in her work rearrange themselves and acquire new meaning, just as purely musical details do—strange association—in serial music, where the note A flat, let's say, might first draw attention because it was repeatedly the top note of a descending minor sixth, and later stand out again as repeatedly the highest note of a phrase, or because it was repeatedly played by a clarinet.

Or maybe the association isn't as strange as it seems; Monk tells me she always starts by planning the structure of her works. *Acts from Under and Above* is in two parts, one with Monk alone, the other with Monk and Harrison. The two parts had different colors—the first dark, the second bright and cheerful, accompanied by piano rags silkily played by Nurit Tilles—but in many ways the same shape: Part One had three musical numbers played by Monk, Part Two had three played by Tilles. But at the same time the second part seemed to evolve from the first. We saw a film in Part One, and three films in Part Two; Monk played the same piano three times in Part One, while in Part Two Tilles moved from her own grand piano to Monk's upright and then back again (and at the upright introduced her own variant of the "How many ways can we approach a piano?" game from Part One). Who was it who said, "All art aspires to the condition of music"? Music doesn't shape the whole, and yet the whole is shaped like music; more precisely, music, movement, film, and speech combine to create a flow more like music than anything else.

The Earthly and the Celestial

What does it mean? I might quote my colleague Linda Sanders from the *Voice,* who, though she didn't like the piece as much as I did, described it neatly as a "collection of vignettes, each suggesting some recognizable byte of experience and arranged in an archaic psychic hierarchy: the subterranean (Monk alone in an underground cave singing about fear), the earthly (Monk and Harrison in the everyday

world of the street, work, companionship, and fun . . .), and the celestial (an epilogue in which Monk and Harrison, wrapped in the blue of the heavens, look down upon a tiny twinkling New York"). (That last, I might add, was pure magic.)

But *what* it means is—especially for readers who've never seen anything like it—far less crucial than *how* you find out what it means. You've seen *Lohengrin,* perhaps, and you didn't know what *it* meant either, why Elsa had to die when she dared to ask who her hero husband was. But you were smart enough not to probe for an answer; you let the images wash over you and added them up at the end. That's what you do with Monk, though with no story to hang on to—the kind of story George Bernard Shaw called "police intelligence," which tells us who did what to whom—you might feel lost at first, assaulted by dramaturgical moths, or, more precisely, by unexplainable metaphors, images that demand explanation because in the absence of a story they're the only landscape the piece presents.

What saves you, perhaps, is the structure, which, just as purely musical structure does (whether you notice it or not) in the opera house, defines both the tone and importance of everything that happens. As Donald Tovey wrote about Wagner's *Das Rheingold:* "The jealous Fricka *did* hope (in F major) that the domestic comforts of Walhalla would induce Wotan to settle down. Wotan, gently taking up her theme in E flat, dashes her hopes by this modulation more effectively than by any use of his artillery of tubas and trombones." In a similar way the twinkling city at the end of *Acts from Under and Above* wrapped up everything that went before, though I couldn't quite say why.

In fact Monk has a commission from the Houston Grand Opera, which might prove she belongs in this column. Until someone shows me a new opera in traditional style that speaks for our time as Wagner and Berg spoke for theirs, I'd say the future of the form belongs to artists like her.

Edward Strickland

Voices / Visions:

An Interview with Meredith Monk

Strickland: Let's take it from the top. Is it true you sang before you spoke and read music before words?

Monk: Yes. I started reading music and taking theory when I was about four. I still have a little workbook from those days that I found when my parents were selling their house. I had a piano teacher who was also teaching me to read, and I was also studying Dalcroze Eurhythmics, which is a system of teaching music through very simple movement, so that you actually see the relationship between rhythm, pitch, and space. For example, children working on a scale might start with their arms down and raise them for the higher pitches and finally at the high *do* their arms would be straight up.

Strickland: Were you studying dance at that age?

Monk: Dalcroze Eurhythmics involved movement but not so much dance per se. It was more simple physical exercises, like skipping in time to music or throwing hoops in certain rhythmic combinations.

Strickland: What about voice?

Monk: Well, I always sang. My mother was a singer, my grandfather was a singer, and my grandmother was a concert pianist. I always had music at home. My mother said that I sang back melodies at a very early age.

Originally published, with minor differences, in *Fanfare,* January/February 1988, and included in *American Composers: Dialogues on Contemporary Music* (1991).

133

Strickland: Where were you raised?

Monk: I was raised in Queens, New York, for a while and—*[interviewer raises arms in triumph over head; Monk waves imaginary pennant]* Ya-ay! And later Connecticut.

Strickland: Did you study music and voice formally through high school?

Monk: Before I went to high school I started studying voice with my mother's teacher. My mother did commercials and musical variety shows on radio and early television. She was also studying classically, so I started working with her teacher when I was thirteen or fourteen. I remember at school singing solos and choral concerts at Christmas and other occasions.

Strickland: Where did you go to high school?

Monk: The George School in Bucks County, Pennsylvania, a Quaker high school. In high school I started studying theory again, and composition. There was a wonderful music teacher that I loved, Mr. Richard Averre.

Strickland: You then went to Sarah Lawrence. Did you major in music?

Monk: I had what they called at that time a Combined Performing Arts program. So by the time I was a senior two-thirds of my program was in performing arts—I had one academic course *[laughs]*. I'd figured out a way to do that. The combined program included music and voice. I had two voice lessons a week, and I was coached the other days. I was taking Opera Workshop, so I was singing in operas and learning about staging. And I was taking vocal chamber music with a composer by the name of Meyer Kupferman. That was a wonderful class. I had a great year. He was doing small chamber pieces with voice and maybe one or two instruments—things like the Stravinsky piece for violin, clarinet, and voice. Twentieth-century repertoire basically. And I was taking theory and harmony, dance technique, composition, history, and also some theater classes.

Strickland: All of which stood you in good stead.

Monk: During that time I started getting a feeling, a glimpse of a musical form that combined all those elements: music, movement, visual images, character, costume, light—that kind of thing.

Strickland: You also sang folk music and in a rock group for a while.

Monk: When I was in junior high and high school, I was singing folk music, but I was also singing, especially in junior high school, things like "Be-Bop-a-Lula." I was entertaining in functions like the prom, singing calypso. But a long while later, after college, I was singing in a band called the Inner Ear. That lasted about two months *[laughs]*.

Strickland: I know it wasn't a sustained commitment, but I mention it since you've said that you found a lot of the classical music at the time seemed to be written for people whose bodies extended down as far as the chin. I was wondering if the rock and folk influence was complementary.

Monk: I'm sure it had a lot to do with how I started writing my own music. What happened to me in that band was that I had really been doing my own work for a number of years by that time, and it seemed that singing in a band wasn't something you could just do on the side. It wasn't really my main interest. My main interest was making pieces, writing pieces, so that's why I didn't stay longer than two months.

Strickland: What type of music was in the air? It was a good time for pop culture, but in terms of contemporary classical music . . .

Monk: Really the most vital music at the time was rock 'n' roll. The Beatles were coming out with *Rubber Soul, Revolver,* and *Sergeant Pepper.* I don't remember thinking very much about contemporary classical music, though I was still singing lieder at that time, and I remember singing in a concert of Satie music around 1966. I sang some of his music-hall pieces with a wonderful composer and teacher by the name of Philip Corner. Actually, now that I think about it, there was a very interesting group of people working in classical music—Philip Corner, Malcolm Goldstein, Morton Feldman, James Tenney, that generation. Nam June Paik, Dick Higgins. And in 1966 Dick Higgins had a Satie festival at his house in the West Twenties. We did a concert at night that included some of his music-hall pieces, and then we did

Vexations starting at midnight and going on till about noon. People stayed overnight, brought sleeping bags, and it was really amazing.

Strickland: It's odd you mention Satie now, because I was wondering if you were conscious of a Satie influence in your multimedia works, *Turtle Dreams,* for example. I don't know if you're familiar with his *Relâche,* but did you know that was the first time film—by René Clair—was incorporated into dance?

Monk: I actually performed in *Relâche* in 1965. I played the Woman. We did it very much like a 1920s period piece. It's funny that when I started using film in my own work that direct connection didn't occur to me. But when I was about ten years old I had a piano book of various short modern pieces, and I remember playing Satie, and I had never heard of who this person was. And I remember loving that music, *Gymnopédies.*

Strickland: In *Turtle Dreams* you have a very apocalyptic aura in the film of the turtle as the last survivor in Manhattan. Clair had a camel dragging a hearse around the Eiffel Tower.

Monk: I don't remember the film very well. I think I was offstage. I think it comes in the middle with a piece of music that was played by James Tenney and Philip Corner, four-hands. It's a wonderful piece.

Strickland: Very repetitive too. A measure repeated eight times then another repeated eight times and . . . he calls it *Entr'acte.*

Monk: Yes. I remember the music but not the film so well, since I couldn't see it from backstage.

Strickland: How much mixed media was going on at the time?

Monk: A lot. I came to New York at the end of the Happenings period. What they would do visually was very strong, though sometimes the time element was not taken into consideration because they came from the visual arts. In the Judson era, just before I came to New York in the mid-1960s, there was a lot of cross-fertilization of ideas. It wasn't exactly taken for granted, but nobody had to fight for it very much anymore.

Strickland: In a way you fused drama and song in your extended vocals. You also experimented with the performance context right in this loft.

Monk: That's right. I was very interested in trying to do concerts that were not eight-thirty-get-tickets-in-lobby-and-walk-into-theater. I liked the idea of performances that were experiential for the audience, so I would do concerts in the morning here, and the audience would get coffee before the performance. The first piece I did in my loft dealt mainly with darkness and silence. The events would come out of the darkness, and the music would cut through the silence. It was a very quiet piece. Or I did performances that took place in different spaces. The audience would either walk to the next space or I would take them by bus, so that they were experiencing environment in a very direct way. A piece called *Vessel: An Opera Epic* in 1971 started out in my old loft in Great Jones Street, and then I had a bus to take the audience to the Performing Garage. And then on the weekend there was a large outdoor piece that took place in a parking lot near there. History is not very accurate, and a lot of people think these works were big free-for-alls, but each piece was very rigorously put together.

Strickland: The impression's been given that you had your audience racing for the subway to catch up with you.

Monk: It was *never* like that. I think that was in John Schaefer's book, and that was very odd, because it's a wonderful book—and he's a wonderful person, one of the great friends of new music. But if you actually read reviews from that period, you'll see it was all carefully planned, because the logistics were very difficult. In the outdoor piece I was working with almost a hundred people, and we had to work with the police department, etc. The environment gave the pieces their resonance, but it all had to be very rigorous.

Strickland: Now you're making me skeptical of these early legends. Is it true you composed a piece for eighty-five singers with eighty-five Jew's harps?

Monk: At the Guggenheim in 1969. I was using the sound of that space, which has almost a half-second delay. The performers were all up on the ramps, so the audience down below had the sensation of

being *inside* the piece, getting waves of sound coming from all different directions. Then there was a section where the audience walked around the Guggenheim, encountering events at very close range. Then finally the audience was on the ramps and the performers down below. The piece was called *Juice*. In those days I was very involved with how an audience perceived in terms of distance. The architecture of the building contributed very much to the idea of the piece.

Strickland: You have a wonderful voice—an incredible range and a lovely lyric soprano. You could have been singing mainstream classical vocal music for the last twenty-some years instead of doing what you've been doing.

Monk: Thank you. But I knew that I couldn't go into that because of my temperament. I didn't have the kind of temperament that easily did what was expected of me *[laughs]*. Sometimes I wish that I did! I think it would be a lot easier if you knew what to do next as a soprano—you know, you do this step, then the next step, then the next step. Somehow I had the kind of spirit that needed to find new ways. I wanted to make my own work, explore things, discover things.

Strickland: Maybe I'm making a false distinction, but could you say you had more a creative than an interpretive impulse?

Monk: I think that was more my impulse. I was very interested in seeing how different things worked, how to combine forms. But I loved to sing so much—I mean, it's the thing I love most in life!—and I didn't exactly know what to do about it. I just sat down and started vocalizing every day. And one day at the piano, doing straight vocalizing, I realized the voice could have the same kind of flexibility and range that the body has, and that you could find a language for the voice that had the same individuality as a dancer's movement, that you could find a vocabulary that was actually built on your *own* voice. That really excited me, and right from the exercises I started branching out. That was the beginning.

The irony is that the first piece I did for voice was with an Echoplex, a little echo chamber machine that my cousin, an engineer, had. I would sing, and he would do things with the echo. We would record that and later on in the piece it would be played back and I'd sing

against that and he'd record *that* and we'd keep on adding layers during a live performance. Now after working all these years with the voice I've realized that the voice can do almost anything that electronics can do. I've stayed very much away from electronics.

Strickland *[laughing]:* When I play your pieces for friends they assume you're programming your voice. Other artists involved in extended-vocal techniques haven't shied away from electronics, for example, Joan LaBarbara.

Monk: She's a wonderful singer, and I'm sure in the right hands it's a fine thing to be working with. It's just that for me there's still so much to find within the voice itself. It takes all my time and energy to work with that. And the exciting thing is that the group and I can perform almost anywhere, even if we don't have microphones or lights or anything.

Strickland: Other people were working around the same time with modifications of the voice. Crumb, Berio, Stockhausen in *Stimmung* . . .

Monk: Do you know that I've never heard *Stimmung?*

Strickland: I don't believe it! You've got to hear it!

Monk *[laughing]:* I keep on saying I've got to hear it. Every time we do *Dolmen Music* people ask, "Have you ever heard *Stimmung?*" I even know one of the singers in the original record.

Strickland: It's amazing, because I thought you were actually quoting *Stimmung* in one technique you use in *Dolmen Music [attempts to sing it].*

Monk: You mean where the two women *[sings]?*

Strickland: Yes! So when you started out with this, did you feel you were working in a vacuum?

Monk: I was pretty much working by myself with my own instrument, trying to find out what it could do and reveal. But as for the sound in

Stimmung, when you've been working with voice for a while you realize there are universal sounds, even archetypal songs. Working with your own instrument you come upon, say, the glottal break. Now in many cultures that glottal break exists: in yodeling, Balkan music, African music, North Carolina hollarin'. That's comforting and one aspect of it. The other aspect is that each person's voice is unique. There are certain sounds that I can get that other people have a hard time doing, and some people in my ensemble can do sounds I have a hard time getting. That's the excitement of working with the voice—having the *universal* human experience yet working very much with your *own* instrument. It's a little bit like phylogeny and ontogeny.

Strickland: What type of music were you listening to when you began to explore these techniques?

Monk: I always liked all kinds of good music. Classical music, jazz, rock 'n' roll, folk, ethnic music . . . in jazz at the time I was conscious of Albert Ayler, as well as the singers Ella Fitzgerald and Mildred Bailey. Also African folk music, which I *loved.*

Strickland: Many have seen a minimalist influence in your work. Do you identify with the term?

Monk: I really don't. First of all, I don't like the term. It bothers me. People like Steve Reich, in the early days, were working more with pattern and overpattern. There was a similar kind of movement in painting, so-called pattern painting. It's hard to be labeled. The repetition in Steve's music seems to set up a long enough time base so that when things shift it becomes an event, whereas in my music I use instrumental repetition more as a carpet for the voice to fly off—to fly from and back onto.

Strickland: Your vocals are anything but minimal. They're extraordinary in their range, rhythm, and variety of timbre. But there *is* a similarity insofar as you tend to use accompanying drones, repetitive broken chords, etc., beneath complex figuration, in your case vocal. Talking about other influences now, obviously a strong one in your work is chant. I don't know your religious background but—

Monk: I'm Jewish.

Strickland: I'm Catholic, so your work hits me very immediately, very viscerally—it's not something I had to acquire a taste for, since I was raised with Gregorian chant. Did you have anything similar?

Monk: Jewish liturgical music is mostly single lines. It's a vocal tradition but usually without harmony, usually unaccompanied in the Orthodox tradition. But I grew up as a Reform Jew and didn't really have a strong religious upbringing. In our temple there was vocal music, but often with organ behind it.

Strickland: Maybe that carries through in your work. You often use just a simple organ or synthesizer background . . .

Monk: I wouldn't think of that connection consciously. It's always hard to tell how your ethnic background influences your work, but the only thing I would connect here—not that I think about it in a conscious way when I'm working on it, but just as a temperament thing—is that I usually write modally and in minor keys rather than major diatonic. You could say that minor modal feeling is a very Jewish tendency, but I'd hate to generalize about things like that. And actually *[chuckles]*, I don't really know where some of this music comes from in me at all.

Strickland: The chant influence is very strong not only in *Dolmen Music*—you've got the antiphonal element in the "Rain" section, for example—but "Scared Song," which lives up to its title. It's not only scared, it's *scary.* That's an odd piece insofar as it conveys an extreme emotional state yet has a very liturgical feel to it. I saw it as a kind of liturgical psychodrama.

Monk: I'm so *curious* about that—it seems so secular to me, but somebody else said that to me. I think it was more like dealing with the *human* tendency in this society to be afraid of being afraid.

Strickland: Yes, but with that organlike synthesizer . . . it sounds to me like someone trying to confess—here we go again, Catholics . . .

Monk: I love it! *[Laughs.]* Not beating their chests but confessing.

Strickland: It's very churchlike to me. Someone confessing his or her soul in an empty church.

Monk: I just hope this music would evoke people's *own* images. That's why in the past few years I've sometimes thought I prefer just doing the music concerts to the big theater pieces. I really love that subjective element.

Strickland: I can get very subjective here—though I almost feel I'm going into analysis! When I first heard "View 1" I just about fell over because the childish, mocking voice in the piece sounded like a voice that I sometimes heard as a child trying to sleep and have remembered periodically since then.

Monk: Wow! In my own conception of the piece it was as if I were in a spaceship looking down at the earth, seeing someone in one place going *[sings in childish voice]* and someone in another place going *[sings in lyrical voice]*. It was as if you could see the whole world at once— that's how I was getting the images: some were like children and some were like old people. I was thinking of calling the piece "Aerial View."

Strickland: Another influence is organum, for example in "Astronaut Anthem."

Monk: I've always loved medieval music. I love music through Bach and then go to the twentieth century. One of my absolute favorites is Perotinus.

Strickland: In *Our Lady of Late* you're adapting organum technique with a kind of *upper*-voice drone in the water glass.

Monk: Yes. It starts in E-flat and goes up to G.

Strickland: What about your use of overtones? Were you familiar with Tibetan and Mongolian overtone chanting?

Monk: In the late 1960s someone gave me a Jew's harp, and that's given me a lot of ideas. Now I sometimes sing through the Jew's harp, pulling my breath in at the same time, which creates a partial between the Jew's harp and the voice. I translated the Jew's harp to voice, and that's how I began with overtones. I heard about Mongolian singing in 1976, when someone came backstage after my *Songs from the Hill* concert at

Town Hall and said, "You should really get an album"—and so I heard those techniques. But I'd never heard them live till last week, when the Mongolians came to New York for the first time. The man doing the *hoomi* singing was *unbelievable*—it was so inspiring! Bob Een in my ensemble was also there and told me he went right home and started practicing! I was doing overtones in my mouth and cheek area. Now we're all working on very high fundamentals and overtones that go *way* over, right through the forehead. I don't know why it's taken me so long to get to that—I had to be inspired by this wonderful *hoomi* singer. He's the best I've ever, ever heard.

Strickland: You've mentioned your ensemble. How did that begin?

Monk: I'd been working on *Quarry,* a big opera piece of mine, and I needed a chorus of twenty-seven who could sing and move well. From the twenty-seven I chose three of the women singers who were outstanding: Andrea Goodman, Susan Kampe, and Monica Solem. That's when I started working with extending *Tablet* from a solo version with piano to a piece utilizing four voices in as complex a way as my own voice as a soloist.

Strickland: *Tablet* was on the same album as *Songs from the Hill,* written in New Mexico in 1975 and 1976. What took you there?

Monk: I was visiting my sister. That's one of my favorite landscapes— in Placitas, New Mexico, between Albuquerque and Santa Fe—in the hills.

Strickland: There's an American Indian influence in a couple of those pieces, especially "Mesa." I felt that carried through in *Tablet,* written the next year. Did you feel a continuity between the pieces?

Monk: I never think of *Tablet* as the same landscape. I always think of *Tablet* as ancient Greece—winds and goddesses, Furies, that kind of mythic quality. Whereas *Songs from the Hill* really came from my sitting out in the hot sun every day, deciding that my discipline for the summer was to work on solo voice pieces, which I hadn't done for a long time. I had mostly worked with voice and keyboard. Basically I was writing a song a day—not the whole song, but the idea.

Strickland: Do you notate all your songs?

Monk: At that time I didn't because some of those songs are hard to notate. I would take a little tape recorder with me.

Strickland: If it weren't for recording technology it would be hard to preserve your work at all. You could look at a score and have *no* idea of what's really going on.

Monk: It's very difficult.

Strickland: What about your singers? Do they come from a homogeneous classical background?

Monk: I met Andrea Goodman when I was doing a series of workshops at Oberlin in 1974. She was not a conservatory student but studying music in the liberal arts school. She had the room across the hall in the dormitory and knocked on the door and said, "Hello, my name is Andrea." Somehow we started going through a book of hymns from the Appalachians called *Sacred Harp*. Then an organ player down the hall heard us singing, and he came in and we started reading through these hymns—all beautiful modal hymns. It was my first afternoon in Oberlin and I thought, boy, this is really going to be *fun!*

In late 1975 I was in Morocco and thinking about changing *Tablet* to a group piece. I'd been working with recorder and called a friend in New York asking if Andrea, who'd graduated just before Christmas, knew how to play one. "Well, yes, she *does!*" "Tell her I'll be back in a week and we're doing this concert for Merce Cunningham and can she be in it?" That was a primitive version of *Tablet,* working with two other voices. Andrea had been studying piano and when she got to New York started studying classical voice—she's always had such a naturally beautiful voice, but in recent years it's grown, it's gotten more body, a wonderful, wonderful dark sound and a beautiful light sound. And like everyone in my ensemble, she's very quick with new ideas.

The person working with me the second longest, Robert Een, came from a musical family and had studied cello with the Suzuki method and also voice—an excellent, excellent musician. Then came Naaz Hosseini, whom I started working with in 1980. She had been a violin major at Wesleyan and told me how in the middle of her senior exam

one of the strings broke and she sang the rest of the exam *[both laugh]*. She also had classical voice training. Those are the three who've been with me the longest. They all have a fantastic technical base, but what I love about their singing is that when you hear them it's not that you go, "Opera singer!" It's *Andrea's* voice or *Bob's* voice or *Naaz's* voice. I don't want them to sound like an imitation of my voice.

Strickland: Let's talk about a couple of the other extended extended-vocal—have to do something about this stutter—pieces, the longer works. What inspired *Dolmen Music?*

Monk: When we were performing in Brittany in 1977 someone said you have to see the Fairy Rocks, *Les Roches aux Fées.* Monica Solem, Tony Giovannetti, and I were driving down little back roads past farms and suddenly there were these huge rocks in the shape of a table. It was a very *strong* place. You could feel the energy of those rocks. It had a very mysterious quality because it was hard to figure out exactly how they had been placed that way—a huge horizontal slab over four uprights, so you're talking about tons of weight. And the uprights were about ten feet high.

Somehow Monica and I started singing. We just felt like singing. When I went back to America I started writing some phrases and realized the connection to these rocks, so I called it *Dolmen Music.* I was thinking about Druids, the ancient people who had constructed this table. I was trying to make music that had a kind of primordial quality but also a futuristic quality at the same time. Because when you were there you felt that it could have been creatures from another planet that had constructed that table. That's what it felt like.

Strickland: A lot of your music presents emotional extremes, and I wonder if that accounts for your reliance on temporal extremes, primordial or imagined future landscapes to . . .

Monk: To get deeper into the present. I think we're living in a society that is not really that interested in emotion *[both laugh]*. So in a way you have to go outside it a bit to have the human memory of feeling. And I think the voice is a wonderful instrument for dealing with emotion that we don't have words for. It can get between the emotions that we can catalogue. It has so much nuance and yet a very direct connection to the center of each person.

Strickland: That's true even of a less dramatic piece like "I Don't Know."

Monk *[laughing]:* "Mid-life Crisis," you mean?

Strickland *[laughing]:* Don't look at me when you say that!

Monk: I was thinking about calling that piece "The Ambivalence Waltz."

Strickland: Why do you think emotion is at such a premium in our society?

Monk: Things have sped up so much, sometimes it's hard for people to be open enough to feel any pain. If you're intelligently—not ignorantly or stupidly—open and things hit you, you can move through them. Instead, people are so afraid of feeling and so closed-in that if something does hurt them they hold on to it so hard that it's actually more painful. I don't think these defense mechanisms are very accurate in terms of what reality is. They have to do with fixating—fixating the way you think about yourself and other people.

Strickland: My single favorite of all your pieces is directly related to this—"Biography."

Monk: It's certainly one of my favorites too.

Strickland: In terms of how you perceive our society, it's almost as if that piece functions on the level of primal therapy. I'm not trying to reduce art to therapeutic or cathartic utility, but do you see a connection?

Monk: "Biography" is from the second act of *Education of the Girlchild.* It was one woman's life, from death through old age to youth, kind of a revery piece. I don't think of it as therapy so much as I think that music has the power to be a healing force in offering its energy and expansiveness to people.

Strickland: "Biography" is *so* moving . . . *[laughs]* but the funny thing is that on *Dolmen Music* it comes right after your *craziest* piece ever,

"The Tale." When I first heard it I couldn't stop laughing *[starts laughing, tries to stop]* all through the piece—and then "Biography" came on and I felt as if I'd completely lost my balance.

Monk: That was Manfred Eicher's idea. He's very good at ordering pieces. I had never sung it that way in a concert situation before. I sang "Biography" before "The Tale," but now I do it the other way.

Strickland *[laughing again]:* Just thinking about your voice in that piece, the kind of pinched . . .

Monk: It's sort of an old woman doing an inventory, talking to Death and going *[adopts creaky, high-pitched voice]*, "Well, you can't take me away 'cause I still have my this, I have my that . . ."

Strickland: "My money, my telephone . . . my allergies, my philosophy . . ."

Monk: And then Death's going *[shakes head, snaps fingers, drops voice]*, "Too bad!" I've always loved comedy and I think it would be a shame to do a work without it. I would hope every concert we do would have at least one funny piece in it. When audiences come to our concerts, it often takes them a while to figure out that they can have a good time. But then they do. Art doesn't always have to be totally serious.

Strickland: Getting back to "Biography," what do you draw on for a piece like that? I'm not trying to psychoanalyze you—"Have you had a rotten life?" and so on—but it's so pulverizing.

Monk: I think I worked on vocal qualities first. I thought of the opening section as a dirge, then toward the end the young girl's voice comes in *[sings]*. I saw it as a dialogue of her selves. So I don't start with emotion as my base. I really start with voice as my base and if it moves toward an emotion naturally, then that's what it is.

Strickland: How vulnerable do you feel when you're performing? Because you certainly destroy your audience's defenses.

Monk: When I'm singing "Biography" I'm just listening very hard. If you as a performer are going through this catharsis I don't think the

audience is. When I'm performing well it's a combination of pin-pointed awareness, absolutely focused, like a needle—focused on the moment, being there completely—and complete openness, so that it feels very expansive.

Strickland: You're conveying emotions either without words altogether or using words fragmentarily. One example is the waltz in *Turtle Dreams,* where you have the most prosaic statement in the world transformed into something terrifying.

Monk: "I went to the store." I was starting with a very ordinary reality that goes farther and farther and gets more and more extreme as the song goes on.

Strickland: It reminds me of Peter Handke's saying we must experience a nausea at words similar to Sartre's protagonist's nausea at things. What led you to begin *Turtle Dreams?*

Monk: I started realizing that I was living right here in this time in New York and that I was hearing a lot of dissonance and sounds grating against each other and that I was being bombarded by sensation. It seemed interesting to me to work on a piece that acknowledged that. Even in *Girlchild* you're in an ahistorical world, and *Dolmen Music* is out of time. In *Turtle Dreams* I was looking at this culture and trying to have some reflection of it in the music. That's why it has an edgy quality—very much like New York City.

Strickland: In the "Waltz" section you have a lot happening at once. People moving robotically with excruciating cries, on the screen the turtle moving through New York, and meanwhile a woman in a hoop-skirt waltzing with an imaginary gallant. Was she meant to suggest the nineteenth century?

Monk: It was just a collision of worlds, as if you sliced through the world of four city people—I always think of them as contemporary types, definitely urban, that have a lot of surface to them, yet the emotions come from inside. The waltzer is as if another galaxy suddenly cut through that world—I always think of her as coming from the Moon and cutting through this reality. I deal with that a lot in my

pieces, different realities presented simultaneously so that you get the feeling of a multidimensional spectrum of things.

Strickland: If we compare your work to a lot of contemporary compositions, it seems much more committed emotionally and at times politically—the fascism in *Quarry,* the apocalypse in *Turtle Dreams* or *The Games*—than the norm.

Monk: In those last two works I thought it was important to state the problem. After I finished them it seemed more appropriate to continue working but in a sense offer an alternative in behavioral terms—to show in a concert how people could work together creating an environment where tenderness, sensitivity, humor, emotional commitment, a certain kind of bravery and rigor can exist—that's already an alternative. Everybody pretty much knows what the problem is at this point. I still feel responsible.

Strickland: There are all sorts of concerts you or I might go to where the music may be technically or formally interesting or experimental but leaves you feeling "That was good, let's have a beer." Know what I mean?

Monk *[laughing]:* Yes, I do.

Strickland: So one statement of yours that impressed me was "I'm still interested in reaching people's hearts." There aren't a lot of composers today who'd use those words.

Monk: It sounds too romantic or something, right?

Strickland: No, it sounds great!

Monk: But I mean to a lot of people. That's been going on for at least the last fifteen years. That's why reaching feelings is so important—it's the only thing we *can* do now. Everything else is covered by the mass media. You can sit in front of your TV all day and not have any kind of feeling at all. Live performance seems a very important thing to try to continue doing. A direct connection with the audience on the level of heart is something music can do and a lot of other media can't do so easily.

Strickland: I think the reason a lot of artists might *not* say, "I'm interested in reaching people's hearts" is that the currency in mass culture is prepackaged emotions. People in the coffeeshop . . . most of them are stars in their own sitcom or soap opera. They've learned how to act with one another by watching *Cosby* or whatever. Friendship is emulating the same TV show.

Monk: But do you go along with that or just do something else?

Strickland: I think a third alternative taken by artists today is simply an abnegation of emotional content.

Monk: But that's what I would call going along with it.

Strickland: "We can't feel anything. We're all so corrupted by false images that even if we think we're feeling something we're not."

Monk: I don't believe that's true.

Strickland: I don't either, but I *do* believe we're facing a *massive* proliferation of freeze-dried emotions.

Monk: I totally agree with you. Something like "I Don't Know"—it's a very elusive song. I worked on it and worked on it and worked on it, and it can go in a lot of different directions. In some performances I've sung it with more irony than on *Do You Be*. For some reason that day it just went a little more toward tragedy. It has that funny edge of both self-irony and being in quicksand a little bit. It just eludes me all the time. That's the kind of emotion that's very delicate and complex, and that's something you don't usually have on TV.

Strickland: Just the uncertainty of the title and performance is something I think people are very loath to admit. I remember when I was a student, a friend of mine who'd dropped out of college asked me, "How many times did you ever hear a professor say 'I don't know'?" Now I'm a professor, so I know the answer—*far* too few. Or on a personal level: "Do you love me?" "I don't know." *[Both laugh.]* What happens is "Of *course* I love you." "Me too." So your piece is poignant because it points to something that's fundamental yet constantly

evaded. But what about the ambiguity of the title of the album. Is *Do You Be* an ungrammatical question?

Monk: Uh huh. I tried to translate that into Italian on my last tour. They'd translated the song "Do You Be" into *Si!*—exclamation point and all. And that did *not* seem to be it.

Strickland: The song was first recorded on *Key* back in 1970.

Monk: I'd like to hear that old recording again.

Strickland: I think it stands out from that album. But the new version has better sound, and your voice is more incisive. It's the only piece I know of that you've recorded twice.

Monk: It just seemed right to put it on this record. Working on *Do You Be* was very complicated. Manfred was more interested in an intimate album this time, and I was more interested in recording *The Games* as a whole. We talked and talked and talked about it and started working with some of the songs from *The Games*. "Memory Song" was the first we recorded. It became clear that the first side would be the piano and solo voice pieces, mainly from *Acts from Under and Above,* and that the second side would be mostly choral work from *The Games,* going from an intimate to an epic quality. It had a nice progression.

I was doing a duet concert with Nurit Tilles with some of the songs from *Acts.* At the end of that set in Munich we performed "Do You Be." Manfred was in the audience, and he said, "That sounds like it would be really nice for this album." I felt it was so many years since I'd recorded it, and it's very different with piano instead of organ. It felt right as the end of the first side of the album, and I did like the idea of recording it as a very young person and an older person. I also liked recording digitally for the first time. The dynamic range is unbelievable! I remember when we were working on *Songs from the Hill,* the engineer was going *crazy!* It would go from a whisper to full voice in one song and he had limiters on it, he had compressors . . . it was just ridiculous.

Strickland: On the question of keyboards, one thing that interested me in *Do You Be* was a new use of organ against acoustic piano, drone against riff, in "Scared Song."

Monk: I'd never tried that combination before. I'm getting to love playing the piano so much now that I've had to get my chops up to play duets with Nurit. I'm becoming so interested in writing for piano again. I used to like organ or synthesizer better because you could have a drone feeling and connect tones. But I love the articulate quality and richness of sound of the piano.

Strickland: The central section of "Scared Song" is very virtuosic. In my notes I've got this jotted down: "How avoid hyperventilation?" Was circular breathing involved?

Monk: Not there. It just doesn't bother me at all. I guess I'm used to it. It's just a matter of getting enough air in.

Strickland: That simple. Let me ask you about the two "Panda Chants" on *Do You Be?* Why a panda?

Monk: "Pahn-da pahn-da" had a really nice sound to it, and the people in Germany said that the sound was actually an animal.

Strickland: You weren't originally thinking of the bear?

Monk: No. Not panda but "pahn-da," just the sound. But it turned out that panda's pronounced "pahn-da" in German. If it had the meaning of a bear, it was fine with me. A lot of people think it's some kind of song for keeping the species alive.

Strickland: "Save the Panda." Well, it's a good idea . . .

Monk: "Save the Panda"—okay! *The Games* was a piece about the end of the world and the survivors living on either another planet or a spaceship remembering Earth's culture. The older people, that is—the younger people don't remember it. They don't remember what a cup of coffee is or a football game or a chair or an aspirin. Every year the society has games to reenact Earth's culture, but everything gets a little askew. In that song I was taking the idea of a chant, the way people would chant at a football game, but putting a word in there that doesn't usually belong. But that's the way the society is in *The Games*. A lot of other things are a little off like that.

Strickland: "Memory Song" from *The Games* is itself one of your most lyrical pieces, with beautiful use of Naaz Hosseini's violin and that bell-like synthesizer. The feeling of nostalgia and absurdity at once.

Monk: "*Foott*-ball . . . *Foott*-ball . . ."

Strickland: In *Turtle Dreams* the most commonplace phrase becomes terrifying. Here the commonplace becomes vaguely disorienting. Toward the end the tone changes with the overlapping voices from nostalgia to haunting.

Monk: I like the fact that it sounds like more than three voices, as in *Dolmen Music,* when it sounds like a lot more than six voices singing.

Strickland: It sounds like a whole monastery. One other piece we haven't mentioned is "Wheel," which is a beautiful ending to *Do You Be,* especially with the bagpipes.

Monk: Thank you. I've been wanting to work with bagpipes for years and it just happened that a wonderful player named Wayne Hankin— he plays all medieval and Renaissance reed instruments: rauschpfeife, shawm . . .

Strickland: You should use them! The double reeds and your overtones . . .

Monk: I'm working with him now on a new ensemble piece called *The Ringing Place,* Nurit playing hammer dulcimer and Wayne playing didgeridoo and maybe some of his other double-reed instruments. In *The Games* what inspired me to work with the bagpipes was that I love the idea of juxtaposing something as futuristic and spaceship-y as the synthesizer with the bagpipes, which are so fundamental, universal, and ancient.

Strickland: "Wheel" has the otherworldly quality of Celtic music. "Double Fiesta" is spaced-out too, but in a different way.

Monk *[laughing]:* I always think of "Double Fiesta" as someone going to a party and getting more and more out of it. It starts out very light and gets darker as it goes along.

Strickland: Here's the question I've been asking everyone. Which composers today do you particularly admire?

Monk *[after long pause]:* That's a hard one. Think about that one for fifteen minutes. I don't get a chance that much to hear other people's work, and when I have time off I go to the movies, almost any kind of film—I love old films. I like music across the board—the Mongolian singer I mentioned, the Brazilian percussionist Nana Vasconselos, who's a good friend of mine. I love to hear good jazz singers or players. I have a lot of records, but when I'm working on a piece I have a very hard time listening to music. Sometimes I just like to have silence.

I love a lot of Steve Reich's work. And of course I love La Monte Young's. A performance of *The Tortoise, His Dreams and Journeys* in 1966 I'll never, never forget. I remember going into a three-story building and hearing one note, which you could hear all the way down in the street. You could stay on the floor where La Monte, Marian, and John Cale were playing and singing or you could go to other floors, but you had to sign a paper that said if anything happened to your mind after you left, they weren't responsible for it! Which put kind of an edge on the situation *[both laugh]*. I remember going in there having a very bad headache, staying about three or four hours, and leaving feeling wonderful. I love La Monte's music, and the visual aspects that Marian does are so beautiful. I remember when Charlemagne Palestine was playing—he strummed the Bösendorfer—I also loved his music.

Strickland: What are your plans?

Monk: That's easier than the last question. At the Next Wave Festival from November 20th, my birthday, to the 22nd we're doing *The Ringing Place,* which we'll present as a work in progress if I haven't finished it. I'm also working on music for the score of a film that a friend of mine is doing called *The Fayum Portraits,* pieces for solo voice with Nurit playing the hammer dulcimer and also some really interesting things for voice singing through a double ocarina and getting a three-note chord and a lot of partials. In March I'm going to France to shoot a film of my own that I've been working on for about five years called *Book of Days.* I've written the music for it already and am working on the film aspect of it.

Strickland: What does it treat?

Monk: It deals with the Middle Ages and contemporary life, going back and forth between the two times. It's basically a film about time. It's a little hard to explain, but I'll show you the storyboards, drawings of the film from beginning to end, so you can *see* what it's like. I'm also starting to work on an opera for the Houston Grand Opera in 1990. I mean, I love these things planned so far in advance! You just wonder. There was a time years ago when I hated knowing what I was going to do in advance. I was kind of a hot-rodder and I could never plan and always felt very constricted if I had to. Then Merce Cunningham said to me, "Just plan. It's never going to end up being like that anyway" *[laughs]*. Anyway, the working title of the opera is *Three Ghost Stories*.

Strickland: Are they traditional or are you inventing the ghosts?

Monk: I'm inventing them *[laughs]*. Inventing ghosts . . .

Meredith Monk

About *Book of Days*

Early on in the process of conceiving *Book of Days,* I decided that the period of 1348–50 interested me particularly. The 1340s were very intense years in Europe generally, with obvious parallels to our time: the end of an era (we are now coming to the end of a millennium); the premonitions of spiritual apocalypse; the sense of the individual's powerlessness in the face of technology (or, at that time, of war, famine, and so on) as opposed to the Renaissance idea of the individual being the center of power; the AIDS plague and the plagues of the Middle Ages; the longing for spiritual redemption. Human nature—in its essential qualities and concerns—remains the same, even when the particulars of a society (environment, current events, knowledge, beliefs) are different. Suffering, ignorance, and violence are constants throughout history, as are joy, compassion, and love. By jumping from one period to another, weaving one period through another, I was trying to encourage the viewer to ponder, on the one hand, the ultimate fragility and ephemerality of human experience and, on the other, the continuity and durability of life.

Time

Book of Days is very much about the transparency and relativity of time—the sense that you can see one period through another and the sensation that everything could be happening simultaneously. That history is a thought, eternity is now. People who are able to glimpse this (visionaries, artists, healers, spiritual practitioners) are

Drawn from a manuscript by Joan Knight. In its original form, the material was elicited by questions posed to Monk by Knight in 1988.

usually a minority in the society. They live, in a sense, out of time and are rarely listened to.

Time goes backward and forward constantly in *Book of Days*. I wanted the audience to have the sensation of time travel. The film breaks expectations as to narrative structure, timing, text, character, and ambience. For some people, not getting what they expect is hard. For me, it's always very exciting when someone tries a new way of doing things. So that in that way I tried to please myself, be true to myself as much as I could, in the hope that my excitement would be passed on to the audience. I was working with perception as an active element. It was really part of the content; rhythm was also. To appreciate it, you have to suspend habitual ways of thinking about film and film structure. You have to be open to experiencing the film directly, on many levels, rather than relying on discursive mind to interpret what is happening. *Book of Days* is quiet enough to allow audience members space and time to perceive and feel the weave. My hope is that different people will have different ways of hooking into the material.

We did a great deal of research for the film. I read book after book. I thought it was important to have a solid ground of accuracy to work from since the film is a kind of visual poem or fantasy. Then our choices, such as the abstract costumes that convey the *essence* of the period and the poignancy of the individual faces, would come from a position of knowledge rather than from ignorance or carelessness. Jean Rosensaft, a curator at the Jewish Museum, suggested that I contact Dr. Ivan Marcus, a Jewish scholar specializing in the Middle Ages. Ivan is a wonderful person, with information coming out of every pore. His enthusiasm for the period imbued every discussion with rich vitality and humor. He deals with history as a living thing, not as something to be precious or pompous about. We had wonderful talks. I asked him all kinds of questions, ranging from what a Jewish family's bed linen would be like to what exactly a family would eat at its midday meal. Did men wear a yarmulke or another kind of headgear at home? Would people be allowed to sit in a cemetery? And so on. One day, I asked him whether a young girl would do such and such, and he said: "No, only a boy would, but have the young girl do it anyway! You're not making a documentary; you're making a piece of poetry!" I was incredibly relieved. So, although we tried to be authentic in an essential way in *Book of Days,* there is plenty of poetic license. When I

Page 20

Cut to (B&W) extreme long shot
of fields outside of town's walls.
As frame is held, farmers appear.
Christian musicians, nomadic monk
and Jewish storyteller enter frame.

Enter vocal music from Book of Days
score

Camera dollies in to follow
travellers walking toward town
gate

Camera dollies in to follow
travellers as they walk up
to town gate

Page 21

Travellers knock on town gate.
Camera tilts up to medium shot.

Vocal music stops

Cut to CU of guard looking out
of gate

Cut to extreme CU of travellers
showing guard their travel pass

Fade up on sounds of modern
airline terminal

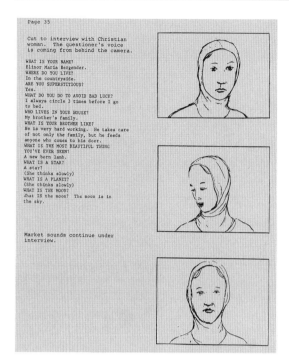

Page 35

Cut to interview with Christian
woman. The questioner's voice
is coming from behind the camera.

WHAT IS YOUR NAME?
Elinor Maria Bergender.
WHERE DO YOU LIVE?
In the countryside.
ARE YOU SUPERSTITIOUS?
Yes.
WHAT DO YOU DO TO AVOID BAD LUCK?
I always circle 3 times before I go
to bed.
WHO LIVES IN YOUR HOUSE?
My brother's family.
WHAT IS YOUR BROTHER LIKE?
He is very hard working. He takes care
of not only the family, but he feeds
anyone who comes to his door.
WHAT IS THE MOST BEAUTIFUL THING
YOU'VE EVER SEEN?
A new born lamb.
WHAT IS A STAR?
A star?
(She thinks slowly)
WHAT IS A PLANET?
(She thinks slowly)
WHAT IS THE MOON?
What IS the moon? The moon is in
the sky.

Market sounds continue under
interview.

Three storyboards for *Book of Days*. Renderings by Yoshio Yabara
(1988).

explained to Ivan that I wanted the film to take place in "generic" Europe so that the environment had an archetypal rather than a specific character to it, Ivan said, "Great! Shoot some of it in France and some of it in Germany, and you'll be making a 'medieval salad.' " And that's exactly what we did.

To create a sense of displacement, I used interviews like contemporary TV coverage for some of the medieval characters. The idea of *Book of Days* is to examine contemporary life from the vantage point of a person living in the Middle Ages. The little girl sees our world with unbiased (but bewildered) eyes. Her drawings of common contemporary objects, such as a bus, glasses, a gun, an airplane, a suitcase, are uncannily accurate, yet, as she draws, she doesn't know exactly what she is drawing. When we look at them, we sense an irony about what our world looks like to an innocent eye. In the same way, I liked the idea of using contemporary techniques to get closer to the medieval characters and, at the same time, convey disequilibrium or displacement. I hoped that the medieval characters answering the ques-

tions of the contemporary interviewer's voice in such a straightforward and direct manner would be poignant. At the same time, I hoped that people would find humor in some of the juxtapositions. The modern voice asks questions that have meaning for us, such as, "Are you athletic?" "What is a radiator?" "How do you treat stress?" How the medieval characters deal with things they have never heard of has a kind of irony to it. In all my work, I attempt to create a world in which the audience has a chance to see things that they take for granted, or never think about, in a new way. So that in their own lives, they might experience each moment in a conscious and vital way. *Book of Days* attempts to examine the world that we live in with fresh eyes.

Characters

The little girl and the madwoman are like some artists. They live outside of time; they transcend it. During the Middle Ages, artists were an anonymous but organic part of the society. The girl and the madwoman would have been seen more as visionaries (possibly dangerous), because what they were seeing did not correspond to the iconography of the Church, which was the dominant cultural organ. Since the Industrial Revolution, when a mind/nature, mind/body split occurred, artists lost the close link to society and became more like outsiders hired by the emerging bourgeoisie to entertain or to confirm the existing order. In the Romantic period, the artist became a disrupter of order, but continued to be regarded as an outsider—excessive, but politically impotent. Both of these trends have continued to today. So in a way, I thought of both the child and the madwoman as outsiders, an early version of the archetypal artist or poet. In some ways, you can also see them as prophetesses who are not listened to. No one really listens to what the little girl has to say. People interpret it in their own ways, as the grandfather does in the cemetery scene, or they don't believe what she sees exists, since it is not visible to them. The job of an artist is to listen to the inner voice: to what it asks for, to what it demands, to its images and insights. And then, to the best of his or her ability, to fulfill that vision, to bring it to earth in as perfect a form as possible. There is humility involved in knowing that he or she is attempting to make something timeless, invisible, and mysterious manifest in this transient world. In the case of the girl, she is true to her visions, even though she doesn't know exactly what they are. There is a quiet stubbornness about her. I hope that audiences can identify with her loneliness.

I always think of the madwoman as someone who can turn the dials

on her cosmic radio and go from station to station at will. (The girl is like a beginning adept. She keeps getting one station on her radio, but doesn't quite know what to do with it.) The madwoman sees all of time and human history (the good and the bad) with a sense of equanimity and compassion. She has learned to accept that this message cannot be heard by everyone, so in public (the market scene) she feigns stupidity, which is more convenient. At the end, during the plague, she becomes a scapegoat, destroyed by the mob, which in its panic tries to eradicate any outsider or minority (the Jewish community), in the ignorant hope that eliminating difference will eliminate the pain. The projecting of fear onto an "other" seems to be a recurring thread throughout human history.

I was thinking of the characters as strata of that particular society: the monk who has given up formal monastery life to get back to a more fundamental idea of Christianity; the grandfather who has obviously known persecution, but can still speak with courage and humor about "trouble"; the Jewish storyteller with his wily survival tactics; the quiet dignity of the Jewish mother. I like the honesty and simplicity of all the characters. And their sense of innocence—which they don't "act," but which they let permeate their faces and bodies.

Music

In *Book of Days,* music is used as an overview field—a kind of objective aural landscape that is outside of the reality of the images. In fact, it creates a kind of armature for the images to lie on. The music becomes part of the action, and identifies the characters or becomes a kind of language in itself.

When the images for the film first came to me in the summer of 1984, I was also beginning the music that became *Book of Days,* a vocal concerto performed by my Vocal Ensemble and a chorus of twenty-one at my Carnegie Hall concert in February 1985. It became apparent to me, after the concert, that the music and film seemed to relate to each other in some way. I realized that the music would probably form at least part of the film score. As the film concept became clearer, I knew that I would have to compose additional music.

I wrote "Eva's Song" (with performer Toby Newman's voice in mind) and "Madwoman's Vision" in the summer of 1987 at the Mac-Dowell Colony. This past summer (1988), I wrote "Jewish Storyteller's Dance / Dream," "Evening Lullaby," and "Morning Melodies"—also at the MacDowell Colony. I was very interested in knowing what medieval Jewish music was like. I went through the book *Jewish Music in*

Its Historical Development, by A. Z. Idelson (this was suggested to me by Nurit Tilles, who, along with Wayne Hankin, was musical consultant for the film). Many of the Jewish modes have a direct relation to some of the Church modes of the period. The two cultures did influence each other, although there are certain Jewish scales that had a distinctive Middle Eastern flavor. I wrote the Jewish melodies with that in mind, so that you could easily distinguish one culture from the other by hearing the melodies.

Often music and movement relate very directly. For example, when we shot the Jewish home scenes, I didn't think I wanted sound in those images—only the sound of the grandfather's interview. But when we edited the scene, those shots looked too much like cutaways, when, in fact, each one held up as a little scene in itself. So I decided it would be nice to hear a little sound in each of the shots as a kind of home texture under the grandfather's interview. I knew that the sound would make the images come forward and that the audience would feel the warmth of the characters more. So I tried to write a lullaby for Lanny (the Jewish mother) to sing. I looked at the sequence over and over to get a sense of her body rhythm as she rocked Hannah, the youngest daughter. Was it a 3/4 rhythm, or was it a 4/4? What was she singing when we shot it? I finally wrote a little, slow lullaby and hoped that it would work. I ended up telephoning Lanny to find out if she remembered what she was singing during the shoot. She said, "Sweet and Low," which is a 3/4 metered song. In the recording session, she sang the lullaby that I had written, watching her own image on the screen to try to get as close to her body rhythm as possible.

In some ways, the songs have a kind of content in themselves. The little girl's song (taught to her by her grandfather) becomes her way of speaking, her text. She sings it in the cave with the madwoman. Later, at the end of the film, when the camera is panning across her drawings (seen after six hundred years have gone by), the audience hears her singing it and knows that she (her spirit) is present.

In all my films, I'm interested in the musicality of images as well as in the music itself. In a sense, I want the whole—images, text, movement, music—to be so interwoven that they become like a piece of music for all the senses. Since I am a composer, however, the music itself and how it is used are extremely important to me. In *Book of Days,* I limited the instrumentation to voices, organ, bagpipe, hurdy gurdy, dulcimer, and shawm, so that it would be transparent enough to let the images have their own life. I am always extremely concerned

with rhythm; I try to find a way for the music to combine with the images so that the rhythms give each medium a richness and luminosity, and yet help them maintain an independence. I wanted the whole film to sing.

Kyle Gann

Ancient Lullabies

It was 75 heavenly degrees in Miami when I left the New Music America festival December 10 and flew into New York's first deadly cold spell of the year to hear Meredith Monk and Nurit Tilles at Town Hall. They made me glad I did. Attendance at the festival was the highest in six years, but each night the numbers declined. It's not that there wasn't good music (more detail next week), but aside from Naná Vasconcelos and Lou Harrison's Third Symphony, little of the music bothered to do what Meredith Monk does best: communicate. Watch an audience dutifully endure some character's computer-hindered guitar improv; then watch Monk, doing something just as weird, zip her energy into a crowd's psyche with such superconductive efficiency that they leap to their feet and yell when she finishes. You'll suddenly realize what most new music lacks.

Monk opened with a string of solo songs, whimsical streams of humming, glissandi, nonsense syllables, and tongue clicks whose utter simplicity would have embarrassed any composer with pretensions. Her basic formal model, which has changed little since her 1976 *Songs from the Hill,* is one every kindergartner understands: sing a phrase, repeat it, sing a different phrase, work your way back to the first one. With that pattern she drew us into each piece, set us up, and played with our expectations. Get used to a syllable pattern, she'd drop one out and pop it in again where you least expected it. In its way, it was as profound a reduction of music to its essentials as was achieved by any major figure of the previous generation. Cage's and Lucier's paradigm is nature, Oliveros's is breathing, La Monte Young's is the sustained tone, but Monk's is the lullaby (she's recorded three explicitly

Originally published in *The Village Voice,* December 27, 1988.

so titled). If that isn't humankind's most primordial *musical* image, then why do her songs sound as though they echo across the millennia from a tone-world we subconsciously remember?

Nothing she's done has sounded more ancient than her newest work, *Fayum Music*. This was as delicate as its subject matter—ancient Alexandrian portraits painted in pigmented beeswax—and would have benefited from a more intimate space. Beneath projections of strikingly realistic second to fourth-century B.C. faces, Tilles hammered a dulcimer while Monk sang and blew repetitive motifs on an ocarina. Monk's plaintive wail was sometimes static, other times made from haunting modal formulas reminiscent of Hebrew chant. Lay them over Tilles's shimmering, bowed-string drone, and they satisfied one's intuitions about how ancient Indo-European music must have sounded far better than the stilted Greek parchment transcriptions one occasionally finds on scholarly records.

The program's more extroverted second half collected seven diverse pieces, including the entire first side of her ECM album *Do You Be*, under the title *Music for Voice and Two Pianos*. Here she had found in Tilles no mere accompanist, but a reflection, matching her folksy voice tone and scintillating finger precision in perfect attunement. Like children's drawings, or the stunningly frank etchings of Jean Dubuffet, these songs evoked emotion through sheer content rather than their manner of depiction. In "Scared Song," the sparkling sixteenth notes with which Tilles accompanied Monk's chant "Scared, oh I'm scared" dredged up to consciousness the painful helplessness of childhood fears more chillingly than any tone-painting could have done. It worked for adult anxieties, too; in a song about midlife crisis, Monk sprinkled gorgeously facile melismas through an aria of inarticulate stutters: "Um, well, uh yeah . . . I don't know."

Other songs were of more purely musical significance. Monk paid homage to Henry Cowell in "Anger Dance," imitating his instructions in one work to "play each phrase until you get mad enough to change it." "Double Fiesta" wrapped a cadenza around the word "vacation," chosen only because it fit the piano's rhythm so well. The exuberant arabesques on "Ninininini," "Nuhaydenda, Haydenda Ho," and "Hnga-Nga-Nga" proved not exactly that music is fundamentally about sound—many recent composers have told us that much—but that music is humanness *projected in* sound, a point frequently forgotten by avant-garde apologists.

But rarely forgotten, fortunately or otherwise, by audiences. Music

doesn't reach listeners unless it has enough power to jump over its pretensions, and because she has none, Monk's merest ditty scores a bull's-eye. Admittedly, some great modern art has been obscure, so we've started assuming that obscurity is a necessary feature of important art, and have forgotten that even Faulkner wished some editor had had the guts to correct his grammar. The pinpoint directness of Monk's art, the fully comprehending laughter of her audience, show that you can still follow unconventional paths and carry a crowd right along with you. That vagueness aids profundity is the great lie of twentieth-century art. In Meredith Monk's music, the truth sings like a canary.

Meredith Monk

From Liner Notes for *Facing North* Album, 1992

In November and December 1989, I was in residence at the Leighton Artists Colony in Banff, Canada. I was there to work on the music and the scenario for my opera, *Atlas*. Looking out the window of my studio in the woods, I could see the slender pine trees and snowy mountain peaks of the Canadian Rockies. Elk, mule deer, squirrels, magpies, and coyotes were my occasional visitors. Toward the middle of November, it began to snow. It snowed for days at time, transforming the woods into a luminous, velvety world. Having lived in the city for many years, I realized how long it had been since I experienced the silence and stillness of that world.

I temporarily put away my work on *Atlas* and began composing some a cappella vocal pieces inspired by what I was seeing and hearing. One piece ended up being the "Ice Demons" section of *Atlas;* the others became *Facing North*. In each piece I tried for a clear and simple structure that would allow for primal yet transparent vocal qualities. As I was working on the music, I had the sensation that I sometimes feel in the desert—the awareness of the fragility of human life in relation to the forces of nature and in turn the vulnerability of nature itself to the indifference of human beings. As I worked, I tried to evoke the elemental, bracing clarity of the northern landscape. I realized then that "north" is also a state of mind.

I had been wanting for some time to compose a duet to perform with Robert Een, a longtime member of my Vocal Ensemble and an extraordinary singer and musician in his own right. I had had the pleasure of singing with him for many years but never in the context of a duet. From the time I first met him in 1977, I was moved by the bell-like clarity of his musical understanding and the beauty and honesty of his singing and playing. As I was working on the *Facing North*

material, I thought that this would be a wonderful basis for the duet.

When I returned to New York in January, I presented the music to Bob and we began rehearsing. Having grown up in Mankato, Minnesota, Bob had rich associations to bring to the material, which in turn influenced the direction in which it went. I had written out some of the music, but early on, we realized that the process of singing it demanded the concentration and speed which came from getting it into our voices and bodies directly without the intermediary step of looking at it and memorizing it. Some pieces ended up being close to what I had conceived of in Banff, while others were formed and transformed during our rehearsal process. We first performed *Facing North* as a music suite in concert. Then, images and movement ideas began to enter my mind. Bob and I began playing with the visual and kinetic elements. I asked Debby Lee Cohen to design the environment and the costumes and Tony Giovannetti to create the lighting. In June 1990, we premiered *Facing North* as a chamber music/theater piece about a barren wilderness and the fortitude and tenderness of two people surviving within it.

Sometimes when we rehearsed, Bob and I would talk about the fact that both of our families have relatives who came from northern climes: his from Norway, mine from Russia. So, then, *Facing North* could be a tribute to our ancestors or to all the people and creatures who have ever lived in the north; or it could be an homage to the land itself. Or perhaps it could be an appreciation and acknowledgment of the north in all of us.

Deborah Jowitt

Materials Transformed

Meredith Monk's epic music/dance/theater works are like mosaics—except that the materials haven't the uniformity of colored tiles. They differ in shape, texture, weight, and we juxtapose them across time; one action, remembered, may illumine the one we are currently experiencing. Her smaller works—like *Turtle Dreams, Paris* (a collaboration with Ping Chong), and her new *Facing North* (developed in collaboration with Robert Een)—are more like landscapes that separate into layers: now one part swims into prominence, now another; now the performer is a person sitting under a tree, now she is the tree. As in many Eastern theater forms, the performers switch modes: being, standing in for, commenting on, illustrating.

In the layers that make up *Facing North,* Monk and Een—the sole performers—invoke snow, totem ancestors, birds, bears, moose, Inuit tribespeople, European explorers. At least, I imagine they do. Through objects and clothing, through minimal, but eloquent movement and gesture, through complicated, often astonishing vocalizing, the half-hour duet (shown as a work-in-progress to invited audiences) brilliantly, fastidiously creates a frozen wilderness. Humans stay here at their peril, yet they can destroy it. May destroy it.

Monk and Een stand behind a miniature landscape—a hill of un-bleached muslin dotted with tiny, scraggly pines. They're wearing bulky fur clothing turned hideside out (Debby Lee Cohen designed both model and costumes). Their thrust-forward lips produce a susurration that grows to a whine; commingled, their voices sound like winds in collision. Occasionally one or the other plants another tree in the hill, and at the end each sets a tiny human figure on the white slope.

Originally published in *The Village Voice,* July 3, 1990.

Most of their singing recalls, but in no way imitates, the intense but playful "throat singing" of the Inuit Indians. Like these people, they often stand close together and face each other to sing. In one duet, they hold harmonicas with their mouths only and advance cautiously and clumsily toward each other, hands held like paws, for a cautious, numb-fingered handshake. Their playing emphasizes the breath-in-breath-out mechanics, and a later wordless song also, eerily, produces tones on the intake of breath.

When they stand over an imaginary fire, slapping themselves to keep warm, their little modules of contrapuntal singing are jaunty, conversational. Een maintains a ground bass of *he, heh, ha, ha, ho, hos,* with variations, while Monk weaves higher, sweeter calls into it. Later, side by side, they do an eccentric little song-and-dance—lifting their shoulders in tricky rhythms to their cheery sing-a-ding-a-dinging and jumpy keyboard chords. It sounds like a lunatic Scandinavian folk song.

In the most amazing scene, they advance on each other, tossing their voices out. Sudden, high notes burst out of a low humming and fall back into it; gradually the notes take on a yodeling fall and rise. Monk and Een seem to be taking turns filling in the melody, like people finishing one another's sentences; now and then, sounds collide uncannily in the air between them.

Their actions are few. They put on and take off heavy gloves and hats. They bed down like animals and stare slowly around. He breaks sticks while she turns her head with birdlike quickness. They trudge as if through deep snow.

At the end, we hear a helicopter in the darkness, and suddenly a small tentlike white swag of fabric lights up showing two pairs of snowshoes entombed inside it. And in a single second we can think of relics of rescued explorers and artifacts of an endangered culture.

Meredith Monk

Process Notes on *Atlas*, 1989

The basic theme of "Ghost Stories" is the loss of wonder, mystery, and freshness in our contemporary life and the possibility of rediscovering it. As Joseph Campbell so eloquently says in "An Open Life": "The sense of the mystery, the gratitude for being alive, the sense of transcendent energy that unites all of us, coordinates our cities, coordinates our lives—that's all been lost. The work of the artist is to interpret the contemporary world as experienced in terms of relevance to our inner life." Since I work as a mosaicist, building my pieces out of modules of music, movement, character, light, image, text, and object, it is difficult to describe "Ghost Stories" in an absolute manner at this point in my process. I am at the stage of gathering my materials, discovering the strands that I will later weave together. What I am working with is three different manifestations of this basic theme. I am allowing the ideas to come for all three, knowing that possibly and probably they will combine in some way—these three islands will connect underwater to form one whole. There are similar motifs in all three:

1. There will be three acts with elements that recur or transform from act to act. For example, there will be the image of the Big Dipper, which will be seen in different perspectives in each act.

2. In each version, there is a cappella, pure, ethereal music for eight voices, which I began working on in 1987 under the name of "The Ringing Place." This music has the radiance and resonance that implies the existence of an invisible world that underlies what we think reality is but that we rarely notice or connect with.

171

3. Each version also has contrasting music sung by the characters which is robust, earthy, full in quality. This will be accompanied by the instrumentalists.

4. Each deals with time—either jumping from period to period or showing the stages in one person's life that take place in three different times.

5. Each is mythic and epic in its concept, but each will be realized in simple and essential means.

In order of my thinking process, the three approaches are as follows:

a. My first idea was to do a piece in three acts dealing with three "ghost stories." Each act would take place in a different location during a different period of time. The locales and eras that I had in mind included a contemporary urban section, a section of pioneers on the prairie during the mid-nineteenth century, and a traditional Japanese section (based on a story from Lafcadio Hearn's "Kwaidan"). Each section would have some similarities serving as constants throughout the piece—for example, each would take place at night; a ghost or phantom would enter and change each situation. There would also be images of other nights which would seep into the atmosphere—flappers from the 1920s would enter the urban section; the traditional Japanese section would be intruded upon by futuristic elements; prehistoric and Mexican elements would appear in the prairie section. The entire piece would work with perceptual contrasts both musically and visually, all within the framework of night.

b. These ideas transformed into a piece about reincarnation, focusing on the mystery and impermanence of life. The overture would take place in another world on which a harmonious society existed. Singing the ethereal music that conjures up images of the universe resonating, of planets spinning, the group would perform a ritual that ends in sending down one of their members to Earth to become part of the human race. A narrator or guide character conveys to him/her and to the audience before each of the acts, the current events of the period in which he/she is entering. The three locations and eras are: (1) Pompeii right before the disaster; (2) the Spanish Inquisition; (3) contemporary urban office. He/she forgets where he/she came from and becomes embroiled in human existence. In each act, a ghost or phantom (from his world) delivers a message about how to avert a disaster that is occurring on Earth. He is the only one who can per-

ceive this figure, but not until the last act is he aware of himself and where he comes from and then changes the course of events on Earth. In each act, he dies and becomes reborn in another incarnation (sometimes as a man, sometimes as a woman) in the next act. The hero-heroine can be identified by a constant costume element (such as red sleeves, for example); similar movements and vocal themes recur in each act. At the end, he goes back to his world.

 c. The third set of ideas is based on my interest in Tibet (and, by extension, other non-Western cultures) and in the life of Alexandra David-Néel—a female explorer who was one of the first Westerners to reach Tibet (in 1912); lived to be 101 years old; spoke fluent Tibetan in order to reach Lhasa undetected; spent years in hermitages meditating and becoming a Buddhist scholar. This piece is about the idea of search—the eternal quest for the meaning and transcendence in life. It is also about the cycle of one person's life, paralleling events in our century in which the notion of an uncorrupted or untouched society has been steadily eroded. The main character (which right now I'm thinking of as a man, but may be a female hero closer to the model of Madame David-Néel) is first seen in the first act as a child. There has been an overture of the ethereal, ringing music. The child is lonely and sensitive except for his or her fleeting glimpses of another existence (characterized by short phrases of the pure music of the overture). There is also a sense of his knowing that his destiny is to travel. In the piece, his physical wandering parallels his spiritual search. At the end of the first act, the child stands in the center of the space and is replaced by his adult self. The second act is the main act of the piece, which is his journey with and without companions to distant lands. He spends time alone as a hermit where he is visited by apparitions, temptations, and dreams. He finds places (untarnished by the fragmentation of industrial life) where other realities are allowed to exist as part of the culture. His journey is also marked by romances, follies, and misunderstandings. As the act goes on, we sense coming in around the edges, the threat of soldiers, tourists, intruders that begin to cause the destruction of the society. The act ends with the man in the center of the space being replaced by his older self. In the third act, the old man goes back to the place of his youth to revisit the world of his memories. Ruins and rubbish are all that remain. An old woman, who we realize is his wife, enters. He shows her the place and sings a song about his youth. They quietly walk to a table, where they perform a simple, tender scene, drinking coffee as the scenes of destruction

around them go to black. After his search, tests, adventures, and romances, he finds utopia in the simple acts and tendernesses of the moment. The pure, ringing music that has been underlying the whole piece swells.

So, these are the ideas that I am playing with. I think of them as seeds that have been planted, ready to bloom when the time is right. My job is to cultivate them, water them, nurture them until the strongest ones come up. The process of making a piece is very much like a quest: you start out in the dark; you have a sense of the potential that opens out before you; there is a sense of danger because no one has gone this way before; you follow clues, listen to instincts, look for what is needed; soon, the way becomes apparent as more and more layers are added in and the piece takes on its own life.

Bonnie Marranca

Meredith Monk's Atlas of Sound:

New Opera and the American

Performance Tradition

In the history of modernist performance ideas the representa-
tion of the body in space has always been shaped by each theatrical
generation's expression of the search for spiritual renewal. This persis-
tent though often overlooked theme of theatrical modernism, ex-
tending from its beginnings in Symbolism to our own turn of century,
is at the center of Meredith Monk's oeuvre, nowhere more expansively
than in her first full-scale opera conceived for an opera house, *Atlas*.
Still, with its eighteen singer/performers and ten orchestra members,
and premiere at the Houston Grand Opera, this is no ordinary work
in the genre. In place of the conventional book there is a repertoire of
vocal techniques that encompasses glottal effects, ululation, yodeling,
speech song, animal sounds, and vocalization. Texture of the voice is
more important than text in this opera that dances. The musical line,
which overrides any sense of literary line, is inseparable from the line
of the body.

Atlas: An Opera in Three Parts evolves as continuous movement,
organized in the thematic divisions of "Personal Climate," "Night
Travel," "Invisible Light." Movement joins with song in a melisma
effect that characterizes the opera from the very start, generating
highly emotional moments. It opens with a scene of domestic life. On
one side of the wide proscenium stage of the Annenberg Center at
Philadelphia, where *Atlas* was presented as part of the American Music
Theatre Festival, there are two parents in a conventional living room
setting, and at the other side is a young girl in her bedroom, its win-

Originally published in *Performing Arts Journal* 40, vol. XIV, no. 1, (1992)
and included in Marranca's *Ecologies of Theater* (Baltimore: Johns Hopkins
University Press, 1996).

dow looking out to the world, a lighted globe nearby. Pictorially, the opera emphasizes this horizontality as a reflection of its internal linear movement, specifically, the work's unfolding as a journey. Warming this space of desire, lit by bright colors and framed by patterned wall paper, are the restless dreams of thirteen-year-old Alexandra.

She gets up from her bed, cuts a wide span of the torso, in simple stretching, grasping movements that match the open vowels of her vocalizing, "la-la-la. . . ." The emphasis on vowels, here and elsewhere in the opera, enunciates its theme of travel, to inner and outer worlds. Not unlike their proliferation and effect in Monk's earlier *Recent Ruins,* they open wide to the air, to experience. What is a vowel but a song?

Alexandra's dance is used less to give steps to a character than to create a movement pattern. This is a general principle of *Atlas;* one might call it figuration instead of characterization. As the scene progresses a French horn highlights the mood of travel, and the clarinet adds a certain reedy breeze to it. In contrast, the violin and cello underline the parents' worried duet; the father's anguish registering in his lower aching tones, the mother's in the high-pitched shrills of a wounded animal. In this way, the trio of mother, father, daughter— sometimes at opposite ends of the stage, at other moments close together—is dramatized musically, through major and minor keys covering a wide range of vocal textures. The voice is choreographed as it were, the expressive content reinforced by Monk's distinctive ostinato.

Some critics have interpreted the first scene as a commentary on the sterility of bourgeois life, but this interpretation distorts Monk's imagery. Scenes of home life and childhood are an essential thematics in her theatrical narrative over more than two decades; the institutional branch of her artistic company she named "The House." Monk's domestic scenes have always been cast in loving, respectful tones. In *Atlas* the parents appear in three scenes, two in the first section and a third in the second section. They are also given some of the most beautiful melodies in the opera. Nonetheless, the daughter leaves this balmy climate to seek out new worlds; her search is for enlightenment, not love. The interplay of light and dark, harmony and dissonance, wisdom and ignorance filters through *Atlas,* whose intrinsic subject is vision, the art of seeing—but only in the sense of spiritual radiance.

A film (in negative) of a horse running wildly is projected just beyond Alexandra's window, uniting freedom and eros in her fantasy of adventure. The horse's head splits open and out step two guides for the impending journey, a male and a female dancer: performers as

guardian spirits. At times the guides interpose variety acts between parts of the opera in a manner similar to Robert Wilson's "knee plays," but they are more integrated by Monk into the narrative as individuals, dancing their way into the opera, moving it along.

Young Alexandra begins her rite of passage to womanhood. Monk herself now comes on stage to play Alexandra from the ages of twenty-five to forty-five, at first interviewing potential travel companions in an airport. Whether or not they belong to her chosen group depends on the sound of their voices; those who do not belong have a dissonant tone. From time to time a screen high in the corner of the stage will project the biographical facts of a performer to personalize him or her. *Atlas* draws its inspiration from the life of Frenchwoman Alexandra David-Néel (1868–1969), the remarkable seeker of spiritual perfection who traveled through India, Sikkim, Tibet, and Nepal in the first quarter of the century. In remote parts of Tibet she was frequently called *khadoma,* the name given to a reincarnated female spirit—the privilege of such a role not unappreciated by the former opera singer. Like many other *fin-de-siècle* Europeans attracted to theosophy, occultism, and mysticism, David-Néel turned from the West to the Orient for wisdom. The tireless lecturer, writer, and traveler published more than two dozen books on Buddhism and her sacred experiences in Asia. But *Atlas* is much less her story than Monk's own spiritual biography, a personal mythology linking it to her signature works, such as *Quarry* and *Recent Ruins,* and the films *Ellis Island* and *Book of Days.*

Structurally, the narrative of *Atlas* follows closely Joseph Campbell's view of mythological adventure outlined in *The Hero of a Thousand Faces:* separation-initiation-return. Campbell calls this the "nuclear unit of monomyth." Its constancies include wondrous sights, the figure of a guide, visits to unknown regions of the earth, trials and temptations. All of these defining points find their way into Monk's poetics.

The tripartite structure of *Atlas* depicts this journey and transformation, the horizontality of the performance space arranging itself naturally as a zone of myth. Like travel narratives, which are becoming increasingly popular, the journey is spatial, the searching outward for new places; but like the mythic quest, it is temporal, a soul-searching. In her mapping of consciousness, Monk combines the two (site/sight) through music (time) and movement (space). The route is the vocal line that grows organically from the line of the body. So the voice itself then has body. Eventually, the journey ends where it begins: at home. In the last scene Alexandra, now sixty, is seated at a table, and on the

same bed where she as a girl dreamed of faraway places, the other two Alexandras sit quietly. The child-woman is one of Monk's enduring portraits, *Atlas* demonstrating in a larger context the education of the girlchild, her most persistent motif.

In its own way it is a teaching play of sorts whose ethos is founded on the ideal of community, even the more Jungian world soul. However, though the opera is designed with a series of lessons represented in a frame, accented by the staging of scenes (stage pictures) in squares of the space, it is not Brechtian in its intentions. The performers always inhabit an emotional space that reaches out toward the audience. They don't quote social behavior in any gestic manner; besides, Monk proposes a view of "human nature" as an internal process. If *Atlas* is epic in its narrative structure, nonetheless it demonstrates that the Brechtian dramaturgical style can open up new possibilities for use in a highly abstract, emotive, and more allegoric theatricality. In this way, it avoids the prosaic psychological plotting of both dramatic realism and conventional opera.

The use of imagery as a narrative strategy retains a strong attraction for Monk and many influential artists of the past three decades who, like her, have deep roots in the dance, visual arts, theater, and music worlds of the 1960s and 1970s. A key concept of that period, "energy," has evolved in contemporary art into the discovery of spirit and the sacred, a powerful theme in Monk's theater. The polyvocality of her community-based ethos, as it pertains to the musical settings of *Atlas,* the fullness of the orchestral sound, and the opera's relation to the audience, serves as both structural and political principle.

Alexandra's travels with her explorer-companions take them to many kinds of communities: Western, Middle Eastern, Nordic, Asian; they visit rural and urban landscapes; they experience arctic, forest, desert climates. The scenes—whether warm, cold, dark, or light—flow easily into one another, as in the fluidity of dreamscapes, so parts of stage props and more elaborate design elements appear in one scene and then another, almost as if the staging itself were moved by the feeling of legato.

To illustrate the manner of segue: after overcoming the trials of the ice demons in an arctic bar the explorers find themselves in a forest, where they walk the tracks of an ancient man's beard, spread out in five directions on the ground. In made-up wordplay Alexandra "translates" for him the questions of her friends, "Has anything changed?" "Can one find love?" Musically, the scene (one of the rare verbal sec-

tions) is very moving, culminating in the final moment, after the explorers have all left the stage carrying their tree props, when a lone woman who remains does a brief angular twist away from the old man toward the wings, as if she were uprooted in a great gust of wind. All the while the cello and viola instrumentation subtly incorporates the tango rhythms of the next scene, which is a desert tango set in the Middle East. In a visual pun on the dry passion of the dance, the two guides dressed in formal attire dance downstage while tents are set up behind them, and performers costumed as camels prance in between. The early part of this scene (it later turns dark and ominous) is a good example of Monk's humor, while also signaling a certain whimsical performance attitude that is identifiably an outgrowth of the New York avant-garde of the past three decades.

Monk's work has a willful naivete, even utopianism, but that masks a sophistication that can go unremarked. Oftentimes a contemporary attraction to new themes brings into focus aspects of an artist's work that were overlooked in other years due to political or aesthetic preoccupations prevalent then. Monk has had a long-standing interest in the life of cities and world cultures, way in advance of contemporary events. Seeing her work against the background of current concerns, what is immediately striking is, of course, the ecological theme, which in the American context is inseparable from the spiritual theme. Extending from Thoreau, this seems an even more powerful linkage within the perspective of the environmental crisis. Monk's view has always been biocentric, with its dimension of concern for all species of life and the overall survival of the Planet. The long scene in the second part of the opera, which takes place in an agricultural community, is in a sense a testimonial highlighting the value of self-sufficient human labor on the land, organized by the rhythms of work songs. In *Atlas,* the concept of culture is implied in its classical meaning, that the measure of a civilization is the attitude of a people toward their land.

Given the thematic composition of *Atlas,* with its attention to *communitas,* self-knowledge, and cosmic harmony, especially the spiritual climate of a place, it is not surprising that the opera should include a contrapuntal response to the peaceful agricultural society portrayed. That moment comes in the frantic gesticulation of a man in a business suit spotted at his desk in glaring yellow and green light, accenting his arms as they cut wildly through space. He conducts the "Possibility of Destruction." Troops in bright orange uniforms march behind him in

an industrial setting to the sound of electronic noise, the sky raining white flakes of doom. This condemnation of the combined forces of the military-industrial complex is the harshest note of the opera. Led by the guides the explorers climb a ladder that takes them out of this social terror and, in fact, out of this world. They join a heavenly choir and observe the Earth from above. Here they inhabit a dark blue sacralized space, filling it with an ethereal sound that takes on architectural dimensions, pure sound that calls to mind the religious chanting echoing across the mountain peaks of Asia. The strong tones of the color blue in this opera, whose scenes are rendered in precise color choices, reach back to the early modernist preoccupation with the coordination of emotional states, sound, and color, the result of the unity creating illumination in the spiritual sense. (Kandinsky believed that blue was the color of spirituality.) Of necessity, it is more sound than song.

Musically, Monk has for a long time now experimented with the rhythms and harmonics of Asian, Middle Eastern, Western and Eastern European composition; folk, classical, avant-garde, and popular music; chants, animal sounds, children's rhyme. Certainly, she has thrived on the resources of the world beat longer than any well-known artist working in performance. Monk also has the singular distinction of being the only woman from the "downtown" scene to have a commission to create an opera in a leading opera house, a rare enough occurrence for any artist in this country, much less one without academic credentials.

She is of the generation who inherited the musical freedom opened up by Cagean aesthetics, and empowered by its reaction to serial music. Monk is frequently placed with the minimalists since she came of age in the milieu of LaMonte Young, Terry Riley, Steve Reich, and Philip Glass, all of whom have been interested in harmony and tonality. But minimalism doesn't describe her music any more than it does theirs; she shows much less interest in structure than in the use of the voice as a lyrical medium, expressing the melodies of world cultures. Monk seems to be striving to create an ethnopoetic atlas of sound.

This transcendentalism, part primitive, part avant-garde, is a defining factor in the American performance tradition. In fact, music theater and avant-garde opera (not only by composers such as Monk, Glass, and Adams, but the directors Sellars and Wilson as well) is increasingly outlining a performance style that may be a way out of

the solipsistic impasse of performance art and, at the very least, an alternative to European opera convention. Dance, and movement-based performance, is slowly coming to the forefront in the American way of making opera, not only in Monk's work of many years, but in the Robert Wilson–Philip Glass landmark, *Einstein on the Beach,* in the more recent Peter Sellars–John Adams opera choreographed by Mark Morris, *The Death of Klinghoffer,* and in the new Bill T. Jones–Leroy Jenkins opera, *The Mother of Three Sons.* Directors and composers who ordinarily might have remained in the theater are turning for inspiration to opera, which is filling in the gap left by the international decline in dramatic literature that transcends local culture, and providing an alternative to the dominance of realism on our stages. American artists have always had the luxury not to have to use theatrical forms to preserve the speech of a minor language or small country, or the political discourse of an oppressed one; they preferred to create imagery that was narrative; and, ironically, there is a certain unregulated exploration because theater work is so marginalized and noncommercial in the culture. At another level, this new work reflects today's worldwide yearning for spiritual transformation because, as music, it is linked to the notion of the sublime, and, as dance, to a freedom of spirit that has made dance so prominent a part of American performance style in this century. Perhaps it is not unfair to say that in the realm of inspiration a pragmatic idealism influenced American artists as much as Marxism did European artists, the one generating a new vocabulary of formal experimentation, the other highly theorized political stagings.

What is occurring in this country in the new vision of opera is the elaboration of an American idiom based in imagery and movement that, unlike traditional opera that has been rooted historically in the dramatic text, instead draws upon traditions of the New York school in performance, dance, and the visual arts, and Asian aesthetics, especially Japanese.

The Japanese influence in *Atlas* is striking, not only in Monk's collaboration with Yoshio Yabara, who worked on the scenario and designed the opera's storyboards, costumes, and co-designed (with Debby Lee Cohen) the sets. More specifically, it defines the opera's second section, "Night Travel," which is performed in the style of Bunraku. A space is created by masking in black the upper and lower parts of the stage; a long horizontal opening is shown, running the

length of the stage. Hooded performers in black pass from one end of the space to the other, manipulating long sticks held upright, with a miniature airplane, ship, planet, car, or truck at their tips.

Japan has been an extraordinary influence on the New York experimental arts scene, beginning at least in the 1940s with Martha Graham, and spreading in the postwar period in the "downtown" worlds of dance, music, video, performance, and theater. It would be difficult to imagine the New York arts scene without the Japanese influence, whether philosophically through Zen and its spread by Cage, or aesthetically in the highly formal theater that has influenced artists from the era of Black Mountain, Happenings, Judson, Fluxus, and the more recent decades of the 1970s and 1980s. In the long view, American transcendentalism seems to have intermingled with Buddhism to forge a distinctive performance style, embodying for the most part a spiritual reverence for space (place) and an abiding interest in the rhythm of consciousness.

Monk's own eclecticism, an aspect of her integrity as an artist, gives definition to her ethics of performance. The interweaving of ethic and formal principles is found, for example, in the use of harmony, of duets, trios, chorus, and the principle of polyvocality; in the international casting of performers who represent world cultures; in the ideal of transcending the self to envision a larger society; in the geographic settings of the narrative. Geography—the gestalt of a place—is a recurrent theme in the work Monk has produced for more than two decades, not only *Atlas*. Monk treats geography the way Stein, the guiding spirit of American avant-garde performance aesthetics, did: as a field of revelation. And, like Stein, whose theater work is more musical than literary, she sets the rhythm of the voice—human breath—at the center of textuality. (This may be Walt Whitman's theatrical legacy, carried into theater by Stein, as much as his gift to poetry.)

The prominence of the voice is nowhere more compelling than in the scene just before the final image of the sixty-year-old Alexandra returning home. This a cappella setting, "Invisible Light," is the long last scene of *Atlas*. Here the performers have an out-of-body experience and appear as a chorus (oneness) in black robes, lined up on either side of the stage, perpendicular to the audience, at first bowing and tilting like human bell tones. The repetitive (because it is eternal) harmonies, at times nasal drone, build to a sound that levels off only when it reaches ecstasy, the kind that accompanies a deep calm.

This energy has a spiritual dynamics, elaborating the Symbolist her-

itage of Monk's vision, and, of course, linking it to her choice of Alexandra David-Néel as spiritual double in the opera, a woman whose "aesthetic spiritualism" originated a hundred years ago in the impulses of the Symbolist movement. The two women and their enlightenment project interface in the reflection emanating from "atlas," as image and concept, for the family atlas, an obsessive interest of the adolescent David-Néel, now figures onstage in the lighted globe, and it is Monk's appellation for her own spiritual journey in art. Symbolism, with its allegorical imagery, its profound faith in nonmaterial reality and the sign, its praise of solitude, and its Orientalism, is just as resonant a path for artists now as it was a century ago. What is increasingly clear at this turn of century is Symbolism's deep affinity with the poetic side of the theater of images as it has evolved over more than two decades. The only international modernist movement, nonideological in its dreams, Symbolism defined an avant-garde style founded in spiritual crisis, in myth rather than history, in the celebration of nature and the senses, in the ideal of universal culture. Its visionary poetics and idealism, joining modernism and medievalism, East and West, art and spirituality in pursuit of ecological consciousness, now quietly breathe in the world's winds of change. In *Atlas*, religiosity accompanies aesthetics, the other face of contemplation, in the heroic quest for beauty. Perhaps this is nothing more or less, but it is all, than the search for form, which is a kind of harmony.

Philippe Verrièle

Mellow Meredith

We wait, curious. The stage, small as the solo she is to perform there, is covered with several pieces of cloth.

Meredith Monk arrives, accoutered with casual chic in a nondescript black pullover, a long black skirt, and homely black boots, her hair dressed in completely incongruous little Rastafarian braids. An antiheroine. She travels past a sort of window suspended in midair and sets herself up to sing. Here is everything that might disgust a spectator: no special effects, little light, no interaction between performers, nothing but a thin woman who sings in an unbelievable fashion, leaping octaves and accompanying melody with rhythmic motion. A woman whose singing gives birth to dance naturally, like a primordial movement from which all others flow. Each song gives the feeling of a stage of life: the little girl, the woman, then approaching age. Next, Meredith positions herself at one corner of the orange floor covering where she had been singing. She moves. She dances. In a series of short vignettes, she summons up the whole of life, with preposterous and "poor" accessories (pendulous false breasts, a clouded window, giant rubber gloves, a bristling headdress). The air trembles with the rumbling of a volcano, life flows. A parade of faces, from youth to old age, shot in extreme close-up, follow one another across the large cloth hanging at the back. Meredith's body stamps and reels. When the end comes, from four black cubes spaced out below the screen, garlands of fruit and vegetables rise toward the sky and hang there. Life continues, superb and ridiculous.

At fifty-two, Meredith Monk, a figure in the American avant-garde as unexpected as she is unclassifiable, remains essential and irreplaceable.

Originally published in *Les Saisons de la Danse* 269 (January 1995); translated by Deborah Jowitt.

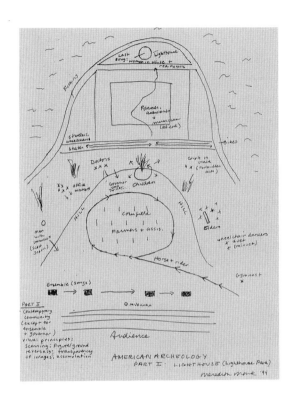

Plan for Part I of *American Archaeology #1* by Meredith Monk (1994).

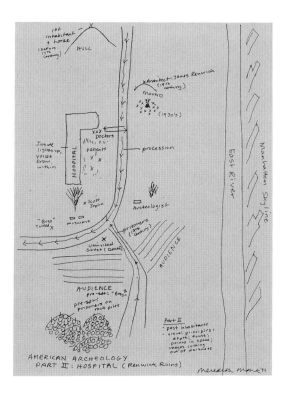

Plan for Part II of *American Archaeology #1* by Meredith Monk (1994).

Meredith Monk

From "Ages of the Avant-Garde"

I am now fifty years old. For thirty of those fifty years, I have been making pieces. When I think about it I realize that first of all I'm lucky to be alive this long and also to have been able to continuously engage in activity that I have loved for all these years. I haven't measured my growth in years so much but rather in my sense of expanding or deepening the vision that I originally had.

I started thinking of age when I was creating *Atlas* and realized that I was the oldest singing performer in the cast. What a shock! Right around that time, I also started to feel physically vulnerable— I wasn't always sure my highest notes would be there; I had to think about my balance in the dance movements whereas in the past I took it for granted. Fear entered the picture. I think the pain of aging is partially caused by becoming more conscious. What seemed totally natural seems like an insurmountable challenge. You suddenly see the situation that you are in as if you were looking through the wrong end of a telescope: "My God, I'm standing here in front of two thousand other human beings trying to get some sounds to come out of my mouth!" The struggle seems to be to become *so* conscious that you are aware of when you are not breathing, are off-center, or are distracted and to gently make an adjustment. It is literally a kind of walking through the fear to be able to surrender to the moment. Not to have a frozen concept of what something should look or sound like. I knew these things instinctively when I was a young performer. Now, I find that I have to relearn them with a kind of compassion

Originally published in *Performing Arts Journal* 46, vol. XVI, no. 1 (1994). Monk's essay was one of twenty-one by various writers included under the title "Ages of the Avant-garde."

for myself and for other performers who struggle with doubt or nerves.

Last spring, I had the privilege of working on and presenting a revival of *Education of the Girlchild,* a piece that I first premiered in 1973. I say "privilege," because unlike visual artists or writers who can examine their past work in its original form, we performing artists have to reproduce the old pieces to get a feel for what they were and to assess our growth. Often there are only blurry videotapes, sketchy notes, and the performers' memories to help in this reconstruction. The process of reclaiming and recreating *Girlchild* was lively; filled with poignancy, humor, and irony. It became apparent that the process itself mirrored *Girlchild's* themes of growth, change, life cycles, and community. It was a miracle that the five other original female "companions" (Blondell Cummings, Coco Dalton, Lanny Harrison, Monica Moseley, Lee Nagrin) were able to perform with me again. All of us were dealing with the sense of ourselves now in relation to our past selves who had first performed together in 1973. Some of us had pursued our own careers, others had become mothers, while others had begun totally new interests.

Girlchild's transparency of form seemed to allow for the experiences and transformations that each woman had gone through. In performance, each companion's unique qualities and strength shone through, with history adding another layer of content to the piece. Even though we had performed *Girlchild* in 1975, 1979, and 1982, with all the subsequent changes that always happen as a piece's life cycle progresses, I was interested in going back to the 1973 form to get a feel for the original impulses. From the shards of videotape footage that I had from the period, I noticed that *Girlchild* had a more painterly quality to it than it had in subsequent versions. There was an inner quiet to the performing style—the lines were finely drawn. The ground base was stillness and silence. I told the other performers that this was what I was after, and they tried to find their freedom within those restrictions.

I was taking a risk, knowing that this is a harder path than going for outside effect first, particularly since we were performing it in a theater space where the impulse is to make everything bigger and more immediately visible. I also added six younger women (Janis Brenner, Allison Easter, Dina Emerson, Katie Geissinger, Karen Ginsburg, Maya Kanasawa), who appeared twice in the piece. I felt that it was important to open our world to women from other generations even

while the companions would continue on and on (Gayle Turner who played one of the silent "narrators" said that we should continue to perform *Girlchild* every ten years as long as we're alive!).

The act of performing Part 2 (a long solo meditation on one woman's life) contained a number of ironies. The solo begins with me sitting on a little platform at the end of a long, white muslin road (which was unrolled at the end of Part 1). I have been dressed as an old woman with white wig, apron, and rimless glasses. I sit on my little stool as the old woman throughout the intermission. My first movement is a kind of "waking up" breathing and from there, the solo travels through sequences of the old woman to the same person as a middle-aged woman and finally to the same person as the young woman character that I played in Part 1 (the overall structure of *Girlchild* is like an accordion).

Some of the gestural motifs occur in all three sequences but are modified by the "age" of the character performing them. One of the ironies of the solo was that when I made the piece, I was closer in age to the young woman so that even though the piece was moving backward in time, I as the creator was looking ahead. Now, twenty years later, I am more like the middle-aged woman with a distinct glimpse of the old woman's reality. I was amazed to see from the 1973 videotape how deeply and intuitively I understood old age. This time I could understand in a more concrete way what the aging process entails. Now, it was more a question of intuiting what a young person's ease and flow feel like. I was pained to think that I had lost some of the spontaneous surrender and confidence that I never thought about in those days.

In Part 1 there is a short dance that the young woman performs as an introduction to the entrance of an Ancestress character who passes on knowledge to the tribe of companions. I knew that it was useless to try to reproduce that dance exactly (especially since that had been a partially improvised sequence) but instead to find in a fresh way the qualities that I observed were in the original dance—continuous flow, lightness, wit, asymmetry, delicacy—and to fulfill them with the knowledge that I have now. I had to learn both not to push and not to give up; and not to think that I had to "invent" all the time but to accept what came up in the moment and work with that. In some ways working on Part 2 was easier because the very rigorous form allowed for a precise framework for me to fill in with my present discoveries. It was an incredible experience for me to realize again the continuous inner transformations that the solo requires.

I think the hardest aspect of having done something for a long time is the sense of carrying around a lot of baggage that has to be discarded to be able to begin again. This is not to say that one doesn't have an area of interest or a set of ideas which recur during a lifetime (in fact, which seem to deepen as time goes by) but to renew energy, one has to risk starting at zero. This is harder than it sounds—those old ideas come flooding in, haunting the present with the past. It seems that even the attempt to start fresh creates energy and vitality. There is no fear that what is created will not have a sense of continuity with the past—after so many years of working one has formed an overall vision even if the attempt has been to create a unique world in each piece. There has been a refinement of thinking and of means. To me, the most important thing is to balance this natural refinement with a kind of daring, the willingness to fall on my face; to be vulnerable both as a person and as a performer. I think the readiness to pull the rug out from under oneself is something that can be shared with an audience. In a sense, they become part of the process, which they instinctively feel.

I enjoy working with younger people, passing on some of the ideas and ways of working to a new generation who seem very much in tune with what I have been trying to do all these years. I also learn a lot by watching their way of finding their own paths. I realize that one of my great pleasures is to keep learning and asking questions. This in itself seems to bring about regenerating energy. While our culture perpetuates the myth of a life having a peak and then a decline, I've always thought of time as a spiral—things always come around again, adding some knowledge and subtracting some other aspects. Doing *Girlchild* again showed me that some of my concerns remain the same twenty years later while in other ways I have changed and grown. Performing with a cast ranging from age twenty-three to sixty-four was an affirmation of the life process itself—there was a lot we could give each other.

I would be lying if I were not to speak about the pitfalls of the aging process. Right now I am in the midst of great changes which naturally stem from the fact of being the age that I am. I realize that many of my old strategies don't work for me any longer, but I haven't found new ones to replace them. The driven energy and pressure that I used to think were essential to my creativity now seem counterproductive. My impatience actually gets in the way of the true insights that are always there. It seems that one has to go through a process of undoing

oneself to get to the richness and depth of new, authentic impulses and methods. This, of course, is very painful. Often to get myself to begin a new project is an agonizing process in itself. It takes time for me to find an area of interest that I feel I haven't explored before. I want to keep putting myself in a state of risk, even though hanging out in the unknown is terrifying.

I sense that I am now at the threshold of finding out what my new voice might be.

Stephanie Skura

From "Interview with Meredith Monk"

. . . After a while, okay, you've worked twenty years or twenty-five years. Okay, so you've got this many grants, you've got this long a résumé, you have these people that hate you, you have these people that love you, you've done this piece, that piece, this piece, that piece . . . and then you go to your grave. And what do you think you have—a piece of paper that tells you all the pieces you've done? So what? The only reason for doing it is that you might have the joy of discovery on a day-to-day level. The only reason for doing it is really that you love doing it. . . . What it gets down to is: how do you want to spend your time on Earth?

Originally published in *Heresies: A Feminist Publication on Art & Politics*, no. 17 (1984).

Chronology

Early dance pieces, music compositions, music theater works, and films (1962–96), with dates of premieres. Choreography, direction, and music by Meredith Monk unless otherwise noted.

1962 *And Sarah Knew* (Israeli folk music), 5 performers. May 1962; Sarah Lawrence College, Bronxville, New York

1963 *Troubadour Songs* (medieval French music), 3 performers. January 1963; Sarah Lawrence College, Bronxville, New York

 Vibrato (William Schuman), 4 performers. January 1963; Sarah Lawrence College, Bronxville, New York

1964 *Timestop*, 5 performers. January 19, 1964; Sarah Lawrence College, Bronxville, New York

 Untitled (Daniel Pinkham), 2 performers. January 19, 1964; Sarah Lawrence College, Bronxville, New York

 Diploid (collaboration with Elizabeth Keen), 2 performers. April 13, 1964; Clark Center for the Performing Arts, New York City

 Arm's Length (sound collage), 6 performers. May 1964; Sarah Lawrence College, Bronxville, New York

 Cowell Suite (Henry Cowell), solo. May 1964; Sarah Lawrence College, Bronxville, New York

 Break (tape collage by M. M.). solo. September 28, 1964; Washington Square Galleries, New York City

1965 *Cartoon*, 7 performers. April 3, 1965; Judson Memorial Church, New York City

 The Beach (tape collage by M. M.), solo. May 1, 1965; Hardware Poets Playhouse, New York City

 Relâche (Erik Satie; collaboration with Dick Higgins), 6 performers. September 10, 1965; Judson Hall, New York City

193

Blackboard, solo. September 12, 1965; Judson Hall, New York City
Radar, 2 performers. September 12, 1965; Judson Hall, New York City

1966 *Portable,* 2 performers. April 6, 1966; Judson Memorial Church, New York City

Duet with Cat's Scream and Locomotive (tape collage by M. M.), 2 performers. December 4, 1966; Judson Memorial Church, New York City

16 Millimeter Earrings (solo incorporating film), solo. December 4, 1966; Judson Memorial Church, New York City

1967 *Excerpt from a Work in Progress* (tape collage by M. M.), 6 performers. May 8, 1967; Village Theater, New York City

Children (black-and-white film, silent, 16 mm, 9 minutes) May 8, 1967; Village Theater, New York City

Goodbye/St. Mark's Window, solo. July 1967; St. Mark's Studio, New York City

Blueprint, 5 performers. August 7, 1967; Group 212, Woodstock, New York

Overload, 4 performers. September 10, 1967; Youth Pavilion, Expo-67, Montreal, Canada

Dying Swan with Sunglasses (musical composition), solo. September 10, 1967; Youth Pavilion, Expo-67, Montreal, Canada

1968 *Blueprint (3), (4), (5)* (music for 3 and 4 only by M. M.), 2 performers (3 & 4), 5 performers (5).
January 29, 1968; Colby College, Waterville, Maine
April 10, 1968; The House, New York City
May 16, 1968; The House/Julius Tobias's Studio

Coop, 10+ performers. November 3, 1968; Loeb Student Center, New York University, New York City

Ball Bearing (color film, silent, 16 mm, 16 minutes; designed to play continuously forward and backward), November 3, 1968, Loeb Student Center, New York University, New York City

1969 *Title: Title,* 2 performers. February 4, 1969; Billy Rose Theater, New York City

Untidal: Movement Period, 5 performers. February 4, 1969; Billy Rose Theater, New York City

Tour: Dedicated to Dinosaurs, 60 performers. March 10, 1969; Smithsonian Institution, Washington, D.C.

Tour 2: Barbershop, 65 performers. April 18, 1969; Museum of Contemporary Art, Chicago, Illinois

Juice: A Theatre Cantata in 3 Installments, 85 performers. November 7, 1969; Solomon R. Guggenheim Museum
November 29, 1969; Minor Latham Playhouse
December 7, 1969; The House, New York City

1970 *Tour 5: Glass** March 3, 1970; Nazareth College, Rochester, New York

*Tour 6: Organ** March 10, 1970; Douglas College, New Brunswick, New Jersey

*Tour 7: Factory** May 1, 1970; State University of New York, Buffalo, New York

Raw Recital, (musical concert), 2 performers. April 27, 1970; Whitney Museum of American Art, New York City

Needlebrain Lloyd and the Systems Kid: A Live Movie, 150 performers. July 20, 1970; American Dance Festival, Connecticut College, New London, Connecticut (four outdoor locations)

Plainsong for Bill's Bojo (music composed for *Bojo,* a dance choreographed by William Dunas), November 2, 1970; The Playwright's Unit, New York City

1971 *Tour 8: Castle** February 18, 1971; Stevens Point, Wisconsin

Mountain (color film, silent, 16 mm, 10 minutes), August 21, 1971; Goddard College, Plainfield, Vermont

Vessel: An Opera Epic, 75 performers. October 18, 1971; The House/ Performing Garage/Wooster parking lot, New York City

1972 *Our Lady of Late* (music composed for a dance by William Dunas), April 28, 1972; Robert Megginson & Associates, Inc., New York City

Education of the Girlchild, solo. May 19, 1972; The House, New York City

Paris (collaboration with Ping Chong), 2 performers. December 12, 1972; The House, New York City

1973 *Our Lady of Late* (concert version), solo. January 11, 1973; Town Hall, New York City

Education of the Girlchild (complete), 11 performers. June 12, 1973; Common Ground Theater, New York City

*Pieces entitled *Tour . . .* were assembled at each new site and included local performers along with members of The House. Information on number of performers not always available.

1974 *Chacon* (collaboration with Ping Chong). 24 performers. January 25, 1974; Oberlin College, Oberlin, Ohio

 Roots (collaboration with Donald Ashwander; music by M. M., Ashwander, Ravel, Schutz, Bach, and Satie), 2 performers. April 23, 1974; The House, New York City

1975 *Merce Cunningham Events #118* (musical accompaniment by M. M.), February 15, 1975; Cunningham Studio, New York City

 Anthology and Small Scroll, 9 performers. April 30, 1975; St. Mark's Church, New York City

 Quarry (black-and-white film, silent, 16 mm, 5:3 minutes; designed to be projected during the opera *Quarry*), August 15, 1975; Goddard College, Plainfield, Vermont

 Merce Cunningham Events #148 (musical accompaniment by M. M.), December 2, 1975; Roundabout Theater, New York City

1976 *Quarry: An opera,* 40 performers. April 2, 1976; La Mama Annex, New York City

 Venice / Milan (collaboration with Ping Chong), 13 performers. June 20, 1976; Washington Project for the Arts, Washington, D.C.

 Plateau #2, solo. July 1976; Naropa Institute, Boulder, Colorado

 Songs from the Hill (musical composition), solo. October 28, 1976; Town Hall, New York City

 Tablet (musical composition), 4 performers. October 28, 1976; Town Hall, New York City

1977 *The Travelogue Series (Paris, Chacon, Venice / Milan)* (collaboration with Ping Chong), 30 performers. March 1, 1977; Roundabout Theater, New York City

 Merce Cunningham Events #189 (musical accompaniment by M. M.), March 18, 1977; Barnard College Gym, New York City

 Home Movie Circa 1910 (black-and-white film, silent, 16 mm and super-8, 5 minutes; incorporated into Ping Chong's *Humboldt's Current*), April 17, 1977; 550 Broadway, New York City

 Tablet (House of Stills), 9 performers. May 18, 1977; MoMing, Chicago, Illinois

 Plateau Series: Plateau #3, 7 performers. May 18, 1977; MoMing, Chicago, Illinois

1978 *Quarry* (color documentary film of the opera, sound, 16 mm, 86 minutes; produced by Amram Nowak Associates)

Merce Cunningham Events #215 and *#216* (musical accompaniment by M. M.), March 25 and 26, 1978; Roundabout Theater, New York City

The Plateau Series, 8 performers. June 1, 1978; St. Mark's Church, New York City

Vessel Suite (musical concert), October 15, 1978; Metamusik Festival, Berlin

1979 *Dolmen Music* (musical composition), 6 performers. January 1979; The Kitchen, New York City

Recent Ruins: An Opera (incorporating *Ellis Island*—black-and-white film, silent, 16 mm, 7 minutes), 14 performers. November 16, 1979; La Mama Annex, New York City

1980 *16 Millimeter Earrings* (1966) (color film, sound, 16 mm, 25 minutes; produced, directed, and photographed by Robert Withers)

1981 *Turtle Dreams (Waltz)* (music concert with film), 8 performers. May 19, 1981; The Space at City Center, New York City

Silver Lake with Dolmen Music (installation included in the exhibit *Soundings*), September 20, 1981; Neuberger Museum, State University of New York at Purchase

Specimen Days: A Civil War Opera (costumes, decor: Yoshio Yabara), 15 performers. December 6, 1981; Public Theatre, New York City

Ellis Island (color and black-and-white film, sound, 35 mm, 28 minutes [also videotape]; producer and co-director, Bob Rosen; camera, Jerry Panzer), December 20, 1981; ZDF-West German Television

1982 *View #1* (music composed by M. M. for Ping Chong's *AM/AM*), January 28, 1982; La Mama Annex, New York City

Paris (collaboration with Ping Chong; videotape, 26 minutes; produced and directed by Mark Lowry and Kathryn Escher), August 1982; KCTA-Television, Minneapolis, Minnesota

1983 *Turtle Dreams: Cabaret*—including *Mermaid Adventures* (color film, silent, 16 mm, 10 minutes; camera, David Gearey), 7 performers. April 19, 1983; Plexus, New York City

Turtle Dreams (Waltz) (videotape), September 15, 1983; WGBH Television, Boston, Massachusetts

The Games (collaboration with Ping Chong; costumes, set: Yoshio Yabara), 16 performers. November 28, 1983; Schaübuhne, West Berlin

1984 *Graduation Song* (music composed for Ping Chong's *A Race*), February 17, 1984; La Mama Annex, New York City

 City Songs (musical composition), 2 performers. April 1984; Japan American Theater, Los Angeles, California

 The Games, American version, (collaboration with Ping Chong; costumes, set: Yoshio Yabara), 18 performers. October 9, 1984; Brooklyn Academy of Music, Brooklyn, New York

1985 *Book of Days* (musical composition, work in progress; costumes: Yoshio Yabara), February 7, 1985; Carnegie Hall, New York City

 Window Song (music composed for Ping Chong's *Nosferatu*), February 11, 1985; La Mama Annex, New York City

 Road Songs (music and choreography for the film *True Stories,* directed by David Byrne)

1986 *Acts from Under and Above* (collaboration with Lanny Harrison), 3 performers. April 3, 1986; La Mama Annex, New York City

 Ellis Island (musical composition), 2 performers
 Double Fiesta (musical composition), 2 performers
 Scared Song (musical composition), 2 performers
 I Don't Know (musical composition), 2 performers
 Window in 7's (musical composition), solo piano
 September, 11, 1986; Alabama Halle, Munich, Germany

1987 *The Ringing Place* (musical composition), 9 performers. November 20, 1987; Brooklyn Academy of Music, Brooklyn, New York

 Duet Behavior (collaboration with Bobby McFerrin), 2 performers. November 20, 1987; Brooklyn Academy of Music, Brooklyn, New York

1988 *Fayum Music* (musical composition; collaboration with Nurit Tilles), 2 performers. December 13, 1988; Town Hall, New York City

 Light Songs (musical composition), solo. December 13, 1988; Town Hall, New York City

 Book of Days (film in video format, 35 mm, 74:21 minutes [see below]), October 31, 1988; Montreal Festival of New Film and Video, Montreal, Canada

 Raven, Parlor, Cat Breath, Graveyard Pavane (music composed for Ellen Fisher's *Dreams Within Dreams: The Life of Edgar Allan Poe*). November 18, 1988; P.S. 122, New York City

1989 *Phantom Waltz* (musical composition for 2 pianos), April 13, 1989; Walker Art Center, Minneapolis, Minnesota

Book of Days (black-and-white and color film, sound, 35 mm, 74:21 minutes; director of photography, Jerry Panzer; art director and costume designer, Yoshio Yabara; editor, Girish Bhargava; a production of Tatge/Lasseur Productions Ltd. and the House Foundation for the Arts), October 1, 1989; New York Film Festival, New York City

Book of Days (video version, 54:33 minutes), August 30, 1989; Alive from Off-Center

1990 *Facing North* (collaboration with Robert Een), 2 performers. June 1, 1990; The House, New York City

1991 *Atlas: An Opera in Three Parts*, 29 performers. February 22, 1991; Houston Grand Opera, Houston, Texas

1992 *Three Heavens and Hells* (musical composition), 4 performers. August 22, 1992; West Kortright Center, East Meredith, New York

1993 *Street Corner Pierrot* (choreography for Donald Ashwander's *Particular People*), August 21, 1993; West Kortwright Center, East Meredith, New York

Evanescence (choreography for Donald Ashwander's *Particular People*), August 21, 1993; West Kortwright Center, East Meredith, New York

Excerpt from *Steppe Music* (musical composition), solo piano
Volcano Songs (musical composition), 2 performers
St. Petersburg Waltz (musical composition), 3 performers
New York Requiem (musical composition), 2 performers
December 4, 1993; Merkin Concert Hall, New York City

1994 *St. Petersburg Waltz* (solo piano version), February 26, 1994; Walker Arts Center, Minneapolis, Minnesota

Volcano Songs, solo. May 11, 1994; P.S. 122, New York City

American Archeology #1, 70 performers. September 23, 1994; Roosevelt Island, New York City (Lighthouse Park and Renwick Ruin)

1995 *Den-Kai* and *Krikiki Chants* (musical compositions for *Envoy*, a *Star Trek* book on tape; Simon & Schuster)

Nightfall (musical composition for Musica Sacra), 16 voices. June 8, 1995; Chapel of the Fifth Avenue Presbyterian Church, New York City

1996 *The Politics of Quiet: A Music Theater Oratorio*, 14 performers. July 17, 1996; Musiktheatret Albertsaland, Copenhagen

A Celebration Service (non-sectarian worship service), 20 performers. July 8, 1996; James Memorial Chapel, Union Theological Seminary, New York City

1997 *Steppe Music* (musical composition–expanded), solo piano. February 2, 1997; Hertz Hall, University of California, Berkeley, California

Select Bibliography, 1966–1995

Note: Essays included in this book in their entirety do not appear in the bibliography.

Books

Balk, J. Wesley. *The Radiant Performer: The Spiral Path to Performing Power* (Forewords by Meredith Monk, Andrew Foldi, and Joan Susswein Barba). Minneapolis: University of Minnesota Press, 1991.

Banes, Sally. *Terpsichore in Sneakers* (1980). Middletown, Conn.: Wesleyan University Press, 1987.

———. *Writing Dancing in the Age of Postmodernism.* Hanover, N.H.: Wesleyan University Press, 1994.

Chinoy, Helen Krich, and Linda Walsh Jenkins, eds. *Women in American Theatre* (revised and expanded edition). New York: Theatre Communications Group, 1987.

Cohen, Selma Jeanne, ed. *Dance as a Theatre Art: Source Readings in Dance History from 1581 to the Present* (1974). Princeton: Princeton Book Company Publishers, 1992. (*"Vessel: An Opera Epic,"* an interview with Brooks McNamara, *The Drama Review,* Spring 1972, T-53.)

Croce, Arlene. *Afterimages.* New York: Alfred A. Knopf, 1977.

———. *Going to Dance.* New York: Alfred A. Knopf, 1982.

Duckworth, William. *Talking Music: Conversations with John Cage, Philip Glass, Laurie Anderson, and Five Generations of American Experimental Composers.* New York: Schirmer Books, 1995.

Foster, Susan Leigh. *Reading Dancing: Bodies and Subjects in Contemporary American Dance.* Berkeley: University of California Press, 1986.

Gere, David. "Swallowing Technology: An Ethnomusicological Analysis of Meredith Monk's *Quarry.*" Master's thesis, University of Hawaii, 1991.

Henri, Adrian. *Total Art: Environments, Happenings and Performances.* New York: Praeger, 1974.

Johnson, Roger (selection and commentary). *Scores: An Anthology of New Music*. New York: Schirmer Books, 1981.

Johnson, Tom. *The Voice of New Music, New York City, 1972–1982*. Eindhoven, Holland: Apollohuis, 1991 (American representative: New York: Two-Eighteen Press).

Jowitt, Deborah. *Dance Beat*. New York: Marcel Dekker, 1977.

———. *The Dance in Mind*. Boston: David Godine, 1977.

Kostelanetz, Richard. *On Innovative Performance(s): Three Decades of Recollections on Alternative Theater*. Jefferson, N.C.: McFarland, 1984.

Kreemer, Connie. *Further Steps: Fifteen Choreographers on Modern Dance*. New York: Harper & Row, 1987.

McDonagh, Don. *The Complete Guide to Modern Dance*. Garden City, N.Y.: Doubleday, 1976.

———. *The Rise and Fall and Rise of Modern Dance* (1970). Pennington, N.J.: Chicago Review Press (A Cappella Books), 1990.

Marranca, Bonnie. *Ecologies of Theater*. Baltimore: Johns Hopkins University Press, 1996.

———. *Theatrewritings*. New York: PAJ Publications, 1984.

Pendle, Karin, ed. *Women and Music: A History*. Bloomington: Indiana University Press, 1991.

Quadri, Franco, ed. *Il tempo e gli ambienti di Meredith Monk*. Venice: Edizioni de la Biennale di Venezia, 1976.

Roth, Moira, ed. *The Amazing Decade: Women and Performance Art in America, 1970–1980*. Los Angeles: Astro Artz, 1983.

Schaefer, John. *New Sounds: A Listener's Guide to New Music*. New York: Harper & Row, 1987.

Siegel, Marcia B. *At the Vanishing Point*. Boston: Saturday Review Press, 1972.

———. *Watching the Dance Go By*. Boston: Saturday Review Press, 1977.

———. *Tail of the Dragon*. Durham, N.C.: Duke University Press, 1991.

Smith, Geoff, and Nicola Walker Smith. *American Composers Talk about Their Music*. Portland, Ore.: Amadeus Press, 1995.

Steinman, Louise. *The Knowing Body: The Artist as Storyteller in Contemporary Performance* (1986) (second edition). Berkeley, Calif.: North Atlantic Books, 1995.

Strickland, Edward. *American Composers: Dialogues on Contemporary Music*. Bloomington: University of Indiana Press, 1991.

Zimmer, Judith Lang, ed. *The Musical Woman: An International Perspective*. Westport, Conn.: Greenwood, 1983. ("Invisible Theater: The Music of Meredith Monk" by Gregory Sandow.)

Interviews and Articles by Meredith Monk

Bowman, Rob. "Meredith Monk: Do You Be, A Conversation of Language and Aesthetics." *Musicworks* 42 (Toronto) (1989).

Fischer, Eva-Elisabeth. "A Conversation with Meredith Monk." *Ballett International,* September 1986.

Garland, David. "Meredith Monk." *Ear Magazine,* February–March 1980.

Greenwald, Jan. "An Interview with Meredith Monk." *Ear Magazine,* April–May 1981.

Monk, Meredith. "Comments of a Young Choreographer." *Dance Magazine,* June 1968.

———. "Some Thoughts about Art." *Dance Magazine,* September 1990.

Ryan, Christina. "Meredith Monk." *Ear Magazine,* November 1977.

Skura, Stephanie. "Interview with Meredith Monk." *Heresies: A Feminist Publication on Art & Politics,* Issue #17, 1984 *(Acting Up! Women in Theater and Performance).*

Vermeulen, Michael. "Interview with Meredith Monk." *Chicago Reader,* May 13, 1977.

Weit, Bernard. "Meredith Monk's *Quarry:* An Interview." *Washington Review* 12, no. 1 (June–July 1986).

Feature Articles in Magazines and Newspapers

Anderson, Jack. "Monk's Inimitable Images." *New York Times,* February 28, 1979.

Baker, Rob. "New Worlds for Old: The Visionary Art of Meredith Monk." *American Theatre Magazine,* October 1984.

Baker, Robb. "Landscapes and Telescopes: A Personal Response to the Choreography of Meredith Monk." *Dance Magazine,* April 1976.

Banes, Sally. "The Art of Meredith Monk." *Performing Arts Journal,* Spring–Summer 1978.

Dorris, George. "Music for Spectacle." *Ballet Review* 6, no. 1 (Fall–Winter 1977–78).

Goldberg, Marianne. "Transformative Aspects of Meredith Monk's *Education of the Girlchild.*" *Women and Performance: A Journal of Feminist Theory* 1, no. 1 (Spring–Summer 1983).

Jowitt, Deborah. "How Do You Hear a Dancer Dance?" *New York Times,* September 12, 1971.

———. "Ice Demons, Clicks, and Whispers." *New York Times Magazine,* June 30, 1991.

Koenig, Carole. "Meredith Monk: Performer-Creator." *The Drama Review* 20, no. 3 (September 1976).

Lynch, Joan Driscoll. "*Book of Days:* An Anthology of Monkwork." *Millennium Film Journal,* nos. 23–24 (Winter 1990–91).

McDonagh, Don. "Second Avant-garde Generation: Meredith Monk and Twyla Tharp." *The New Republic,* March 23, 1968.

Poster, Constance. "Making It New—Meredith Monk and Kenneth King." *Ballet Review,* June 1967.

Rockwell, John. "Meredith Monk's Tapestry of Music and Dance." *New York Times,* March 28, 1976.

———. "Meredith Monk: Multimedia Artist." *Musical America,* September 1973.

Shapiro, Laura. "Games That Meredith Plays." *Newsweek,* October 29, 1984.

Siegel, Marcia B. "Evolutionary Dreams." *Dance Theatre Journal* (London), October 1986.

Smith, Amanda. "Meredith Monk, Theatrical Seer." *Boston Phoenix,* February 10, 1976.

———. "Taking to the Streets." *Ms. Magazine,* December 1977.

Spector, Nancy. "The Anti-Narrative: Meredith Monk's Theater." *Parkett* (Zurich), no. 23 (1990).

Telberg, L. K. "Meredith Monk: Renaissance Woman." *Music Journal,* September–October 1979.

Reviews

Aloff, Mindy. "Film Translations of Meredith Monk's Work." *Millennium Film Journal,* nos. 10–11 (Fall–Winter 1981–82). (Films of *Quarry* and *16 Millimeter Earrings*)

———. "Meredith Monk's Songs." *Artweek* (Oakland, California), May 12, 1979.

Anderson, Jack. "Meredith Monk's *Quarry.*" *New York Times,* May 16, 1985.

Banes, Sally. "About *Quarry,* About Meredith Monk." *Soho Weekly News,* December 16, 1976.

———. "A Concert for Voice and Wine Glass." *Chicago Reader,* February 22, 1974. (*Our Lady of Late* and other works)

Bernard, Kenneth. "Some Observations on Meredith Monk's Revival of *Quarry.*" *Yale Drama Review,* Winter 1985.

———. "Some Observations on Meredith Monk's *Specimen Days.*" *Yale Drama Review,* Spring 1982.

Blumenthal, Eileen. "On Structure, Song, and the '70s." *The Village Voice,* June 12, 1978. (*The Plateau Series*)

Carter, Curtis. "Monk with Taste." *The Bugle-American* (Milwaukee), February 18–24, 1971. (*Tour 8: Castle*)

Duncan, Kathy. *Soho Weekly News,* November 15, 1973. (*Education of the Girlchild*)

Finkelstein, David. "The Films of Meredith Monk." *Ballet Review,* Summer 1991.

Gann, Kyle. "Meredith Monk." *The Village Voice,* December 8, 1987. (Vocal Ensemble concert, with guest artist Bobby McFerrin)

Hering, Doris. "*Vessel,* An Opera Epic." *Dance Magazine,* January 1972.

Johnson, Tom. "Meredith Monk, Medieval Allegory, and Other Stories." *The Village Voice,* November 15, 1976. (Town Hall concert)

Johnston, Jill. "Meredith Monk." *The Village Voice,* May 13, 1967. (concert at the Village Theater)

———. "Indelible." *The Village Voice,* December 21, 1967. *(Overload / Blueprint)*

———. "Horses Teeth." *The Village Voice,* December 11, 1969. *(Juice)*

Jowitt, Deborah. "Profusion within Tidy Limits." *The Village Voice,* December 3, 1979. *(Recent Ruins)*

Jungheinrich, Hans-Klaus. "Spirit and Spirits of a Life Journey." *Frankfurter Rundschau,* March 2, 1991. *(Atlas)*

Kisselgoff, Anna. "Events Complement Non-Events in Dance by Meredith Monk." *New York Times,* November 5, 1968. *(Coop)*

———. "Guggenheim Offers a Setting for *Juice.*" *New York Times,* November 8, 1969. (Part One of *Juice*)

———. "Cantata by Monk Unfolds One Further." *New York Times,* December 1, 1969. (Part Two of *Juice*)

———. "*Juice,* 3-Part Work by Meredith Monk, Comes to a Finish." *New York Times,* December 9, 1969. (Part Three of *Juice*)

———. "*Specimen Days* by Miss Monk at Public." *New York Times,* December 14, 1981.

Kriegsman, Alan M. "The Avant-Garde in Question." *Washington Post,* March 2, 1969. (Billy Rose season)

———. "*Facing North:* Poetry in Motion." *Washington Post,* February 24, 1992.

———. "Mesmerizing Monk." *Washington Post,* November 15, 1984. (vocal recital)

Loppert, Max. "*Atlas,* Houston Grand Opera." *Financial Times* (London), February 26, 1991.

Martinson, Ivan. "Monk's Mirth." *New York Native,* May 19, 1986. *(Acts from Under and Above* and *Turtle Dreams [Cabaret])*

McDonagh, Don. "Program of Dances by Meredith Monk Mixes Art and Life." *New York Times,* February 5, 1969. (avant-garde season at the Billy Rose Theater)

Mueller, John. "Meredith Monk's *Quarry.*" *Dance Magazine,* November 1979. (*Quarry* film)

Pally, Marcia. "The Twilight of Romance." *New York Native,* January 4–17. *(Specimen Days)*

Perrault, John. "Out of Time, in the Center." *The Village Voice,* December 16, 1966. *(16 Millimeter Earrings)*

Sainer, Arthur. "In the Merry Monk of October." *The Village Voice,* November 4, 1971. *(Vessel)*

———. "We Cease to Be Victims of the Past." *The Village Voice,* April 26, 1976. *(Quarry)*

Siegel, Marcia B. "Armchair Explorer: Patrolling the Universe with Meredith Monk." *Dance Ink,* Winter 1991–92. *(Atlas)*

Smith. Craig. "Meredith Monk: Self-Possessed and Self-Assured." *Santa Fe Reporter,* July 24, 1985. (solo music concert)

Smith, Michael. "Theatre Journal." *The Village Voice,* November 15, 1973. *(Education of the Girlchild)*

Strini, Tom. "Meredith Monk's Voice Still Startles." *Milwaukee Journal,* November 4, 1989. (solo music concert)

Sudol, Valerie. "Dance a Moving Epic of Roosevelt Island." *Star-Ledger* (Newark), September 27, 1994. *(American Archeology #1)*

Temin, Christine. "A Haunting Portrait of Ellis Island." *Boston Globe,* February 2, 1983.

———. "Monk's Brilliant Manipulation of Gesture, Sound, and Film." *Boston Globe,* June 2, 1986. (Meredith Monk and Vocal Ensemble concert)

Discography

Candy Bullets and Moon (1967), single, out of print; rereleased on *Better an Old Demon Than a New God* (1984), Giorno Poetry Systems Records, GPS 033.

Key (1970), Increase Records; rereleased on Lovely Music, Ltd. (1977), LML 1051.

Our Lady of Late (1974), Minona Records; out of print.

Rally, Procession on *Airwaves* (1977), one of a set of ten, OTOO1/2.

Biography on *Big Ego* (1978), Giorno Poetry Systems Records, GPS 012-013.

Songs from the Hill (1979), Wergo Records, SM 1022.

Dolmen Music (1981), ECM New Series, CD and cassette, 78118-21197-2.

Turtle Dreams (1983), ECM New Series, CD and cassette, 78118-212240-2.

Our Lady of Late: The Vanguard Tapes (1986), Wergo Records, SM 1058; includes previously unreleased performance tapes from 1973.

Do You Be (1987), ECM New Series, CD and cassette, 78118-21336-2.

Book of Days (1990), ECM New Series, CD and cassette, 78118-21399-2.

Facing North (1992), ECM New Series, CD and cassette, 78118-21482-2.

Return to Earth on *Eternal Light* (1992), anthology of choral music performed by Musica Sacra, Catalyst, CD, 09026-61822-2.

Atlas: An Opera in Three Parts (1993), ECM New Series, CD, 78118-21491-2.

Phantom Waltz and *Ellis Island* on *U.S. CHOICE* (1993), anthology of American music performed by Double Edge, CRI CD 637.

Monk and the Abbess: The Music of Meredith Monk and Hildegard von Bingen (1996), performed by Musica Sacra, Catalyst, CD, 09026-68329-2.

Volcano Songs (1996), ECM New Series, CD, 78118-21589-2.

Credits

Grateful acknowledgment is made for permission to reprint from the following writers and publishers: to Liza Bear for "Meredith Monk: Invocation / Evocation, An Interview with Liza Bear," © 1976 by Liza Bear; to Mark Berger for "A Metamorphic Theater" and to *Artforum,* © 1973 by *Artforum;* to Kenneth Bernard for "Some Observations on Meredith Monk's *Recent Ruins,*" © 1980 by Kenneth Bernard; to Kyle Gann for "Ancient Lullabies," © 1988 by Kyle Gann, reprinted by permission of the author and *The Village Voice;* to Marianne Goldberg for "Personal Mythologies: Meredith Monk's *Education of the Girlchild,*" © 1995 by Marianne Goldberg; to Signe Hammer for "Against Alienation: A Postlinear Theater Struggles to Connect," © 1976 by Signe Hammer, reprinted by permission of the author and *The Village Voice;* to Tom Johnson for "Hit by a Flying Solo," © 1973 by Tom Johnson, reprinted by permission of the author and *The Village Voice;* to Joan Knight for permission to include unpublished material drawn from questions to Meredith Monk (1988); to Sali Ann Kriegsman for "Elephant, Dinosaur, Whale, and Monk," © 1995 by Sali Ann Kriegsman; to Bonnie Marranca for "Meredith Monk's Atlas of Sound: New Opera and the American Performance Tradition," © 1992 by Johns Hopkins University Press; to John Perreault for "Monk's Mix," © 1968 by John Perreault, reprinted by permission of the author and *The Village Voice;* to Arthur Sainer for "A Report on Meredith's Notch," © 1972 by Arthur Sainer, reprinted by permission of the author and *The Village Voice;* to Gregory Sandow for his review of *Acts from Under and Above,* © 1986 by Gregory Sandow; to Guy Scarpetta for permission to translate and publish "Voyage au bout de la voix"; to Laura Shapiro for "Fantasies (Nearly Nude) in the Arboretum," © 1970 by Laura Shapiro, and for "Meredith Monk and the Discreet Charm of the Avant Garde," © 1984 by Laura Shapiro; to Marcia B. Siegel for "Virgin Vessel," © 1971 by Marcia B. Siegel, and for "Exhibit A and Possibly B," © 1982 by Marcia B. Siegel; to David Sterritt for "Notes: Meredith Monk," and to *San Francisco Symphony Magazine,* © 1982; to Edward Strickland and Indiana University Press for "Voices/Visions: An Interview with Meredith Monk," © 1988 by Edward Strickland; to Tobi Tobias for "Arrivals and Departures," © 1995 KIII Magazine Corporation, all rights reserved, reprinted with the permission of *New York* Magazine; to Philipe Verrièle for permission to translate and publish "Meredith Moelleux." "Meredith Monk's Gift of Vision" (1984) and "Materials Transformed" by Deborah Jowitt are reprinted by permission of the author and *The Village Voice.* "Digging for Quarry" by Meredith Monk is reprinted by permission of the author and *The Village*

Voice. Meredith Monk's essay from "Ages of the Avant-Garde" is reprinted with permission, © 1994, Johns Hopkins University Press.

The following have graciously given permission to reproduce their photographs: Jim Caldwell, Ping Chong, Johan Elbers © 1995, Joyce George, Lois Greenfield, Dona Ann McAdams, Monica Moseley, Beatriz Schiller © 1995, Vladimir Sladon, Nathaniel Tileston, Charlotte Victoria, and Doug Winter. Barbara Moore has granted permission to reproduce a photograph © 1965 by Peter Moore; and the House Foundation for the Arts for permission to reproduce © 1971 by Peter Moore. Phoebe Neville has given permission to reproduce a photograph by Philip Hipwell. Two pages of drawings by Yoshi Yabara are reproduced with the artist's permission.

All written and illustrative material, published and unpublished, by Meredith Monk is reproduced with her permission.

Library of Congress Cataloging-in-Publication Data

Meredith Monk / edited by Deborah Jowitt.
 p. cm.—(PAJ books. Art and performance monographs ; 1)
 Includes bibliographical references (p.) and discography (p.)
 ISBN 0-8018-5539-X (alk. paper).—ISBN 0-8018-5540-3
(pbk. : alk. paper)
 1. Monk, Meredith—Criticism and interpretation. I. Jowitt,
Deborah. II. Series.
ML410.M72M47 1997
700'.92—dc21 97-6597 CIP MN